EMBROIDERY
of the GREEK ISLANDS
AND EPIRUS REGION

HARPIES, ~~~~, AND TULIPS

EMBROIDERY
of the GREEK ISLANDS
AND EPIRUS REGION

HARPIES, MERMAIDS, AND TULIPS

SUMRU BELGER KRODY

THE TEXTILE MUSEUM
2320 S Street, NW
Washington, DC 20008-4008

Contents

Foreword	6
Acknowledgments	8
About the Collection	10
About the Book	12
CHAPTER 1 **Two-Tailed Mermaids**	14
CHAPTER 2 **Lions, Kings, and Queens**	30
CHAPTER 3 **Vases and Branches**	60
CHAPTER 4 **Harpies and Roosters**	78
CHAPTER 5 **Brides and Grooms**	90
CHAPTER 6 **Stags and Eagles**	110
CHAPTER 7 **Ships and Flowers**	122
Notes	128
Stitch Glossary	133
Technical and Structural Information	138
Bibliography	152
Index	157

Foreword

Since 1952, with the appearance of Ernst Kühnel and Louisa Bellinger's *Catalogue of Dated Tiraz Fabrics*, The Textile Museum has issued an impressive series of volumes presenting serious scholarship and detailed technical analysis of important groups of textiles and rugs in the permanent collection. Sometimes in the form of catalogues raisonnés, such as the Paracas and Nazca publication, and, in more recent years, in the form of temporary exhibition catalogues, with or without non–Textile Museum material added to the mix, publication of the Museum's distinguished permanent holdings has for more than fifty years been, and will continue to be, a high priority for the institution.

Until the time of Museum founder George Hewitt Myers's death in 1957, all objects in the collection had a common source: they had all been acquired by Myers himself. Since then, the collection has been strengthened in many areas through the efforts and expertise of Museum staff members—Directors, Curators, and Research Associates—to such an extent that any listing of Textile Museum objects will typically include both Myers pieces and non-Myers pieces in varying proportions. Nevertheless, the strength of the Myers component, in quality if not in actual numbers (but sometimes in numbers, too), invariably shines through.

The Textile Museum's rich holdings of Greek Island and Epirus embroidery are celebrated in this volume and in the exhibition that it accompanies. The project is the culmination of several years of research, study, and writing by one of the Museum's senior staff, Sumru Belger Krody, Associate Curator of Eastern Hemisphere Textiles. The book's subtitle, *Harpies, Mermaids, and Tulips*, is more than an

imaginative and visually provocative variation of the tripartite exhibition title that has become such a cliché. It serves as a rich metaphor for the sources of influence—Greek, Italian (Venetian), and Ottoman—that informed the style and iconography and technical qualities of the embroideries under consideration.

It should be noted that this study follows by twenty-two years a Textile Museum exhibition and catalogue curated and authored by James Trilling on the same subject. That study was advanced for its time and still warrants a secure spot on the bookshelf. But the present volume investigates/explores and tries to explain the stylistic diversity of the material by exploring the relationships between textiles and culture, culture and politics, politics and trade, and trade and geography. It is an approach that draws on social, economic, and political history, as well as the art historical evidence of the objects themselves plus relevant documentation, and that requires synthesis in order to tell the story. Some of the objects included in the present study figured in the earlier publication, but many are considered for the first time. Full-color illustrations and detailed technical analyses of the objects provide a level of discussion not previously available to the reader. Textile Museum objects have been supplemented by a number of key loans in order to fill out the picture, and those lenders, cited in Ms. Krody's Acknowledgments along with the generous financial support by The Coby Foundation, Ltd. and other sources of support and assistance, deserve our unreserved gratitude. Neither this catalogue nor the exhibition that it accompanies would have been possible without the generous assistance of The Coby Foundation, Ltd.

Daniel Walker
Director
The Textile Museum

Acknowledgments

The book *Embroidery of the Greek Islands and Epirus Region: Harpies, Mermaids, and Tulips*, as well as the accompanying exhibition at The Textile Museum, would not have been possible without the support and enthusiasm of many institutions and individuals.

The mentorship and support of many would have gone for naught if I had not received generous financial support from the Getty Grant Program, which made it possible for me to visit museums in Greece and England. I am also thankful for the guiding hand of Nancy Micklewright, Program Officer at The Getty Grant Program, during my fellowship.

Special thanks are due to the museums, directors, curators, and conservators who courteously provided access to the collections in their care and expanded my knowledge: Kate Synodinou, and Youla Riska at the Benaki Museum, Athens; Ioanna Papantoniou of the Peloponnesian Folklore Foundation, Athens, and Angela Roumelioti at the Greek Folk Art Museum of the Peloponnesian Folklore Foundation in Náfplion; Dr. Eleni Karastamati, Yianoula Kaplani, and Eleni Naki at the Museum of Greek Folk Art, Athens; Dr. Frances Pritchard at The Whitworth Art Gallery, Manchester; Pauline Rushton at the World Museum Liverpool; Jennifer Wearden at The Victoria and Albert Museum, London; Zoe Perkins at the Saint Louis Art Museum, Saint Louis; Pamela Parmal at the Museum of Fine Arts, Boston; and Bobbie Sumberg at the Museum of International Folk Art, Santa Fe.

For encouragement, advice, information, and guidance, I am most grateful to Milton Sonday, Marianne Ellis, Masako Yoshida, and Dr. Eurydice Retsila. I am indebted to the lenders to the exhibition, Mr. and Mrs. Joseph W. Fell and the Saint Louis Art Museum for their willingness to complement The Textile Museum's collection with first-rate material.

I also extend my thanks to the Board of Trustees of The Textile Museum and to the staff of The Textile Museum for their encouragement, cheerful camaraderie, and collegiality. Among the staff, I am especially indebted to the Textile Museum's former

director Ursula McCracken for her unceasing trust and support for the Greek Island Embroidery project from its start in 2000; Cecilia Gunzburger and Julie Evans for laying the initial groundwork for the project; Carol Bier and Lydia Fraser for their continuous support; Erin E. Roberts, who served admirably as second-in-command in the publication of this book and in the organization of the exhibition and who was outstanding in helping me in many other, varied roles throughout the project; Carma Fauntleroy, the Museum's acting director, for the enthusiasm she has shown to the project and assisting us to secure funding for this book and the exhibition; Sara Trautman-Yeğenoğlu for working hard to secure necessary funds for the project. Without the support of The Textile Museum's current director Daniel Walker, this book and the exhibition would not have proceeded to their final stage. This kind of extensive and important exhibition and the accompanying programs could not have been accomplished without the enthusiastic hard work of Esther Methe, Anna Grishkova, Anne Ennes, Richard Timpson, Doug Anderson, Rachel Shabica, Mary Hauser, Cyndi Spain, and Carly Oftsun.

 I am deeply grateful to Ann Pollard Rowe for her valuable comments and especially her superb editorial work on my manuscript, which gave the text greater clarity and the focus it needed. I thank Emily Hom and Margaret Barreto for their editorial help, Thomas Xenakis and Toula Misitzis for their help in translating from Greek, and Meg Smolinski for her help in translating from Italian.

 I also owe countless debts to two individuals in particular: to Eric, my husband, who supported and encouraged me from the start of the project; through our conversations he provided much needed clarity to my thinking and arguments. And finally I am grateful to Papatya, my daughter and constant partner during the months I wrote this book.

Sumru Belger Krody
Associate Curator
Eastern Hemisphere Collections
The Textile Museum

About the Collection

George Hewitt Myers, founder of The Textile Museum, purchased his first two textiles from the Greek Islands in 1916, very early in his collecting. He focused on acquiring embroidered textiles from both the Ottoman Empire and the Greek Islands throughout the 1910s and 1920s, finding them through dealers and at auctions. In 1925 he purchased a large portion of Alan John Bayard Wace's collection of Greek Island embroidery—a purchase that substantially increased the representation of this material in Myers's collection and reflected his strong interest in the subject. Wace, an archaeologist, worked in Greece from 1902 onward and probably began collecting embroidered textiles at that time. He became director of the British School in Athens in 1914 and served until 1923, continuing to expand his collection.[1] After purchasing Wace's collection, Myers continued to increase his own until 1954 when he acquired his last Greek Island textile. Myers deliberately sought out this material at a time when there was very little interest and appreciation of its importance among collectors, and his collection is now of considerable artistic and scholarly value.[2]

In the years since Myers's death in 1957, The Textile Museum has continued to expand this collection through generous donations, so that it now includes more than 120 objects. In 1983, some of the textiles were shown in The Textile Museum exhibition *Aegean Crossroads: Greek Island Embroideries in The Textile Museum*, curated by James Trilling. Since that exhibition new research has revealed much more about the world from which these textiles came: about premodern Venetian, Greek, and Ottoman political, economic, and social history; the intricate relationships formed among them; and the effects of these relationships on the textile arts. In addition, the careful examination of structural and technical characteristics of textiles has also become more important.

About the Book

This book, published on the occasion of the exhibition "Harpies, Mermaids, and Tulips: Embroidery of the Greek Islands and Epirus Region," is a study of the embroidered textiles produced from the early seventeenth century to the early nineteenth century on the islands in the Aegean and Ionian seas and in the Epirus region of Greece.[3] These textiles, customarily produced for bridal trousseaux and used in domestic life, offer a unique window into island societies at the intersection of two worlds: the Latin West and the Ottoman East.

The story I tell is not an exhaustive survey of Greek Island and Epirus textiles, nor is it a complete one of all "Greek Island embroidery." Instead, this book attempts to catalogue and describe the distinguishing characteristics of each island embroidery tradition. Most important the book explores both how embroidery traditions of the Greek Islands and the Epirus region reflect the political, economic, and social worlds in which they were created and how these together fostered an environment where diverse embroidery traditions could emerge from such a small geographic area.

These embroidery traditions remain an attractive and informative example of Greek Island rural craft. Each demonstrates the complex interactions between the creative energies of an embroiderer, her community, and her exposure to the political, economic, and social environment in which she lived. These embroidered textiles can be seen as remarkable examples of the power of these island communities to assimilate foreign influences into their own native folk traditions.

I have divided this book into chapters that somewhat represent the "established" geographical categorization. In each chapter I discuss the embroidered textiles of a region, their uses, their physical characteristics, and their methods of production. These uses, characteristics, and methods cross over from one geographic region to another. This book explores the reasons behind these crossovers. My aim is to enrich our understanding of their makers, the brilliant choices they made in their work, and how they masterfully combined the very different artistic traditions of Greece, Venice, and the Ottoman world.

Sumru Belger Krody
Associate Curator
Eastern Hemisphere Collections
The Textile Museum

CHAPTER 1

Among the Aegean Islands, Crete is the only one with an embroidery style that has clearly recognizable Venetian influence. Early colonization of Crete by Venice, Venice's control of trade in the eastern Mediterranean in the early modern period, the struggle between Venice and the Ottoman Empire for control of the eastern Mediterranean, and the eventual Ottoman control of Crete all had an impact in the formulation of this embroidery tradition.

Two-Tailed Mermaids

Called *gorgona* in modern Greek, the two-tailed mermaid, often interchangeable with the traditional one-tailed mermaid, had been part of ancient Greek mythology as well as part of medieval and Renaissance art and thinking. The mermaid, who appears as a beautiful woman with long hair and with a moving fish tail, symbolized many, often opposing, ideas in popular culture. With names such as Mixoparthenos, Scylla, and Melusine, she appears most of the time as a kind of fish-demon, of which the fish tail is the serpent in disguise, the one that lost her humanity. She has been seen as an original mother, a protectress, and at the same time a ferocious seductress who sang bewitchingly and drew men to their death.[1]

The two-tailed mermaid is often shown full face. Below her navel, her body splits into two fish tails that coil up on either side of her. She grasps the tails with her outstretched hands as if to keep her balance. On her head is a crown (fig. 1.1). This is the representation we see on Cretan embroidered textiles: women's garments, cushions, and large covers. The motif is always part of a complex and crowded composition of plant and floral spirals and often includes a menagerie of human figures, animals, birds, and imaginary beasts, all in miniature (cat. nos. 1.1, 1.2).[2]

Fig. 1.1 Two-tailed mermaid on carved stone.
Benaki Museum 2906

FIG. 1.2 Cretan women with their traditional garments. Engraving from Tournefort (1656–1708), *A Voyage into the Levant*, 1718, pp. 66–67

Function and Form

Many museum collections contain long embroidered bands that were once the lower borders of Cretan women's skirts. Travel memoirs from the seventeenth and eighteenth centuries contain descriptions and engravings showing Cretan women wearing a garment with a long full skirt that falls from the bust (fig. 1.2). The presumed way of wearing the skirt creates a silhouette that resembles the late fifteenth-century Renaissance woman's silhouette.[3] This style might have been introduced by the Venetians, adapted first by the wealthy elite, and then accepted by all levels of society. Cretan women wore these skirts with the fabric hanging from above the bustline and used very short shoulder straps to hold them in place (fig. 1.3).[4] A tunic with wide sleeves was probably worn under-neath this skirt. By the mid-nineteenth century when people began collecting this material, these skirts and other related garments were long out of fashion and even the older generation was not wearing them. This was probably when the embroidered borders of most of these skirts were cut into panels to be kept as heirlooms or sold.[5]

From the few surviving skirts and borders, we know that the tailoring was very simple. The skirt was constructed of five loom-width rectangular panels. There was no shaping. Each panel was between 61 and 70 centimeters (24 and 27.6 in.) wide (fig. 1.3).[6] The top part of the skirt was gathered with small pleats. A 30- to 45-centimeter-high (11.8 to 17.7 in.) embroidered band along the lower edge was typically the only decoration on the skirt (cat. no. 1.2). Each panel was embroidered separately before the skirt was assembled, with the result that the design did not always perfectly match at the seams.

Fig. 1.3 Cretan woman's dress, late 17th century or early 18th century.
Benaki Museum EE872, EE3308

FIG. 1.4 Herringbone stitch done with silk thread on linen (warp) and cotton (weft) foundation fabric, skirt border (details, front and back), Crete, early 18th century. The Textile Museum 81.50, acquired by George Hewitt Myers in 1925 (cat. no. 1.2)

Method and Motif

The fabric used to construct the skirts as well as pillows and bedspreads is balanced plain weave and was woven tightly, possibly to avoid transparency (fig. 1.4).[7] Linen warp and cotton weft yarns—both Z-spun and undyed—are distinctive characteristics of Cretan textiles.

The yarns used for the embroidery are untwisted or very slightly twisted silk and are similar to the yarns seen on other embroidered textiles from the Aegean Islands with the exception of Rhodes (fig. 1.4).[8] There are some Cretan textiles where the embroidery thread was produced by twisting together two or three silk fibers of different colors. Red and yellow or red, blue, and yellow are common combinations.[9]

The Cretan embroidery style is recognizable by both its design and technique. What distinguishes this style from that of other Greek Island styles is the embroiderers' preference for using a variety of colors and stitches in the same textile (cat. nos. 1.1–1.7). The colors used are red, green, blue, shades of

yellow (from light to dark), and brown, as well as white and black. Several different stitches—five or more—execute the designs drawn on their foundation fabrics.[10] The stitches typically encountered are Cretan feather, herringbone, satin, knot, chain, stem, and outline stitches; embroiderers also used couching and whipping to give further dimension to their stem and outline stitches. In nearly all other Greek Island embroidery styles only one or two types of stitches are used in each single piece of work.

The Cretan feather stitch and the herringbone stitch were often used interchangeably to fill motifs as well as create lines. Although the two stitches appear similar, the Cretan feather stitch has a recognizable braidlike part in the center and produces short lines packed on top of each other at either side of the motif on the reverse of the foundation fabric, whereas herringbone produces parallel lines of single straight stitches in alternating alignment (figs. 1.4, 1.5) (see glossary).

Color plays an important role in the Cretan embroidery style by helping us distinguish between two substyles. One of these styles might be termed "polychrome" and the other "monochrome" (cat. nos. 1.1–1.3). The use of a single color, either bright red or dark blue, on individual textiles characterizes the monochrome style. Compositions in the monochrome style are often simpler than the polychrome style, and there is less variety in the stitches used for the embroidery.

The compositions used in the polychrome style are freeflowing but also complex and crowded; repeating motifs are tightly spaced. Two-tailed mermaids often appear in this style and are placed above vases, from which spring flowers, branches, and tendrils. Many more real or fantastic creatures perch on these branches. Besides the two-tailed mermaid, the double-headed eagle, birds with fantastic tails, snakes, and carnations are often depicted. All these motifs can be found with little alteration in European decorations and pattern

20

TWO-TAILED MERMAIDS

Fig. 1.5 Cretan feather stitch, skirt border (details, front and back), Crete, early 18th century. The Textile Museum 81.51, acquired by George Hewitt Myers in 1924 (cat. no. 1.4)

books as well as in embroidered textiles and lace produced in Europe, especially in Venice.[11]

The surviving large bedspreads and pillows share the same motifs, colors, and techniques with the embroidery found on the skirts. Their design layout, on the other hand, is different from that found on skirts. Pillow faces generally have narrow borders on all four sides and a large central medallion. Large bedspreads exhibit very intricate overall repeat patterns (cat. no. 1.7). The larger surfaces of these bedspreads provide embroiderers the freedom to organize their motifs over a two-dimensional plane rather then just in a linear border.

The use of brilliant, almost jewel-like colors and the juxtapositions of these colors create strong but pleasing contrasts, giving the designs in polychrome embroidery an energy that is not usually seen in the monochromatic Cretan embroidery style. The monochrome style employs much simpler and stiffer designs. Although the two-tailed mermaid, vase with flowers, and animals also appear in the monochrome style, they do not have the vitality present in the designs of the polychrome style.

There is a group of skirts and skirt borders with dates embroidered on them. Examples of polychrome embroidery are dated 1697, 1726 (both in the collection of the Metropolitan Museum of Art), and 1733 (Victoria and Albert Museum), while monochrome examples are dated 1757 and 1762 (Victoria and Albert Museum).[12] The simplified nature of the monochrome style is consistent with the documentation that these examples are of a later date than the polychrome ones. In spite of the undoubtedly Venetian character of the designs, it is interesting to note that all of these dates fall well after 1669, when the change of control from Venetian to Ottoman hands was finalized. We will now look at the political and social developments that might have fostered the creation of the Cretan embroidery style.

History and Influences

About four and a half centuries earlier, after the devastation that the Fourth Crusade had brought to Constantinople and the Byzantine Empire in 1204, the Frankish forces had carved up the empire. Venice demanded and took control of areas that would reinforce its mastery of the Mediterranean Sea and give it an unbroken chain of ports along the route from the lagoon on which Venice sits to the Black Sea and the eastern Mediterranean, including the Aegean Islands and especially the all-important island of Crete.[13]

The Venetians entrusted the ruling of these new lands to vassals, usually the younger sons of leading Venetian families who set themselves up as petty princelings in Thrace, Anatolia, and on the islands of the Aegean Sea. Only a few of the most strategically important bases remained under the direct control of Venice, and Crete was one of them. By 1211, Crete—or as the Venetians called it, Candia, after its capital city—had become Venice's first properly constituted overseas colony.[14] Venice established a government in Crete based on its own, with a governor who bore the title of doge, except that he and his successors held office for two years instead of for life as did the doge in Venice. The arrival of a new doge and his retinue every two years undoubtedly brought the European ideas and the fashions of the day. The prominent Venetian families who flooded the island after the colony was established also brought their religion and customs. They acquired the most fertile parts of the island and established themselves as the new nobility, displacing the native Greeks.

Trade also brought a continuing flow of the western European ideas and goods. By the end of the fourteenth century in the region of the eastern Mediterranean there was scarcely a single major commodity that was not transported in Venetian ships and that did not pass through the Aegean Sea or stop at Crete. Every year approximately six regularly

scheduled major trading convoys set sail, each consisting of up to 500 ships—occasionally more.[15]

It is easy to imagine Crete in the fourteenth, fifteenth, and sixteenth centuries as one of the most important and rich harbors at the center of world trade. This wealth unquestionably helped to form a rich and cosmopolitan Latin merchant class and urban bourgeoisie. This group had close ties with Venice, the mother city, that were frequently renewed. Embroidered textiles serve as a testament to this relationship by exhibiting designs obviously inspired by the European textiles and pattern books that found their way to Crete at this time.[16]

Cretan embroidery designs, as well as the construction of the women's dresses, appear to be a direct adaptation of the Renaissance designs and fashion. They give us a sense of being frozen sometime in the fifteenth or early sixteenth century. When the historical facts are examined, the reason becomes clearer: beginning in the sixteenth century, Crete and the rest of the Aegean Islands saw great drops in trade and the accompanying revenues. This was a direct result of the new trade routes opened around Africa to Asia and across the Atlantic Ocean to America.[17] These new routes struck a devastating blow to the commercial supremacy of Venice—and indeed, to the whole importance of the Mediterranean as a highway to the East.

It could be suggested that the two centuries leading up to the late 1600s can be seen as the period when the Cretan embroidery style began to be formulated. During these centuries, Cretan women might have been copying, transforming, and adapting many Italian Renaissance patterns and dress forms that helped them formulate their own style, and it led to the crystallization of the Cretan embroidery style in the late seventeenth century. The development of this embroidery style under the strong Venetian influence appears to have been a result of several interconnected factors. From the fourteenth century onward, an increasing number of wealthy Greek women entered Latin households as wives. That, and the increasing presence of Greek servant women and slaves, who lived in the Latin households and bore the illegitimate children of Latin fathers, modified the character of these households, which served as conduits for the exchange of artistic ideas between Latins and Greeks. Against Venice's official government policy of enforcing segregation, Latins and Greeks inevitably needed to make accommodations to each other's culture, because they were sharing the same confined space.[18] At the same time, Venetian loss of control of the eastern Mediterranean trade undoubtedly slowed the importation of new ideas and new patterns. A weakened Venice loosened its grip on the island government and its society. Prominent Greek families (*archontopoula*) finally gained new powers from Venice and increased their wealth and status. These families shifted their focus from long-distance to short-distance trade. All these factors appear to have provided the right environment and freedom for Greek women to formulate their own distinct embroidery style using Italian Renaissance designs and stitches as their inspiration. The polychrome Cretan embroidery style was most likely the result.

Despite the extreme fertility of the island, life under Venetian control had been a struggle for most Cretans. Venice was unwilling to change the feudal system under which Cretans had been living since 1211 and made itself very unpopular among its subjects. This resentment worked to the Ottoman advantage, and by the late 1660s the Ottoman Empire had captured the entire island, ending 495 years of Venetian colonial rule. In the centuries leading up to the late seventeenth century, during which Venice's power was waning, the Ottoman Empire was already expanding its territory south in the Aegean Sea and had an eye on

FIG. 1.6 Woman from Kritsá, Lasíthi, Crete. Postcard from the beginning of the 20th century. Photograph from the collection of Peloponnesian Folklore Foundation

strategically located Crete, which is at the entrance to the Aegean Sea on the route to and from Cairo, Istanbul, and the Black Sea. The second half of the seventeenth century witnessed several long wars between the Ottoman Empire and Venice, some fought on Crete. But the century after the Ottomans took control of Crete was relatively uneventful in terms of wars and provided an environment friendly to trading and increasing wealth.[19]

The Ottoman occupation of the island was administratively different from the Venetian occupation. The Ottomans annexed the island and ran it as part of the empire rather than as a colony.[20] With the fall of the city of Candia to the Ottomans in 1669, both the Venetians and the prominent Greek families left the island. The first decades of Ottoman rule saw a big influx of the rural population into the cities including Candia. Ottoman officers and administrators arrived from Istanbul, and immigration from around the Aegean also added to this influx. With the exception of the Ottoman officers and administrators, these new immigrants were Greeks, who were often recent converts to Islam. Thus there seems to have been a complete turnover in the wealthier Greek population. It is this wealthy Greek population that produced and wore all of the surviving dated skirts, in both the polychrome and monochrome styles. Although formulation of the Cretan embroidery style began when the island was under Venetian control, it reached its maturity during the Ottoman period. While the polychrome skirts are all dated to the early years of the Ottoman presence on the island, the introduction of the monochrome embroidery style seems to have been the first phase of a gradual disappearance of the Cretan embroidery style by the early nineteenth century. Although the Ottomans ruled the island, commercial ties to Venice were slow to die. When Napoléon gained control of Venice in 1797 and then made Venice part of his Kingdom of Italy, France came to have more interest in the island trade.[21]

F. W. Sieber, writing in 1817, commented that in his day the dress illustrated by earlier travelers was worn only by old women and a few girls in the towns, while most of the women had adopted Turkish fashions with pants, called *shalvars*. The Turkish way of dressing was the norm when Robert Pashley visited the island in 1834. He commented that "there is scarcely any perceptible difference, to an eye neither practiced nor skillful in observing articles of female apparel, between the dresses of Greek and Turkish ladies."[22] Neverthheless, Cretans did not adopt the language of their new rulers. Robert Pashley referred to Greek as "the common language of the island." Both Ottomans and Christians spoke Greek at home as their mother tongue, and very few knew Turkish, and those who did tended to be among the city dwellers (fig. 1.6).[23] But why Cretan women turned away from the embroidery styles handed down to them is not entirely clear. It is true that this was a time of change in a historically cosmopolitan island. Throughout the seventeenth century, the Ottomans encouraged conversion to Islam by granting social and administrative privileges. Newly arrived Muslim merchant families and Ottoman officials also had an effect on Cretan culture by the 1750s. The Cretan embroidery tradition was at an end.

The Venetian domination of trade in the eastern Mediterranean in the early modern period and the eventual Ottoman control of Crete influenced both the formulation and the loss of the embroidery tradition we recognize today as the Cretan embroidery style. The penchant for combining multiple stitches in a single piece, the specific embroidery motifs and designs, and the cut of the garments all recall the dress and style of Crete's long-lasting rulers. The extent of the influences these two political powers had on the style and motifs of embroidered textiles from the Aegean Islands will become more apparent in coming chapters.

1.1 Skirt border (fragments), Crete, late 17th century. The Textile Museum 81.69A, B, acquired by George Hewitt Myers in 1922

TWO-TAILED MERMAIDS

1.2 Skirt border (fragment), Crete, early 18th century. The Textile Museum 81.50, acquired by George Hewitt Myers in 1925

1.3 Skirt borders, Crete, early 18th century. The Textile Museum 81.54A, B, acquired by George Hewitt Myers before 1928

1.4 Skirt border, Crete, early 18th century. The Textile Museum 81.51, acquired by George Hewitt Myers in 1924

1.5 (*top*; detail *right*) Skirt border, Crete, early 18th century. The Textile Museum 81.52, acquired by George Hewitt Myers in 1924

1.6 Skirt border (fragment), Crete, late 17th century. The Textile Museum 81.53A, acquired by George Hewitt Myers before 1928

28 | TWO-TAILED MERMAIDS

1.7 (*left*; detail *below*) Bedspread, Crete, 17th century. Collection of Mr. and Mrs. Joseph W. Fell

CHAPTER 2

Embroidered textiles from the Cyclades and the northern Dodecanese exhibit elements of older and more traditional embroidery styles. During the centuries of Latin and Ottoman domination, the population of these islands had a good deal of cultural freedom to continue to live as they had in earlier times.

Lions, Kings, and Queens

Familiar to all visitors of Venice is the symbol of Saint Mark, the lion with outstretched wings, up-turned tail, and one lifted forepaw resting on an open book, proudly indicating what is inscribed on it; "Pax tibi, Marce, evangelista meus."[1] Saint Mark became the patron saint of Venice when two Venetian merchants are said to have returned from Egypt with a corpse in 828, which they claimed was that of the evangelist taken from his Alexandrian tomb. Whether true or not, this story no doubt had political as well as spiritual appeal. The arrival of the body of a saint definitely provided Venice with the respect Venetians wanted to command in the new Europe during the Middle Ages and brought a special privilege beyond that which wealth or sea power alone could grant. As soon as Saint Mark became the patron saint of Venice in the ninth century, his lion was emblazoned on banners and bastions, on poops and prows, placed on gateposts and bridges in Venice and around the Mediterranean Sea. Whenever and wherever Saint Mark's lion appeared, it meant the presence of Venice's command and rule.[2]

Hidden among other prominent motifs and framed by a little diamond, a version of what appears to be Saint Mark's lion with an up-turned tail and raised forepaw can be seen in figure 2.1 and is likewise found on many old embroidered textiles from the central Aegean Islands that are part of the Cyclades and the northern Dodecanese.[3] All surviving examples of embroidered textiles exhibiting this little lion were once used as bed furnishings, such as bed curtains, bed tents, bed covers, and pillows (cat. nos. 2.1–2.25).

FIG. 2.1 Lion motif, bed tent (fragment, detail), Kos, northern Dodecanese, 17th century.
The Textile Museum 81.16A, acquired by George Hewitt Myers in 1915
(cat. no. 2.16)

Fig. 2.2 Photograph showing a Cycladic bed arrangement created for a Victoria and Albert Museum exhibition of Greek Island embroidery using various embroidered textiles from the Cyclades. Alan Wace Archives, World Museum Liverpool

Function and Form

It is not surprising that most of the surviving embroidered textiles from the Cyclades and the northern Dodecanese are bed furnishings. The bed was a prominent feature of an Aegean Island house and was covered in a lavish display of textiles. These textiles indicated the family's wealth and rank, as well as the abilities of the bride and wife as a fine embroiderer and good housekeeper. Being so prominent, these textiles were also instrumental in exhibiting regional preferences in design and production.

The average Cycladic house was a small single-room building, although a wealthier family might have had a larger room or more rooms. This single rectangular room was visually divided into two parts. The front part was the daily living area where people ate, worked, cooked, and entertained. The back, which was positioned across from the entrance at the other narrow end of the rectangular room, was for sleeping and storage. A wood platform with the bed and the storage area below was the typical built-in furniture for this alcove (fig. 2.2).[4]

This large wood bed was an important focal point for anyone entering the room and the most important place to proclaim the family's standing and to display the wife's handiwork. It is not certain how long and exactly on which islands this type of furniture was in use, but three textile items—pillows, valances, and bed curtains—are believed to have been used on some if not all of the Cyclades.

The pillows were an inseparable part of the bed furnishings and were embroidered with designs either over the entire surface or only along the edges (cat. nos. 2.5, 2.10, and 2.13). In front of the bed was hung a narrow rectangular textile called a valance, or frontal. The valance was often embroidered on the three sides that were exposed to the viewer (cat. nos. 2.18, 2.19, and 2.21–2.23). A pair of bed curtains made out of two or sometimes three loom-width fabric panels hung from either the ceiling or from a bar attached to the wall. These curtains separated the bed from the rest of the room and also created a beautiful display to enjoy when entering the house from the door opposite the bed. Each curtain panel was embroidered on the bottom, on the sides, and in the center (cat. no. 2.3). Another style consisted of curtains that hung like a tent from a narrow point, widening to envelop the bed, so they are usually referred to as bed tents. Each panel of these so-called bed tents was cut to taper off toward the top (cat. no. 2.15). The bed tents are usually attributed to the northern Dodecanese Islands of Pátmos and Kos and are thus considered a part of the Dodecanese embroidery tradition (bed tents are discussed in detail in chapter 3).

The bed furnishings used on the islands shared similarities with those used in western Europe. While showing regional variations in design, bed furnishings including textiles were a prominent feature of homes throughout the European continent. The purpose was to divide the bed from the rest of the room by means of curtains for privacy as well as to exhibit wealth in the form of textiles. There is no clear historical record to indicate whether this tradition came with the Latin overlords to the islands, or if during the Byzantine Empire there had been such a tradition that continued when the Latins took over the islands.[5]

Method and Motif

All the embroidered bed furnishings utilize a linen foundation fabric, although some fabrics are made of finer yarns and a looser weave than the others. The variety in the fineness of the weave suggests that local island weavers wove the foundation fabrics for their embroidery on looms from 44 to 50 centimeters (17.3 to 19.7 in.) wide. These elaborate bed furnishings were probably also in use on islands located in the central Cyclades, the northern Dodecanese, and, to a certain

extent, the south-central Cyclades.⁶ The bed curtains are often attributed to south-central Cyclades, whereas the bed tents are attributed to the northern Dodecanese. Surviving examples of bed valances are generally thought to be from the southern Cyclades, while pillows have a wider distribution.

Most scholars agree that these textiles were produced from the sixteenth to eighteenth century.⁷ It is, however, very problematic to suggest a more precise date for any individual embroidered textile from the Cyclades and the northern Dodecanese. Our current knowledge does not allow us to securely attribute any given piece to a specific island. Nor is it possible to place their production in a chronological sequence. One reason for this lack of knowledge is a corresponding lack of information about the other arts and crafts from these islands that might relate to the textiles. When the textiles were collected they were already old and out of circulation as functional objects. Many were not acquired in their place of origin but had already changed hands several times from their original owners. Thus, the information about their provenance, use, and date remains uncertain. The few collected by A. J. B. Wace in specific islands have the only reliable sources that can be used for provenance.

Compared with the homogeneous Cretan embroidery and the embroidery styles from other Aegean Island groups, those attributed to the Cyclades and the northern Dodecanese exhibit a great diversity of stitches, designs, and color. Three distinct stylistic groups can be defined and named according to the stitches used for each: running, satin, and cross-stitch styles. All these stitches are made by counting the warp and weft yarns of the foundation fabric.⁸

The Running-Stitch Style

The running stitch is the only stitch used to create the motifs in the first of these three embroidery styles. In the running-stitch style, the stitches are made parallel in rows, and in each row the yarn of the foundation fabric is picked up in alternate alignment to the row above it (see glossary) (fig. 2.3). With running stitch, it is easy to change the length of each stitch in order to create a specific motif or effect (fig. 2.1). When rows of running stitches are massed closely together in order to form solid areas of pattern in imitation of woven structures, the technique is referred to as pattern darning.

The running-stitch style of the Cyclades and the northern Dodecanese typically uses a single color, red, for the design. The design is created by the red embroidered areas and the off-white areas that are left unembroidered (cat. nos. 2.1, 2.5–2.8, 2.16). Sometimes green is added to the repertoire. Less frequently white, dark yellow (gold), and a lighter shade of green are incorporated for details (cat. nos. 2.11, 2.12).

Embroiderers from Náxos, Mílos, Amorgós, and Folégandros in the south-central Cyclades and from Pátmos and Kos in the northern Dodecanese used running stitch in two distinct ways to create their designs, and often these two approaches appear on the same embroidered textile. In one of these, the motifs are densely embroidered and placed close together so that the unembroidered background and inside details are left to outline the motifs. Embroiderers also alternate the direction of the stitching, causing the silk thread to catch light differently, creating different shades of same color (fig. 2.3). The best examples exhibiting this technique are embroidered pillows, bed curtains, and covers attributed to the island of Náxos in the central Cyclades (cat. nos. 2.5–2.12). In the second method, the motifs are far apart from each other and the embroidered areas outline the motifs (fig. 2.4). This approach is characteristic of embroidered textiles attributed to Folégandros and Mílos in the south-central Cyclades (cat. nos. 2.1–2.4). Embroidered textiles attributed to Kos in the northern Dodecanese, on the other hand, exhibit the melding of these

FIG. 2.3 Running stitch in alternate alignment that has been manipulated to achieve tonal difference, detail from pillow case, Náxos, central Cyclades, 18th century. The Textile Museum 81.2, acquired by George Hewitt Myers before 1940 (cat. no. 2.5)

FIG. 2.4 Bed curtain panel (detail), Folégandros, south-central Cyclades, 17th–early 18th century. The Textile Museum 2001.4.3B, the Ann Fraser Brewer Collection (cat. no. 2.3)

Fig. 2.5 Two broad leaves (*platýphyllo*) placed on a 45-degree angle, bed curtain panel (detail), Pátmos, northern Dodecanese, 17th century. The Textile Museum 81.6A, acquired by George Hewitt Myers in 1924 (cat. no. 2.14)

two methods (cat. nos. 2.15 – 2.17) while sharing a similar motif repertoire with the embroidered textiles from Folégandros and Mílos. The Venetian lion with his paw raised was especially common among the last two groups.

A leaf motif and a branch motif, the so-called king motif and queen motif, respectively, however, have a wider distribution than the Venetian lions.[9] The king motif is actually two very stylized leaves set in a 45-degree angle on each side of a stem. Among Greek embroiderers the leaf motif is called broad leaf (*platýphyllo*), a name more appropriate than king (fig. 2.5).[10] These double broad leaves are then arranged in vertical or horizontal rows, sometimes in both directions on the same textile (cat. nos. 2.8, 2.10, 2.11, 2.13 – 2.15, and 2.17).[11] When arranged in vertical rows, the narrow end of each pair is placed above the open end of the previous pair (cat. no. 2.14). From surviving textiles, it appears that the northern Dodecanese is the area where the broad-leaf motif was most commonly used. This motif is sometimes quadrupled, especially on pillows, bed curtains, and covers attributed to Náxos (cat. nos. 2.8, 2.11).

There are two theories concerning the origin of this motif. Early twentieth-century scholars, like Wace, see its origin as derived from a tree form.[12] Later scholars, like James Trilling, suggest that the design actually reached the islands with European laces and lace patterns in the form of a quatrefoil. The island embroiderers then adapted the quatrefoil by dividing it into its smallest recognizable unit, which is a single leaf.[13] These theories raise two questions: how is the widespread use of the leaf motif in the southern Aegean Islands of the Cyclades and the Dodecanese to be explained, and why was the other motif that was introduced with European patterns, the two-tailed mermaid, not as popular and widespread in the islands as the leaf motif? It could be argued that the leaf motif is easier to draw than the mermaid and so it was easier to copy. The leaf motif is geometric counted thread embroidery, whereas the mermaid is figurative and requires a different skill to execute. Another suggestion is that the leaf motif was indigenous to the region and was retained even when new motifs from continental Europe began to appear. The theory of the leaf motif's being native to

Fig. 2.6 (*below*) Branch (*spítha* or *kladí*) motif, bed tent (fragment, detail), Kos, northern Dodecanese, 17th century. The Textile Museum 81.16A, acquired by George Hewitt Myers in 1915 (cat. no. 2.16)

Fig. 2.7 (*above*) A 13th- or 14th-century embroidered textile fragment from Islamic Egypt showing a tree with birds on either side. Staatliche Museen zu Berlin

the region is strengthened if its widespread use among the southern islands of the Aegean Sea is considered. It was in fact also the hallmark motif of southern Dodecanese embroidery, although the southern Dodecanese Islands used a style of embroidery different from that used in the north. We should not, however, brush aside the small possibility that some of the European lace motifs might have been adapted from Aegean Island designs. Throughout many centuries, the communication and the exchange of ideas between western Europe and the eastern Mediterranean were much more fluid than was once assumed. There are records of Greek embroiderers in the Italian peninsula, and in Venice a large Greek community had established itself by the fifteenth century.[14]

The other common motif, named "queen" by Wace, is a possible variation on the tree-of-life motif, which has been widely used in many cultures in regions around the Mediterranean Sea (figs. 2.6, 2.7).[15] It is known as "branch" (*spítha* or *kladí*) by island embroiderers.[16] What appears to be a very stylized V-shaped tree often holds two birds facing each other. Variations of this motif range from plain to very

FIG. 2.8 Front and back of a 10th-century embroidered textile fragment from Islamic Egypt. The Textile Museum 73.391, acquired by George Hewitt Myers

elaborate (cat. nos. 2.16, 2.17). The elaborate tree motifs often contain Venetian lions as a small secondary motif among their branches (cat. no. 2.16). This motif is found in the northern Dodecanese, including on Pátmos and Kos, and farther west into the south-central Cyclades, for example, on Mílos and Folégandros.[17]

The running-stitch style seems to hearken back to an older shared Mediterranean embroidery style that was prevalent along the coasts of the Mediterranean Sea. The arrangement of opposing birds on a V-shaped tree trunk has an especially close relationship with the fourteenth-century Islamic embroidered textiles found in Egypt (fig. 2.7) as well as with much later nineteenth-century Moroccan embroidery.[18] It is difficult to be certain whether the branch motif came through trade from Egypt or Venice or if it was part of this older shared

Mediterranean style for which surviving examples are too few to reconstruct its history. But what is important is the longevity of the motif in the Cyclades and the Dodecanese, possibly up until the late seventeenth and eighteenth centuries.[19] An even stronger case can be made relating the technique used for this motif to the just-mentioned older Mediterranean embroidery style. The pattern-darning technique (see glossary) used in the islands is very similar to the way Islamic embroidery was worked on textiles found in Egypt. In both cases motifs are created by the float of the running stitch on the front of the foundation fabric. The outlines and details of the motifs are formed by floating the embroidery stitch on the back. This leaves unembroidered areas on the front that become details and outlines while creating a reverse image of the motif on the back (figs. 2.8, 2.9).

Fig. 2.9 Front and back of a 17th-century bed curtain from Folégandros, the south-central Cyclades. The Textile Museum 81.77, acquired by George Hewitt Myers before 1940 (cat. no. 2.2)

The Satin-Stitch Style

The second of the three embroidery styles is characterized by the extensive use of the satin stitch, sometimes supplemented with the running stitch. The surviving examples of this style are found on bed valances (cat. nos. 2.19 – 2.22). This style tends to employ more color in the embroidery than the previously discussed running-stitch style. Colors vary from pastels to saturated reds, greens, and blues. On the embroidered textiles, birds, often with large honeycomb tails, are frequently depicted facing each other on either side of a large plant or vase (cat. nos. 2.19, 2.20, and 2.22).

Two distinct substyles can be identified in the satin-stitch style. The textiles often attributed to Sífnos exhibit finely embroidered satin stitches on a loosely woven linen foundation fabric (cat. no. 2.19). The colors are always rather muted and pastel in tone. Dark yellow or gold-colored silk threads are characteristic of this style. Motifs are widely spaced on the fabric and formed by outlines. The fine materials, open design layout, exquisite workmanship, and pale colors all contribute to the impression of very delicate textiles. The other satin-stitch embroidery style is seen on textiles attributed to Íos (cat. no. 2.22). In this second group, the colors selected for the embroidery yarns are strong, saturated primary colors. The composition is also very dense with many primary and secondary motifs meshed together. The thick untwisted silk embroidery yarns and large satin stitches make the designs more prominent when compared with the textiles attributed to Sífnos. The foundation fabric used for the embroidery is a densely woven cotton.

The Cross-Stitch Style

The third Cycladic embroidery style relies heavily on a type of cross stitch known as the long-armed cross stitch. The best examples are bed valances attributed to the southern Cycladic island of Anáfi (cat. no. 2.23).[20] The bright colors, similar to those of the bed valances from Íos, are typical of this style as well. A thick cotton foundation fabric and colorful silk fringes are also shared by these two styles of bed valances. What distinguishes the cross-stitch style of Anáfi besides the technique is the motif of a deer with serrated horns presented in profile among the bushes and trees.

One other characteristic of the cross-stitch style is the particular way the bed valances were embroidered and arranged on the bed. They appear to have been made in pairs, with the top one having the two ends embroidered on the opposite side of the fabric from the center. This allows the valance to be turned in at the ends and placed above the bottom one, which was embroidered on only one side (fig. 2.2). There are also pillows attributed to Anáfi worked with cross stitch, in bright colors and on a cotton foundation fabric similar to the bed valances (cat. nos. 2.24, 2.25).

The coarser cotton foundation fabric and the coarser and thicker silk embroidery thread used for the satin-stitch and cross-stitch styles as well as the cruder motifs may point toward less-sophisticated embroiderers who were living on smaller islands, away from the centers of major production and influence. Most of the surviving textiles from Anáfi, Sífnos, and Íos are bed valances; there are no known surviving bed curtains. It therefore appears that less elaborate bed furniture and furnishings were created by families that had lesser means but still wished to decorate their beds.

History and Influences

It can be overwhelming to sort out the different embroidery styles produced in the Cyclades and the northern Dodecanese. Comparing them with the Cretan style embroidery further magnifies the task. Why were there so many different styles on these islands compared with the single consistent style just south of them in Crete? And why did some of the ancient motifs stay in use on these islands for so long?

Embroidery styles and embroidered textiles from the Cyclades and the northern Dodecanese Islands wonderfully reflect the diverse historical, economic, and social circumstances in which they were formulated and produced. By 1204, during the aftermath of the Fourth Crusade and the colonization of Crete, a group of cosmopolitan wealthy fortune hunters under the leadership of the Venetian Marco Sanudo began conquering islands in the central Aegean Sea, now known as the Cyclades.[21] This act resulted with the establishment of the Duchy of Náxos (Duchy of Archipelago) in 1207, which controlled the Cyclades and oversaw the island of Pátmos in the northern Dodecanese.[22] Marco Sanudo's companions established themselves as the lords of the different islands, depending on who conquered which island.[23] Although the Sanudo family was Venetian and had allegiance to Venice, the rest of the independent island lords and their families often had alliances with different powers, since they came from various parts of Europe.[24]

The conquest of the islands appears to have introduced the feudal system. The Catholic Latin families owned the land and governed the indigenous Orthodox Greek population. The feudal relationship between the lords and their tenants endured until the Ottoman government abolished the system in 1720.[25] This system allowed the Greek population a certain amount of freedom to maintain their artistic and cultural traditions, including their textile traditions. There was also apparently a distinct separation between the urban population, which was mostly Latin, and the rural population which was all Greek, with a few very wealthy and noble Greek families in between. Some of the Latin households had established strong family ties over several generations with these wealthy and noble Greek families. At that point the Latin households probably had more connection to native Greek traditions than to their own ancestral traditions as a result of cross-pollination of their artistic ideas.

By 1480, it was becoming increasingly urgent for the Ottomans to gain control of these islands in order to prevent the Venetians and their allies from continuously harassing Ottoman shipping.[26] Starting in the sixteenth century, the duchy islands also saw great drops in trade and the revenues, owing to the new competing trade routes. The end result, as previously mentioned, was a weakened Venice and weakened Venetian domination of the Aegean Islands.

By 1566, the Ottomans successfully took control of the islands, ending 359 years of Latin rule of the Duchy of Náxos.[27] The Ottomans first administered the islands as the Latins had done by giving them to an appointed official to govern as an overlord, in the Ottomans' case, to Joseph Nasi.[28] Nevertheless, by 1579 the Ottoman Empire had permanently annexed the islands to the empire. These islands were given extremely favorable terms of capitulation.[29] This approach was different from what the Ottomans did in Crete a century later. Both the Venetian and the Ottoman policies of not interfering with local customs and traditions allowed the local Greek population to maintain its artistic independence. This is particularly well exemplified by the embroidered textiles, which retained older designs and techniques.

There were apparently distinct economic differences between the large and small islands of the central Aegean Sea.[30] Larger islands in the Duchy of Náxos, such as Náxos,

Páros, Mílos, and Amorgós, were like miniature continents, producing many agricultural products and having rich textile traditions. Each of the larger islands was relatively prosperous because of both its agricultural production and its mercantile activities, which took place in harbors along the trade routes. Feudal lords, Latin merchants, mercenaries, bureaucrats, and churchmen normally did business and temporarily settled only on the larger islands.[31] Wealthy Greeks also mainly lived on the larger islands, in towns and ports but seldom in the countryside.[32] In contrast, the vast majority of the Greek population on the large islands earned their livelihood from agriculture, fishing, and trade, especially as captains, sailors, and oarsmen. Few very wealthy Greeks seemed to own ships, so Latins did most of the trading.

The quality of life on the small islands, however, differed from that on the larger islands or on the mainland. The products of their textile tradition were more humble, but this did not mean that the textiles produced were inferior technically and artistically. On the few small islands that were inhabited, the limited population was isolated, and resources and necessities were frequently lacking. They had no established access to the finer raw and processed materials for embroidery or to patterns that might be adapted. Nevertheless, the lack of outside intervention, with its inevitable artistic and cultural influences, meant that these small islands were able to hold on to their older traditions for a longer period of time.[33]

During the earlier centuries of the Duchy of Náxos, the movement of the population among the islands and to and from mainland Greece was a result of both the continuing pirate activity in the Aegean Sea and the power struggles among the Genoese, the Venetians, and the Ottomans, which continued until the seventeenth century.[34] Both the decreasing importance of international trade, which made the islands literally backwaters of the current world, and the Ottoman Empire's favorable policies helped islanders preserve their traditions until the late eighteenth and early nineteenth centuries when European fashions and ideas began to flow to the islands again.[35]

The islands southeast of the Duchy of Náxos were controlled by the military and religious Order of the Hospital of Saint John of Jerusalem, also known as the Knights of Saint John, or the Hospitallers. When the embroidery styles of neighboring islands are compared, the strong design and technical similarities and contrasts between them become apparent. The contrast is best exemplified by the differing shape of the embroidered bed tents from Pátmos and Kos, which were under the control of the Duchy of Náxos and the Knights of Saint John, respectively, and the cross-stitch style bed valances from southern duchy islands, like Anáfi.

2.1 Bed curtain panels, Mílos, south-central Cyclades, 17th century. The Saint Louis Art Museum 195.1952.1, .2, Gift of Mrs. Frank H. Cook

2.2 (*left*; detail *below*)
Bed curtain panels, Folégandros, south-central Cyclades, 17th century. The Textile Museum 81.77, acquired by George Hewitt Myers before 1940

46 | LIONS, KINGS, AND QUEENS

2.3 (*left*) Bed curtain panels, Folégandros, south-central Cyclades, 17th–early 18th century. The Textile Museum 2001.4.3A, B, The Ann Fraser Brewer Collection

2.4 Bed curtain panels, Folégandros, south-central Cyclades, 17th–early 18th century. The Textile Museum 81.32, acquired by George Hewitt Myers in 1924

2.5 Pillow face (warp direction horizontal), Náxos, central Cyclades, 17th–18th century. The Textile Museum 81.2, acquired by George Hewitt Myers before 1940

2.6 Pillow face (warp direction horizontal), Náxos, central Cyclades, 17th–18th century. The Textile Museum 81.3, acquired by George Hewitt Myers before 1940

2.7 Bedspread (fragment), Náxos, central Cyclades, 17th–18th century. The Textile Museum 81.5, acquired by George Hewitt Myers before 1940

2.8 Bedspread (fragment), Náxos, central Cyclades, 17th–18th century. The Textile Museum 1972.20, Gift of Mrs. J. Warren Joyce

2.9 Bedspread or bed curtain, Náxos, central Cyclades, 17th–18th century. The Textile Museum 81.22, acquired by George Hewitt Myers in 1925

2.10 Pillow case (warp direction horizontal), Náxos, central Cyclades, 18th century. The Textile Museum 81.63, acquired by George Hewitt Myers in 1925

2.11 Bed curtain (fragment), Náxos, central Cyclades, 18th century. The Textile Museum 81.61, acquired by George Hewitt Myers in 1916

2.12 Pillow face (warp direction horizontal), Náxos, central Cyclades, 18th century. The Textile Museum 81.62, acquired by George Hewitt Myers in 1916

2.13 Pillow case (warp direction horizontal), Pátmos, northern Dodecanese, 18th century. The Textile Museum 81.41, acquired by George Hewitt Myers in 1925

52 | LIONS, KINGS, AND QUEENS

2.14 (*left and this page*) Bed curtain panels, Pátmos, northern Dodecanese, 17th century. The Textile Museum 81.6A, B, C, and D, acquired by George Hewitt Myers in 1924

2.15 Bed tent, Kos, northern Dodecanese, 17th century. The Textile Museum 81.34, acquired by George Hewitt Myers before 1940

2.16 Bed tent (fragments), Kos, northern Dodecanese, 17th century. The Textile Museum 81.16A, B, acquired by George Hewitt Myers in 1915

2.17 Bed tent (fragment; warp direction horizontal), Kos, northern Dodecanese. 17th century, The Textile Museum 81.67, acquired by George Hewitt Myers in 1925

2.18 (*below*; detail *right*) Bed valance (warp direction horizontal), Sifnos, central Cyclades, 18th century. The Textile Museum 81.9, acquired by George Hewitt Myers in 1925

2.19 (*above*; detail *left*) Bed valance (warp direction horizontal), Sífnos, central Cyclades, 17th–18th century. The Textile Museum 81.11, acquired by George Hewitt Myers in 1925

2.20 Bed valance (fragment; warp direction horizontal), Sífnos, central Cyclades, 18th century. The Textile Museum 81.75, acquired by George Hewitt Myers in 1925

2.21 Bed valance (warp direction horizontal), central Cyclades, 18th century. The Textile Museum 81.57, acquired by George Hewitt Myers in 1925

2.22 (*below*; detail *right*) Bed valance (warp direction horizontal), Íos, central Cyclades, 18th century. The Textile Museum 81.48, acquired by George Hewitt Myers before 1928

2.23 (*above*; detail *right*) Bed valance (warp direction horizontal), Anáfi, southern Cyclades, 18th century. The Textile Museum 81.49, acquired by George Hewitt Myers in 1925

2.24 (*far left*) Pillow case (warp direction horizontal), Anáfi, southern Cyclades, 18th–19th century. The Textile Museum 81.42, acquired by George Hewitt Myers in 1925

2.25 Pillow case (warp direction horizontal), Anáfi, southern Cyclades, 18th–19th century. The Textile Museum 81.39, acquired by George Hewitt Myers in 1925

CHAPTER 3

The ingenious island embroiderers formed their traditions by the selective adaptation of foreign ideas, the preservation of older traditions, and a judicious melding of the two.

Vases and Branches

The image of a vase overflowing with flowers and leaves has a long-standing and widespread appeal in many artistic traditions throughout history. Its ability to form a compact unit as well as to fill the entire area of a decorative surface with leafy tendrils might be the reason artists have so often turned to this motif for inspiration. The flower-vase motif has an axial composition as well as an axial symmetry. It can consist of a single vase with a few flowers placed in a small panel or niche, or it can be repeated as many times as desired. Sometimes, the vase is of secondary importance to the foliage springing from it. The twisting and the turning of the foliage create a complex composition and fill the rest of the decorative surface while the vase remains insignificant to the composition and disappears in this multitude of foliage (fig. 3.1).[1]

Among the embroidery styles practiced on the Aegean Islands, the flower-vase motif is particularly common in the Rhodian embroidery style. It is simply called *glastra* or "flowerpot" or "vase" and is often represented as a large, compact motif. It is used as a repeating motif in textile compositions (cat. nos. 3.1–3.6). The vase often has a teardrop shape with a bulbous lower part on a thin triangular stand. Flowers and leaves spring from the narrow neck of the vase and spread down and around, enveloping the whole vase (fig. 3.2). The foliage never expands far beyond the vase to connect with adjacent motifs. Occasionally, stylized birds are added, bringing the composition closer in meaning to the tree-of-life interpretation.

Fig. 3.1 (*left*) Vase with foliage on the cover of two unillustrated religious tracts published in Basel in 1521 and bound together in Venice soon after. The Metropolitan Museum of Art, Rogers Fund, 1922 (22.73.2)

Fig. 3.2 (*above*) *Glastra*, bed tent door (detail), Rhodes (Ródos), southern Dodecanese, 17th–early 18th century. The Textile Museum 81.31, acquired by George Hewitt Myers in 1924 (cat. no. 3.8)

FIG. 3.3 Drawing of the interior of a Rhodian house with a bed tent, published in Montesanto 1930

FIG. 3.4 *Milosperveri*. Benaki Museum, acc. no. 7650

Function and Form

The hallmarks of the Rhodian embroidery tradition are the *glastra* motif and the bed tents on which it appears (cat. no. 3.7). These bed tents gave the master bed privacy from the rest of the living area in the house (fig. 3.3). The Rhodian house, like its counterpart in the Cyclades, was a single large room, but the entrance was on the wider wall. An arch divided the room into two parts. The front part of the room contained a fireplace, often to the left of the entrance, with a high bench opposite, which was used as secondary bed, while the master bed was in the back portion of the house on a platform.[2] The bed furniture formed a decorative focal point in Rhodian houses and probably was also meant to display the wealth and standing of the family.

The textiles used to furnish the bed fall into three categories: bed valances (frontals), pillows, and bed tents. Valances (*móstres or serdónia*) were made out of two loom-width linen panels sewn together horizontally.[3] Often only one of these panels was embroidered, and it was draped to exhibit the embroidery when in use (cat. no. 3.7, 3.11). These valances usually contain six to seven side-by-side repeated motifs. The motifs vary from *glastra* to ewer to stylized flower bouquets. Often this row of main motifs is framed on three sides by a secondary motif of a leaf or stylized vase.[4]

Pillows piled on the bed apparently were embroidered on both front and back panels with borders around three or four sides (cat. no. 3.10). They exhibit the same repertoire of motifs found on bed valances. Each Rhodian family had many such pillows. In fact, it was considered that the number of pillows was directly proportionate to the wealth of a family.[5]

The bed tent was called *sperveri* (cat. no. 3.8).[6] It is bell-shaped and constructed of panels that taper toward the top, reduced from 40 to 45 centimeters (15.7 to 17.7 in.) at the bottom to 13 to 15 centimeters (5.1 to 5.9 in.) at the top (cat. nos. 3.1–3.6). The tent was composed of between fourteen and eighteen such panels. The tapered ends of the tent were gathered over a carved or painted wood *milosperveri*. This circular or polygonal wood piece was attached to the ceiling, so that the whole tent, which is 250 to 350 centimeters (about 8 ft. 2 in. to 11 feet 6 in.) high, was suspended from the ceiling (fig. 3.4).

Fig. 3.5 *Dixos*, sleeve of a woman's chemise (detail). Benaki Museum, EE896

Method and Motif

Examination of the surviving Rhodian bed tents in various museums reveals that the motifs are positioned in a specific way. Two heavily embroidered panels flank the central tent opening. The decoration on these door panels often imitates a gabled doorway. There are often additional smaller embroidered panels with three horizontal bands that appear on either side of the door panels and/or above the gabled door (cat. no. 3.8). The panels on either side of these door panels are also heavily embroidered. Each side panel has a large motif repeated vertically up the center. On the side edges and at the bottom of each panel, a secondary motif repeats. The panels on the back are either left unembroidered or have very little decoration.

The tent door panels are the most highly decorated of the panels and contain the full repertoire of embroidery motifs employed in the southern Aegean Islands. There are two distinct construction and design layouts used. The first layout is made of two loom-width panels. One side of each panel is tapered by cutting. Then the top portions of the untapered sides are sewn together to create an opening below with the selvedges forming a clean edge (cat. no. 3.8). These door panels do not have a gable design. Instead, above the opening there is an eight-pointed star, and on either side of the star are two birds, possibly peacocks, with big curved tails, facing each other. Above them is a rectangular panel with two bands of repeating motifs. Two other similar, smaller rectangular panels with three bands of repeating motifs are placed lower down on each door panel.

The second design layout for bed tent door panels has a gable decoration above the door opening (cat. no. 3.9).[7] In contrast to the first group, these door panels are made out of a single loom-width of fabric, cut down the center to make the opening. The side panels are, therefore, narrower than those of the first group. This technique requires the cut edges of the central opening to be rolled and hemmed to prevent unraveling. The uncut outside selvedges create a clean finish. These doors have a rectangular shape rather than the tapered look of the first group. Extending the narrow embroidered side borders and connecting them above the opening create the gable design. The eight-pointed star is again placed just above the opening inside the gable, but this time, because of the narrow space, the full-tailed birds are moved above the gable (cat. no. 3.9). This second group of door panels does not include the rectangular panels with two or three bands and with repeating bands above the gable or on the door panels. However, such bands are sometimes found on the side panels of the bed tent. In some cases they were embroidered separately and then attached to the side panels.[8]

The *glastra* and a variation of it called *dixos* are found only on the islands that form today's Dodecanese.[9] The *glastra* appears to have been used only in the southern Dodecanese, on Rhodes and islands close to it. *Dixos*, which has a more rounded medallion-like silhouette than the *glastra*, has a wider distribution toward the central Dodecanese (fig. 3.5). The floral design in the *dixos* medallion is often very stylized. Both *glastra* and *dixos* are nearly always used as single units placed

FIG. 3.6 *Platýphyllo* and *spítha* combination, bed tent door (detail), Rhodes, southern Dodecanese, 17th–early 18th century. The Textile Museum 81.31, acquired by George Hewitt Myers in 1924 (cat. no. 3.8)

in rows, either vertically or horizontally. It is possible that both originally derived from designs that represented the tree of life. It is not unusual to see birds and animals among the branches, although they are frequently difficult to distinguish.[10]

Another motif that had a wide distribution in the Dodecanese is the motif formed by combining the branch and broad leaves (*spítha* and *platýphyllo*). Two broad leaves placed at a 45-degree angle create a little nest in the center from which the branch motif can spring. The tendrils of the branch, often holding several birds, unfold above the broad leaves like an umbrella (figs. 3.6, 3.7). This motif is often repeated in the small horizontal bands or is vertically stacked on the door panels of the bed tents.

Embroidered textiles from Rhodes (Ródos) are distinguishable from other island textiles not only by their design but also by their foundation fabric, silk threads, and embroidery technique. The foundation fabrics used for bed tents, valances, and pillows are densely woven balanced plain weave. The linen warp and weft yarns are hand spun in the Z direction and are considerably thicker than the yarns used in many other island embroidery styles.[11]

The type of silk thread used for embroidery is unique to Rhodes and the islands surrounding it. This thread is made of either thick untwisted bundles of silk fibers or two slightly S-plied bundles of silk fiber. The size of the Rhodian embroidery thread is double, often triple, the size of the threads used on other islands. This very glossy thick thread often curls during the embroidery process, giving a further thickness to the motifs. When these thick embroidery threads are used to make crossed stitches, as the Rhodian embroiderers did, the effect is heightened even more. Crossed stitches, with whatever embroidery thread is used, always create a depth in the motifs by the crisscrossing of the two threads (see glossary) (fig. 3.6).

FIG. 3.7 *Platýphyllo* and *spítha* combination, bed tent (fragment, detail), Kos, northern Dodecanese, 17th–18th century. The Textile Museum 81.67, acquired by George Hewitt Myers in 1925 (cat. no. 2.17)

Rhodian embroidery uses a composite stitch specific only to that island. This stitch could be referred to as Rhodian cross stitch in order to distinguish it from other crossed stitches (see glossary). This composite stitch is made from a long-armed cross stitch and a zigzag stitch. The embroiderer makes the long-armed cross stitch first and then goes back to the already stitched area and makes a second row of zigzag stitch. This, of course, adds another layer to the motif, further increasing its depth. Because of the second step the embroiderer takes, the Rhodian cross stitch slants in one direction rather than having the usual plaited appearance of long-armed cross stitch.

Crossed stitches seem to be used exclusively on the islands of the southern Dodecanese, including Rhodes, Nísyros, Kárpathos, Astypálaia, and in the southern Cyclades, including Anáfi. The designs and specific motifs tend to be easily transferable from one tradition to another, while the techniques used to produce the objects tend to be less so. This conservative quality of a given technique suggests that the crossed stitches may be native to the southeastern Aegean Islands. Although both the southern Dodecanese and the southern Cyclades experienced different social, political, and economic histories and were exposed to new embroidery designs and techniques through the powers that controlled them, the island embroiderers kept their older native tradition of embroidering with a variety of crossed stitches.

The best example to illustrate the supremacy of technique over design is offered by a comparison of the embroidery of the southern and northern Dodecanese. Kos, Kálymnos, Leipsoí (Lipsós), and Pátmos are the largest islands in the northern Dodecanese. The islanders from the northern Dodecanese used a bell-shaped bed tent, which was constructed of panels that taper toward the top and had main gabled door panels as in Rhodes (see cat. no. 2.15). Embroidered textiles from these islands also share the same motif repertoire with those of

VASES AND BRANCHES

FIG. 3.8 *Koumpaso*, detail from the bed tent, Kos, northern Dodecanese, 17th century. The Textile Museum 81.34, acquired by George Hewitt Myers before 1940 (cat. no. 2.15)

FIG. 3.9 Bed tent with double gables, Pátmos, 18th century. Victoria and Albert Museum T.92-1931, A Maudslay Bequest

Rhodes. They use the combined broad leaf and branch (*platýphyllo* and *spítha*) motif extensively in their embroidery (fig. 3.7; see fig. 2.6), and this motif appears in the same location in the bed tent's design layout (cat. no. 3.8; see cat. no. 2.15). However, the stitches and the materials used for the bed tents of each of these areas are completely different and create different effects.

The bed tents from the northern Dodecanese island of Kos exhibit much greater richness in their selection of motifs than those embroidered by their southern neighbors, although they share a similar design layout. As with the southern Dodecanese bed tents, there are two design variants of the gabled door panels. The first variant contains a single gable (see cat. no. 2.15). Directly above the opening is the combined broad leaf and branch motif, instead of the eight-pointed star of the Rhodian door panels. The birds with upturned tails, on the other hand, frame this central motif exactly as do the Rhodian ones. Above the gable, things get a little more complicated. This area, identified as *koumpaso*, is often very large, compared with the Rhodian ones, and crowded with

variety of motifs embroidered in pairs and placed facing each other on either side of a central axis.[12] Among these motifs are a variety of birds with large upright and downward-turned tails, lions with and without raised paws, deer with serrated horns, double-headed eagles, sailing boats, human figures, and various stylized flowers. Two motifs, however, are never doubled, a simple branch motif and a woman in an enclosed structure above it. These two motifs are always embroidered in the center, one above the other, and divide the field (*koumpaso*) into two equal sides. There is not enough information to be sure about the symbolism of the woman in an enclosed structure (fig. 3.8). Because these textiles were produced as dowries at the time of weddings, this female motif might be a representation of a bride in her new home. A second possible interpretation is that the design depicts a coat of arms such as those decorating the facades of buildings.[13] The second design variation of bed tents from this region has a double gable, instead of a single one, although other motifs are identical. The female motif is, however, often missing in the double-gabled door panels (fig. 3.9).

The most prominent characteristics that set the northern Dodecanese bed tents apart from their southern counterparts are the use of running stitch instead of crossed stitches in their embroidery, and the use of a very fine linen foundation fabric and fine silk embroidery thread. Although these two regions share a similar motif repertoire, they appear to be a world apart because of these technical differences. The embroidered textiles from the northern Dodecanese exhibit close technical links with the embroidered textiles from the islands in the central Cyclades, such as Náxos, Mílos, Amorgós, and Folégandros. All these islands use fine silk thread on fine linen foundation fabric. They also employ the running stitch and manipulate it the same way, in the pattern darning technique (see glossary).

The relationship between the northern Dodecanese and the central Cyclades does not end with their sharing the same embroidery technique; it also includes sharing the same motifs such as the broad leaf and branch. Thus, the northern Dodecanese and the central Cycladic embroidered textiles form a single stylistic group, although when the formulation of this style was going on, the northern Dodecanese were ruled by two different political powers, the Duchy of Náxos on Pátmos and the Knights of Saint John on Kos, and when the style was finally established and the surviving embroidered textiles with this style were produced, the region was under the control of Ottoman Empire. The southern Dodecanese and the southeastern Cyclades, meanwhile, share another embroidery style, although again they were ruled by the same two distinct political powers. This sharing of styles across political borders suggests that the embroidery tradition and its pattern of distribution among the islands were not always the result solely of foreign artistic influences. Rather, the the embroidery styles were formed by the selective adaptation of foreign ideas, preservation of older traditions, and a judicious melding of the two. The wide distribution of the broad leaf (*platýphyllo*) and branch (*spítha*) motifs in the central Aegean Islands suggests that they may have roots that predate the sixteenth century, possibly to the Byzantine period, if not earlier.[14]

History and Influence

It is always interesting to examine the extent to which the political and cultural history of a region influenced which traditions were kept and which were eventually replaced with new ones. For example, the island of Rhodes had always been an important strategic stronghold. Its position on vital trade, pilgrimage, and crusader routes in the eastern Mediterranean greatly influenced the course of its history and artistic development.[15] After the devastating Fourth Crusade in 1204,

Rhodes and the surrounding islands, known today as the Dodecanese, were ruled independently, first by a family from Crete (Kríti or Candia) and later by another family from Genoa until about 1309. At that time, Rhodes became the new base for the Order of the Knights of Saint John, also known as the Hospitallers.[16]

The Order of the Knights of Saint John, a group of military monks following the rule of Saint Augustine, originated at a hospital founded in Jerusalem about 1048 by merchants from Amalfi, Italy. Their goal was to provide relief and protection for poor pilgrims visiting the Holy Land. The Order subsequently grew to be a wealthy fraternity, was organized along military lines, and became one of the chief centers of Christendom in the East, in addition to having dependent "hospitals" and possessions throughout the Christian-controlled lands in the eastern Mediterranean region.[17] By 1340 the Knights had conquered the Dodecanese as far north as Kos and Leipsoí, making Kos their second center. They, however, never managed to control Kárpathos, Kásos, or Astypálaia in the south or Pátmos in the north. These islands remained either semi-independent or under the control of the Duchy of Náxos until they were taken by the Ottomans in 1572. The Knights' initial task was to repopulate the islands with the Latin settlers that were arriving from various directions. They also aspired to develop their commerce and agriculture so that men and supplies would be available for the defense of Rhodes. The smaller islands north of Rhodes were especially important, because they sent their exports to Rhodes. The Knights gave some of the fertile islands as fiefs to Latin families, thus creating a culturally and artistically heterogeneous society.[18]

After the Ottomans had conquered Egypt in 1517, the continual harassment of Turkish and Muslim shipping by the Knights, especially between Istanbul and Alexandria, was a good excuse for the Ottomans to focus their attention on the Dodecanese and to increase their raids against Rhodes and its surrounding islands. The Ottomans were concerned about keeping the trade route open from the capital in Istanbul to Palestine and Egypt, as well as eliminating a hostile foreign power in the middle of their empire. The final blow came during 1522 when Süleyman I, called the Magnificent by Westerners and the Lawgiver by the Ottomans, occupied the island and put the city under siege. After 213 years of the Knights' occupation, Rhodes and its surrounding islands became part of the Ottoman Empire on January 1, 1523, and stayed in Ottoman hands until 1912.[19]

The degree to which the Knights influenced local culture in the Dodecanese remains debatable. It might not have been any stronger than the Catholic Latin influence in the Duchy of Náxos, as was previously thought. Nevertheless, there was interaction between the Greeks and the Latin knights.[20] The number of Latins on Rhodes was relatively large compared with the amount of land they controlled. There were always new knights coming to the island in a steady stream to join the force, bringing with them European culture, ideas, and fashion. One manifestation of the influence of Latin artistic ideas on the local embroidery repertoire can be seen in the adaptation of gables on the bed tents. These gables are very similar in design and decoration to the doorways and gateways seen in many Latin buildings on Rhodes (fig. 3.10).[21]

Two factors should be kept in mind when evaluating the influence of the Knights. First, they came from different countries all over Europe, which might have had a distancing influence on the relationship between the Greeks and the Latins. Among the Order's hierarchy, the Knights were divided into seven groups, depending on the country or region of origin: France, Auvergne, Provence, England, Italy, Germany, and Spain (fig. 3.11). The Knights, therefore, did not form a cohesive group as did the Catholic Venetians on Crete and the Catholic

Fig. 3.10 Ornately carved stone door in Rhodes, published in Montesanto 1930

FIG. 3.11 The Street of Knights in Rhodes, engraving published in Eugène Flandin (1809–1876), *Histoire des chevaliers de Rhodes, depuis la création de l'ordre à Jérusalem jusqu'à sa capitulation à Rhodes.* A. Mame et fils, Tours, 1867

Latins on the Duchy of Náxos islands; each group of Knights would have exposed the local people to a different set of cultural ideas and traditions. This variety of traditions did not have the same strong impact as a single influential culture. In addition, foreign influences were more likely to affect the urban population who lived in the city of Rhodes and to a certain extent in Kos than those who lived in the countryside and/or on the smaller islands.

Second, the Knights always focused their energies on medical work. For more than a century the hospital at Rhodes was considered the best in Europe and sick patients and their relatives came and stayed for extended periods of time. Rhodes, being an important rest stop en route to the Holy Land and the eastern Mediterranean, also hosted many pilgrims from different parts of Europe. The Knights' well-placed commercial entrepot in Rhodes was also a base for merchants of many nations, particularly for the Florentines and Catalans. This varied exposure to a myriad of cultures might explain why Rhodian embroidery shows traditionalism in its technique and materials but some acceptance of European fashion in its function and perhaps in its design.

The Knights' rule of Rhodes and the surrounding islands appears to have had an isolating effect on the local Greek community. They were out of contact with the rest of the Greek Orthodox community on the islands, in Anatolia, and especially in Istanbul, while the Orthodox bishopric of Rhodes remained vacant for centuries.[22] This period also corresponds to the time when the Rhodian embroidery style might have been formulated. The surviving embroidered textiles in museum collections are usually dated to the late seventeenth and eighteenth centuries—at least a century after the control of Rhodes fell into Ottoman hands.[23] The continuation of the Rhodian embroidery style for approximately two hundred years, far into the eighteenth century, after the Ottomans took

control of the island is in stark contrast to the end of the embroidery tradition on Crete a century into the Ottoman period. The many historical and political factors that gave freedom to the local population in many aspects of their lives, seem to have fostered the continuation of their older traditions.[24]

Rhodes and the surrounding islands were captured by the Ottomans in a very short period of time. Unlike Crete, they did not experience a long occupation before the final city fell to Ottoman military might. Thus, the Ottoman government did not need to establish a policy of recruiting Ottoman sympathizers from among the local population by offering extra privileges. These islands also came into Ottoman hands more than a century before Crete did, during a period in which the Ottoman political and financial power was supreme.[25] Thus, Rhodes and the rest of the Dodecanese received privileged treatment as soon as they became part of the empire. Süleyman I granted certain liberties, which encouraged the increase of the Greek population. The islands were declared to be *vakif* (*wakf*), or religious endowments, and were allotted to various Muslim foundations.[26] This gave social and administrative privileges to the islanders and allowed them to prosper financially. After the Ottoman capture of Rhodes in 1523, for the first time in many centuries these islands were reunited with the rest of the Greek Orthodox community.[27]

All these historical and political events had a profound effect on the preservation of older artistic traditions, including the embroidery tradition. The dominant embroidery style in the southern Dodecanese continued to be practiced during the Ottoman period. Many of the surviving bed tents are from this period and date to the eighteenth century. The differences of embroidery style either established or present during the Knights' and the duchy's control of these islands continued under Ottoman sway without hindrance. The Dodecanese was the first island group in the Aegean Sea that Ottomans incorporated into their empire. The second group of islands that became part of the Ottoman Empire following the Dodecanese was the Northern Sporades, off the eastern shore of mainland Greece in the northern Aegean Sea. Northern Sporades embroidery is a blend of both Ottoman and local embroidery traditions.

3.1 Bed curtain panel, Rhodes (Ródos), southern Dodecanese, 17th–early 18th century. The Textile Museum 81.33A, acquired by George Hewitt Myers in 1926

3.2 Bed curtain panel, Rhodes, southern Dodecanese, 17th–early 18th century. The Textile Museum 81.33F, acquired by George Hewitt Myers in 1926

3.3 Bed curtain panel, Rhodes, southern Dodecanese, 17th–early 18th century. The Textile Museum 81.33C, acquired by George Hewitt Myers in 1926

3.4 Bed curtain panel, Rhodes, southern Dodecanese, 17th–early 18th century. The Textile Museum 81.33E, acquired by George Hewitt Myers in 1926

3.5 Bed curtain panel, Rhodes, southern Dodecanese, 17th–early 18th century. The Textile Museum 81.33B, acquired by George Hewitt Myers in 1926

3.6 Bed curtain panel, Rhodes, southern Dodecanese, 17th–early 18th century. The Textile Museum 81.33D, acquired by George Hewitt Myers in 1926

3.7 Bed valance (warp direction horizontal), Rhodes, southern Dodecanese, 17th–early 18th century. The Textile Museum 81.30, acquired by George Hewitt Myers before 1928

3.8 Bed tent door and side panel, Rhodes, southern Dodecanese, 17th–early 18th century, The Textile Museum 81.31, 81.76, acquired by George Hewitt Myers in 1924

3.9 Bed tent (fragment), Rhodes, southern Dodecanese, 18th century. The Textile Museum 81.35, acquired by George Hewitt Myers in 1922

3.10 Pillow, Rhodes, southern Dodecanese, 17th–early 18th century. The Textile Museum 81.74, acquired by George Hewitt Myers in 1925

3.11 Bed valance (fragment; warp direction horizontal), Rhodes (?), southern Dodecanese, 18th century. The Textile Museum 81.66, acquired by George Hewitt Myers in 1925

CHAPTER **4** Among the embroidery styles encountered in the region of the Aegean Sea, the Skýros style is the one that most successfully and skillfully combines Italian, Greek, and Turkish embroidery traditions, resulting in the creation of its own distinct and exuberant style.

Harpies and Roosters

Most often represented as winged birds with female faces, long hair, and claws made of brass, Harpies were believed to carry the souls of the dead to Hades. In Homer's *Odyssey*, Harpies personified whirlwinds or hurricanes, while in later mythology they were represented as hideous winged monsters.[1] Harpies depicted on embroidered textiles from the Northern Sporades, on the other hand, are charming and are shown with colorful bodies, wings, legs and arms, and often with windblown hair (cat. no. 4.1).[2] How and why Harpies, or other fantastic creatures, appear in the arts of these islands is hard to understand. But conservative societies with a strong attachment to their traditions may use images of fantastic creatures like Harpies to avert the evil eye and spirits. The Harpies' association with strong winds might also have played a role in their repeated use in the arts of this island society whose main livelihood came from the bounty of the sea; winds, especially strong ones, needed to be avoided at any cost. The Harpy images might have been thought to protect sailors and fishermen from misfortune.

Function and Form

Skýros is the largest and southernmost island in the Northern Sporades archipelago and the only one believed to have been produced an embroidery style.[3] The geography and architecture of this island frequently remind travelers of the islands in the Cyclades.[4] Skýros houses, with their flat roofs and recessed windows, shared the same architectural style as Cycladic-style houses.[5] Often one-roomed, Skýros houses were rectangular, and people entered from the middle of one of the short sides. The front part contained the fireplace and was used as both a kitchen and a living room. The back half of the house across from the entrance door was occupied by a tall, wood platform built from wall to wall. The area below this platform was used for storage, while the upper level, reached by a short staircase, was the bedroom. Although the beds used in the Cyclades and the Dodecanese were similarly raised on platforms, Skýros beds were not confined to a niche but rather were set in the center of the platform with the head against the back wall. This platform created a grand focal point for visitors entering through the main door, especially when the balustrade of the platform was hung with textiles for ceremonies. Such a practice created a festive atmosphere inside the house and exhibited the woman's skill and the family's wealth. The rest of the interior was usually decorated with elaborate hand-carved wood furniture such as benches and chests, ceramic plates often imported from western Anatolia, copperware, and textiles, especially embroidered examples.[6]

Embroidery was an important part of women's work on Skýros, as on many other Aegean Islands. It was used mostly on home furnishings and, to lesser degree, on garments. The bedspreads, pillow faces, towels, and valances for carved wood benches were all embroidered (cat. no. 4.1–4.9). The Skýros embroidery tradition, however, did not produce any large bed curtains or bed tents like those seen in the Cyclades and the Dodecanese, most likely because of their different interior arrangement for the bedroom. Embroidered garments included women's chemises and men's shirts. The chemises were worn under a long coat or kaftan, and embroidered motifs were clustered on the lower edge and along the outer side of the large sleeves.[7]

Method and Motif

The foundation fabric for Skýros embroidery consists of balanced plain weave with warp and weft yarns of off-white (undyed), Z-spun linen.[8] There are approximately twenty warp by nineteen weft yarns per square centimeter. The yarns are finely spun, and the fabric is loosely woven, which is conducive

FIG. 4.1 Pillow face (detail), Skýros, Northern Sporades, 18th century. The Textile Museum 81.99, acquired by George Hewitt Myers in 1950 (cat. no. 4.4)

FIG. 4.2 (*right*) Bed valance (detail), Skýros, Northern Sporades, 18th century. The Textile Museum 81.80, acquired by George Hewitt Myers in 1927 (cat. no. 4.3)

to counting warp and weft yarns for embroidery. The loom widths of the foundation fabrics are narrow, varying between 42 and 46 centimeters (16.5 and 18.1 in.), probably corresponding to the size of the looms in Skýros households. Larger textiles had to be made by sewing these bands together side by side.

Silk, as in other Greek Island textile traditions, is the primary fiber used for embroidery thread. It usually consists of two Z-twisted silk fiber bundles, S-plied, but in a few cases the reverse twist is used (cat. nos. 4.5, 4.6). The colors are pastel in character, especially when compared with the brilliant reds and greens on the embroidered textiles of the Cyclades, the Dodecanese, and Crete (Kríti or Candia). Skýros embroiderers also employed myriad colors in their embroidery unlike other Aegean Island embroidery traditions apart from Crete.[9]

Like the Cretan embroiderers, Skýros embroiderers appeared to love the juxtaposition of colors and what seven to ten colors could do to their motifs and designs. They explored these uses of color, leading to such a wonderful result as that shown in catalogue no. 4.3. The Skýros embroiderers were also able to achieve quite beautiful effects in their embroidery work not only through color but also by varying the execution of a limited repertoire of stitches. The predominant stitch in Skýros embroidery is the running stitch. It appears both in diagonal alignment and in alternate alignment (see glossary), each creating such a distinct effect that they appear to be two separate substyles (figs. 4.1, 4.2; cat. nos. 4.1–4.4, 4.6, and 4.7). Double-running and satin stitches are also used, but mainly for secondary motifs or details.[10] The use of running stitch and the employment of a limited variety of stitches both closely connect the Skýros embroidery style with its southern neighbors, the Cyclades and the Dodecanese embroidery styles, respectively.

Skýros and Crete share a technique unusual among the Aegean embroidery traditions called *grafta* in Greek. In the *grafta* technique, the motifs that are to be embroidered are drawn onto the foundation fabric with an ink-like substance. In Skýros embroidery, unlike that of Crete, the drawn pattern often is done on the back of the foundation fabric. The technique generally requires the use of a frame, and it is thought that frames were in fact used in Skýros.[11]

An important design detail, which distinguishes Skýros work from the other Greek Island embroidery styles, is a border embroidered with a single line of running stitch, found on large bedcovers along all four edges below the main embroidered border (cat. nos. 4.3, 4.5).

As in other Aegean Island traditions, Skýros embroidered textiles both for home and for garments were produced by young girls, probably with the help of their close female relatives. Most of the embroidery was done either long before the marriage, while the future bride-to-be was a young girl, or shortly beforehand in order to prepare for it. Many of the textiles produced for the home, such as bedspreads, were made out of several panels. Panels of single textile exhibit slight stylistic differences, thus each panel might have been embroidered by the same woman at different times, or it is possible that each panel was given to a different woman to

embroider for faster production. This practice might also have provided an environment for the women of the village to come together for companionship. There is not enough evidence to suggest whether the designs drawn on the textiles were done by the same woman who embroidered them or not. If the closest embroidery tradition, which is the Ottoman tradition, is any indication, there was probably a skilled woman in the village who drew or helped to draw the designs on the foundation fabrics for the other women to embroider. The same skilled woman may also have contributed as one of the embroiderers. This practice would help explain similarly drawn textile motifs as well as similar design layouts and color juxtapositions.[12] This, of course, does not eliminate the possibility that in some cases other women drew designs on their own textiles. Because of the complex details and sophisticated juxtaposition of colors, some of the motifs such as roosters are thought to have been produced by professional embroiderers who might have come from other parts of Greece.[13] Professional embroiderers, possibly local women who excelled in the art of embroidery, may well have also been responsible for the sophisticated designs and excellent workmanship in these textiles.

When we examine the motifs used in Skýros embroidery, however, we encounter another world, one totally distinct from the geometric and often rigid styles of the Cyclades and the Dodecanese. The motif repertoire of Skýros embroidery includes naturalistic figures as well as fantastical creatures. We find musicians, horsemen with raised swords, both female and male figures surrounded by flowers, flowers of different kinds and colors, and three-masted ships with sailors suspended from the masts.[14] Fantastical creatures include Harpies, mermaids, and some hybrid beings with human heads (cat. nos. 4.1, 4.8). Christian religious figures like Saint George slaying the dragon also appear. One of the most popular motifs is a beautiful rooster with an extraordinarily large tail. Both his body and tail feathers consist of myriad colors (cat. nos. 4.2, 4.3).[15] His head is always decorated with a large red crest, and he often holds flowers with his feet. Among these flowers the Ottoman tulip is the most recognizable. Since ancient times the rooster has been a symbol of courage. In Christian religious art the crowing cock has symbolized the Resurrection of Christ. Whether the rooster motif on Skýros embroidery carried any of these symbolic meanings or was just for decoration remains unclear.

Fig. 4.3 *Qadi* figure, bed valance (detail), Skýros, 18th century. Victoria and Albert Museum T57-1926

When the Skýros and Cretan embroidery styles are compared closely, it becomes clear that Skýros embroidery is much more varied in composition than is Cretan work, although both styles use curvilinear motifs. While the Cretan embroiderer mixed all the different motifs in her repertoire in one single complicated composition, the Skýros embroiderer used a single isolated motif. Bedcovers are decorated along all four edges with repetition of ships or roosters or humans (cat. nos. 4.2, 4.5, and 4.7). On rare occasions, however, human figures and fantastical creatures are combined (cat. no. 4.4). Among the human figures, the one most often found is called *qadi* (*kadi*), meaning a Muslim, in this case an Ottoman, judge.[16] The *qadi* creates rather a charming image with his big mustache, large turban, baggy pants, and kaftan. He is always represented inside an enclosure or building, holding floral branches in his hands and is often accompanied by two small attendants (fig. 4.3). Similar to the *qadi* motif, a female character called *xouna*, often described as a witch, appears on the embroidered textiles. She is represented holding a flower and has two other flower branches coming out of the hem of her skirt.[17] *Qadi*, *xouna*, and other fantastical creatures were magical beings used for apotropaic purposes. They appear not only on embroidered textiles, but also in other art forms, strengthening the premise that they are there to avert the evil eye or evil spirits and thus to protect an object or the individual who uses it. It is also noteworthy that all the human figures are embroidered with clothing resembling Ottoman costumes: baggy pants (*shalvar*), short waistcoats (*jelek* or *yelek*), ankle-length garments with long sleeves (kaftans), and large headgear. The inclusion of Ottoman costumes and flowers such as the tulip in the Skýros motif repertoire is a strong indication of the close association of Skýros inhabitants with the Ottoman culture and art. This is not very surprising, considering the historical and political circumstances. The Northern Sporades became part of the Ottoman Empire in 1538 during the early stages of Ottoman expansion into the Aegean Sea and remained under Ottoman control for about three hundred years.

History and Influence

After the Fourth Crusade (1204) and the Frankish conquest of Greece and the northwestern parts of Anatolia, the Northern Sporades were given to the Venetian Ghisi family, who also ruled other islands in the Cyclades. With the exception of a short period beginning in 1390 when these islands reverted to the Byzantine Empire, the Venetian influence on the islands never waned. The Northern Sporades were held by Venice until 1538 when the Ottoman Empire occupied them after capturing Rhodes (Ródos) and its surrounding islands in the southern Aegean Sea. The Northern Sporades stayed under Ottoman control for three hundred years until 1832 when the archipelago became part of the independent kingdom of Greece.[18] These islands had been incorporated into the Ottoman Empire right from the beginning of the sixteenth-century Ottoman takeover and had been more or less left to govern themselves with minimal Ottoman intervention. There were, of course, a few Ottoman officials who were assigned to the islands. Possibly a *qadi* was one of these officials who oversaw the relationship between the Greek population and the Ottoman government and who mediated disputes between the Ottoman government and locals and possibly adjudicated disagreements among the native population as well.

All the surviving embroidered textiles attributed to Skýros were produced while the islands of the Northern Sporades were under Ottoman control. The Skýros embroidery style appears to have been formulated within this period as well, which may account for the significant differences from the Cycladic, the Dodecanese, and the Cretan styles.

The strongest influence on Skýros embroidery was the Ottoman Turkish embroidery tradition. Many of the Skýros floral motifs, such as the tulip and the arching branch, are Ottoman in origin. The local names given to them were also Turkish in origin.[19] Many other visual and technical characteristics of this style point to the strong Ottoman influence, especially the seventeenth- and eighteenth-century Ottoman Turkish embroidery tradition. These characteristics include parts of the Ottoman Turkish costume worn by many figures, the pastel colors, and the technique of drawing the motifs before embroidery. Also important are the frequent use of the running stitch in diagonal alignment, the placement of embroidered motifs at the opposite ends of certain textiles, the use of isolated motifs to create an overall composition, and the names given to the textiles and embroidered motifs (cat. nos. 4.1–4.9). It was perhaps inevitable that a power like the Ottoman Empire, which had a bold visual art language, would strongly influence the arts of the lands it occupied for such a long time.

Italian influence, on the other hand, is less prominent in the embroidery but might be seen perhaps on a few motifs, such as a man in European costume riding a horse. There are also parallels to some of the fantastic creatures in European pattern books and bestiaries.[20] Yet, because there are no surviving embroidered textiles dated before the seventeenth century, we can only speculate that the later and longer Ottoman occupation in Skýros eliminated earlier evidence of the influence the Venetians may have had on the embroidery tradition.

Large sailing ships, commonly used as motifs on the embroidered textiles, might represent a local preference rather than European influence. Although large sailing ships are predominant in embroidery designs, neither Skýros nor the other islands of the Northern Sporades had ever been important commercial ports along the eastern Mediterranean and Black Sea trade routes as Rhodes, Crete, and Náxos had been in the fifteenth and sixteenth centuries. Skýros likely never encountered the influx of merchants traveling from different countries and bringing ships carrying trade goods, pilgrims, and ideas in this period. From the representations of ships on the embroidered textiles, we can conclude that the islanders were very familiar with seventeenth-century sailing ships.[21] It might be that the seventeenth century brought relative peace and prosperity to the Aegean Sea after the long Venetian-Ottoman wars ended with the Ottoman Empire's taking full control of the region.[22] This relatively tranquil period probably allowed the remote islands of the Aegean Sea to remain accessible to merchants and visitors, which in turn raised levels of prosperity on the islands. Increased participation in internal trade among the vast Ottoman lands probably brought many ships and merchants to the area.

During the sixteenth century, when the Skýros embroidery style might have begun to mature, the semiseclusion of the Northern Sporades, with no direct forceful political intervention, may have provided a fertile ground for local preferences to play a stronger role than elsewhere in the process of formulating this embroidery style. The large colorful roosters and other scenes, adapted by observing daily life, appear to be the result of the creativity of the local Greek Island culture. The combination of the engaging, storytelling nature of the compositions and the fantastical creatures is a trademark of Skýros and is not found anywhere else in the Aegean region. Only one of the embroidery styles practiced in the Epirus (Ípeiros) region of northwestern Greece comes close to the liveliness of the Skýros embroidery. Although in this particular Epirus style we do not usually see the fantastic creatures or ships with full sails, we do encounter motifs representing stories adapted from daily life.

4.1 Pillow face (warp direction horizontal), Skýros, Northern Sporades, 18th century. The Textile Museum 81.81, acquired by George Hewitt Myers in 1927

4.2 (*right*) Bedspread, Skýros, Northern Sporades, 18th century. The Textile Museum 81.21, acquired by George Hewitt Myers in 1924

85

HARPIES AND ROOSTERS

4.3 (*top*; detail *above*) Bed valance (warp direction horizontal), Skýros, Northern Sporades, 18th century. The Textile Museum 81.80, acquired by George Hewitt Myers in 1927

4.4 Pillow face, Skýros, Northern Sporades, 18th century. The Textile Museum 81.99, acquired by George Hewitt Myers in 1950

4.5 Bedspread (warp direction horizontal), Skýros, Northern Sporades, 18th century. The Textile Museum 81.59, acquired by George Hewitt Myers in 1928

88 | HARPIES AND ROOSTERS

4.6 Bedspread, Skýros, Northern Sporades, 18th century. The Textile Museum 81.15, acquired by George Hewitt Myers in 1924

4.7 (*above*) Bedspread (warp direction horizontal), Skýros, Northern Sporades, 18th century. The Textile Museum 81.58, acquired by George Hewitt Myers in 1925

4.8 Pillow face, Skýros, Northern Sporades, 18th century. The Textile Museum 81.37, acquired by George Hewitt Myers in 1925

4.9 Napkin or towel, Skýros, Northern Sporades, 18th century. The Textile Museum 81.10, acquired by George Hewitt Myers in 1925

CHAPTER 5

Epirus (Ípeiros) had more direct contact with Ottoman artistic ideas than many other regions of Greece and integrated these ideas more successfully into its local artistic tradition. During the expansion of the Ottoman Empire, Epirus was annexed much earlier than many other regions in Anatolia and northern Africa, so that many aspects of Epirote culture including its embroidery came to reflect the strong Ottoman political, cultural, and social presence.

Brides and Grooms

Many artistic traditions portray brides and grooms on their textiles. In every culture marriage signifies change; it is a tremendous change not only in the lives of a young woman and young man, but also for their families. Thus, the occasion of marriage is always accompanied by ceremonies both festive and religious to celebrate the new beginning and to protect the new couple from any future misfortune. The newly married couple starts their future life together with gifts that friends and family purchased or made for them and things they made themselves, among which textiles take a prominent place, especially in societies where older traditions are still strongly held. These wedding textiles are often decorated with motifs that represent "good wishes" and "blessings" and that are displayed in the hope of averting misfortune or the evil eye. Some commemorate the wedding ceremony by depicting the bride, groom, and attendants; a reminder perhaps of one of the most important days in the couple's life. These wedding textiles also exhibit the bride's skills if she is the one who made them, or their lavishness could reflect her family's economic standing.

Function and Form

Traditional marriage ceremonies in the Epirus (Ípeiros) region[1] of northwestern Greece were some of the most extravagant wedding celebrations among the Greeks on the mainland and islands.[2] The textiles produced for the young bride's trousseau were as elaborate as the celebrations. They included garments for her and her husband and textiles for their home. The major domestic textiles were bed valances embroidered along three edges, bedspreads decorated along all four edges with embroidered bands and pillow faces with overall embroidery (cat. nos. 5.1–5.8, 5.10–5.12). It is the pillow faces that most often depict the bride, groom, and their attendants (cat. nos. 5.1–5.2).

The houses of rich Epirote families, especially those in the capital, Ioánnina, were similar in plan, division of living quarters, and interior decoration to Ottoman houses found in Istanbul and other parts of the empire. The main living area was divided into separate sections for men and women. The men's portion was slightly bigger because it contained the reception room, but both the men's and women's sections were decorated the same way. The fireplace was the focal point of the room, and low divans (sofas) along the wall surrounded the empty center space. Woven and embroidered textiles were hung from the front of the divans, which in addition were strewn with pillows.[3] It is possible that valances were also used on these divans. The large covers embroidered along all four edges are often identified as bedspreads and their embroidered decoration certainly supports this idea (cat. no. 5.6). Nevertheless, in European travel books of past centuries, there is no clear description of how these textiles were used in Epirote households, probably because the sleeping areas, especially those of women, would have been restricted and not accessible to male European visitors.

A separate group of embroidered textiles produced in the Epirus region, however, has a different design layout from the others, and it is not clear if they were part of the usual bridal trousseau. The motifs covering the entire surface of these textiles are organized in two or three square compartments framed by borders with floral scrolls on three sides, with all the motifs oriented in the same direction. These textiles may have been religious objects used as altar frontals, or they may have hung on a wall or as a valance from either a table or a bench.[4] They are covered with many flowers, birds, and human motifs. Single-masted ships with many oars, castle-like structures, deer, and double-headed eagles are frequently represented as well.[5] The imagery also includes what appear to be a bride and groom, often holding flowers above a house- or

castle-like structure. Sometimes this structure contains smaller human motifs that may represent children. The imagery, therefore, suggests these textiles might have been used in marriage ceremonies.

In addition, there are a few Greek embroidered copes for use in religious services, now in museum collections, and they are attributed to Epirus, Skýros, and Crete (Kríti or Candia).[6] These copes appear to have been assembled from recycled textiles that were originally used as home furnishings, especially bedspreads (cat. no. 5.9). New embroidered motifs were sometimes added to fill in the composition and enrich the garment.[7]

Method and Motif

The embroidered textiles attributed to the Epirus region are stylistically diverse, even though they all have linen foundation fabric and silk embroidery thread. It is, nevertheless, possible to categorize Epirus embroidery into three groups according to the stitches used: a running-stitch group, a split-stitch group, and a herringbone-stitch group. Some influences do exist among the styles in terms of design and techniques, but none of them is strong enough to overshadow the distinction.

The Running-Stitch Style

The largest group of surviving embroidered textiles from the Epirus region belongs to the running-stitch style (cat. nos. 5.1–5.4). This group is itself diverse in terms of both motifs and variations in the execution of running stitch. We can define two subgroups, using variations in stitching, one with the running stitch in diagonal alignment, and the other with the running stitch in alternate alignment (figs. 5.1, 5.2).

The running stitch gives embroiderers great flexibility to manipulate its execution from row to row in order to achieve varying effects. One of the two basic techniques of filling motifs with a running stitch is to offset the stitches in each row by one warp or weft yarn, creating diagonal lines from the exposed foundation yarns. The result is a running stitch in diagonal alignment. In the second technique, each row of stitches is worked so that the stitches begin and end next to the middle of the stitches in the previous row, and thus it is called running stitch in alternate alignment (see glossary). Among these two versions the majority of surviving Epirus textiles are embroidered with running stitch in alternate alignment.

Fig. 5.1 (*left*) Running stitch in alternate alignment, bedspread (fragment, detail), Epirus (Ípeiros), 18th century. The Textile Museum 81.8, acquired by George Hewitt Myers in 1924 (cat. no. 5.3)

Fig. 5.2 Running stitch in diagonal alignment, bedspread (fragment, detail), Epirus, 17th–18th century. The Textile Museum 81.97, acquired by George Hewitt Myers in 1939 (cat. no. 5.4)

FIG. 5.3 Embroidery threads carried a short distance under the unembroidered areas, bedspread (fragment, detail, back), Epirus, 17th–18th century. The Textile Museum 81.97, acquired by George Hewitt Myers in 1939 (cat. no. 5.4)

FIG. 5.4 (*right and far right*) Split stitch front and back, bedspread (fragment, detail), Epirus, 17th–18th century. The Textile Museum 81.28, acquired by George Hewitt Myers before 1928 (cat. no. 5.5)

Both styles use a foundation fabric in balanced plain weave with warp and weft yarns of undyed, Z-spun off-white linen. There are approximately twenty-three warp by twenty-five weft yarns per square centimeter. The yarns are finely spun, and the fabric is loosely woven, which facilitates counting warp and weft yarns for stitching. The loom widths of the foundation fabrics are narrow, about 40 centimeters (15.75 in.), so larger pieces like bedspreads are fashioned by sewing together multiple panels.

Again silk is the primary fiber used for the embroidery thread. A thread of two Z-twisted silk fiber bundles S-plied is more often encountered than one with two S-twisted silk fiber bundles Z-plied. The colors are red, blue, green, and yellow. Light orange or pink are also found, and white is often used for details and highlights.

The embroidery motifs used in the running-stitch style are curvilinear and are drawn on the back of foundation fabric—similar to the Skýros embroidery style. Also, the motifs are filled by carefully counting the warp and weft yarns of the foundation fabric. Thus, the embroidery technique used for this style is a combination of *grafta* and *metritá* (see glossary).

One characteristic that indicates Epirus provenance is the use of the technique by which embroidery threads are carried a short distance under the unembroidered areas.[8] This creates a reverse image of what is visible on the front face of the foundation fabric and is similar to Cyclades embroidery, although one style has a curvilinear motif repertoire and the other is geometric (fig. 5.3).

The running stitch appears on three major types of embroidered textiles: long rectangular pillow faces embroidered with running stitch in alternate alignment and bedspreads and valances embroidered either with running stitch in diagonal alignment or alternate alignment (cat. nos. 5.1–5.4). Long rectangular pillows with scenes of wedding ceremonies are among the most famous Epirus embroidered textiles. The pillows often depict a couple in the center, usually holding flowers, and sometimes riding a horse (cat. no. 5.1). The couple is accompanied by, a male and a female attendant. The male attendant is often depicted on horseback. These two figures may be the bridesmaid and best man, and what is represented on the pillow may be the evening procession that always accompanied the groom when he escorted his fiancée from her paternal home to that of her and her future husband's home.[9] All the garments worn by the bride, groom, bridesmaid, and best man demonstrate the strong influence of Ottoman culture on Epirote society. All the pieces in the ensemble, from the large headgear for men (*kavuk*, or turban) to the multiple button enclosures on the chests of the men's and women's long coats with hanging sleeves (kaftans), were adaptations of the Ottoman costume. At least by the sixteenth century, the urban elite of the Epirus region, especially in Ioánnina, appears to have adopted Ottoman dress. The floral motifs—featuring tulips, hyacinths, and carnations—seen filling the rest of the composition on these pillows have unmistakable Ottoman origins as well. They probably came to Epirus with the influx of Ottoman

textiles, art objects, and interior and exterior decorations on buildings. On the other hand, two motifs on these pillows embody the Greek spirit: the large bird with a short colorful tail and the Harpy with her bird's body and female face (cat. nos. 5.1, 5.2).

Bedspreads are embroidered along all four edges, with their centers left plain. They are made out of four loom-width panels, instead of the three panels common in bedspreads from the Aegean Islands. Embroidered borders framing the central empty space consist of two decorative bands, one major and one minor. The major embroidered band displays large repeating floral motifs or birds facing one another, sometimes with a flower vase between them (cat. nos. 5.3, 5.4). The narrow minor border also contains decorative floral scrolls.

As with the pillows, the bedspreads and valances exhibit strong Ottoman influence in their selection of motifs. Even the colors—blue, red, and yellow with white highlights—point to the strong impact of the Ottoman textile arts.[10] In fact, the inspiration from Ottoman art runs so deeply that it includes even the embroidery technique used. The distinctive characteristic of the sixteenth- and seventeenth-century Ottoman embroidery is the exclusive use of running stitch, especially running stitch in diagonal alignment to create curvilinear motifs, mainly floral designs (cat. no. 5.4).

The Split-Stitch Style

The second embroidery style from the Epirus region shares a strong design similarity to the running-stitch group, although the designs in this style tend to be a little more freely drawn (cat. nos. 5.5–5.9). Both styles share the same color palette as well as the technique of leaving unembroidered squares or diamonds while solidly decorating the embroidered areas. The difference is that the embroidery stitch used in this second style is the split stitch (see glossary) (fig. 5.4).

Fig. 5.5 Herringbone stitch front and back, cover (detail), Epirus, 17th–18th century. The Textile Museum 81.96, acquired by George Hewitt Myers in 1937 (cat. no. 5.12)

The split stitch creates smooth surfaces that to a certain degree resemble the effect of satin weave with its surface of long warp floats. The embroiderers may in fact have been inspired by luxurious Ottoman textiles in satin weave. It is not surprising that the thread in split-stitch embroidery is usually untwisted silk, since this type of thread allows the needle to easily split the already worked thread and be pulled through it. The loosely lying fibers in the untwisted silk thread also hide the emerging point of the splitting thread, thus creating a smooth surface (fig. 5.4).

In Epirus textiles, split stitch is executed by counting warp and weft yarns in the foundation fabric, usually nine over and three back and under. The ink used to draw the motifs is visible on the back of the foundation fabrics of all these textiles, which suggests that the embroidery was worked from the reverse side and possibly on a frame. Untwisted silk, because it becomes snagged easily, is also easier to protect and manage if the embroiderer works on the reverse side of the foundation fabric.

Most of the surviving textiles decorated with split stitch are bedspreads. They consist of four loom-width panels, and like the running-stitch style bedspreads, they are embroidered along all four edges with one major border and one minor border (cat. nos. 5.5–5.7). Vases overflowing with flowers are often placed diagonally in the four corners. Floral designs, especially with tulips and birds, are the major motifs used. Flower vases framed by female or male figures are also common (cat. nos. 5.5–5.7). In this split-stitch group, the same motifs are often identically repeated in different textiles, suggesting that there might have been a single source—a person, a workshop, or a stencil—for these motifs.[11]

The Herringbone-Stitch Style

The third group of embroidered textiles from the Epirus region is completely different from the preceding styles in terms of technique, material, design, and color palette.[12] The only similarity is that bedspreads and pillows are the principal products (cat. nos. 5.10–5.12).

This third group is embroidered with the herringbone stitch (fig. 5.5), which belongs to the cross-stitch family and creates an interlaced appearance on the front side of foundation fabric; contrasting strongly with the smooth surface of the running stitch and split stitch (see glossary). The herringbone stitch needs to be worked from the right side; therefore, the motifs are drawn on the front face of the foundation fabric instead of the back. In addition the foundation fabric is completely covered with embroidery stitches, whereas the foundation fabrics in the other style groups play a crucial role in the overall design of the textile.

The materials also differ from the other styles. Very tightly Z-spun dark to medium brown undyed linen warp and weft yarns make up the foundation fabric and the tight twist of the yarns causes a crinkled effect. The warp and weft yarn counts are about twenty-three warps to twenty-two weft yarns per square centimeter. The yarns are thicker than those used for the other styles, making the balanced plain weave foundation fabric appear to be densely woven.

The silk embroidery threads are made of two Z-twisted silk fiber bundles S-plied. They tend to be slightly thicker than the silk threads used for the other groups. The colors include darker shades of red, blue, green, and yellow. Black and dark brown are also extensively used in this style. Dense embroidery and the darker color palette give this group a

BRIDES AND GROOMS

FIG. 5.6 Silk compound-weave textile panel (detail), Ottoman, Turkey, 17th century. The Textile Museum 3.345, acquired by George Hewitt Myers in 1956

distinctively somber look, although the motifs are curvilinear and their arrangement has a flowing movement.

The motif most closely associated with this style is a large red flower represented in a bird's-eye view, with a stylized serrated leaf arching over it. Secondary to this motif is the floral-branch motif, with four small flower heads along with three small leaves and one large serrated leaf. A third motif consists of the same red flower head, but with two serrated leaves framing it. All these motifs are very similar to those used in Ottoman silk woven and embroidered textiles (figs. 5.6, 5.7).

The characteristics of the herringbone-stitch style create an interesting conundrum for us to consider. The group exhibits strong design similarities with Ottoman silk textiles, but the embroidery technique used is unknown in the Ottoman textile arts. While the running-stitch group discussed earlier shares closer technical similarities with the Ottoman embroidery, it appears to borrow selectively from the Ottoman motif repertoire and combines Ottoman with other more local motifs. The split-stitch group, on the other hand, does not share technical similarities with Ottoman embroidery, but like the running-stitch group, it borrows selectively from the Ottoman motif repertoire.

The reasons for such diversity in Epirus embroidery have been much debated over the years.[13]

There is no clear evidence to suggest that these textiles were produced either in the same place or in different parts of the Epirus region. If they did come from same place, it is unclear whether they might have been produced in different periods. Forming structural groupings and identifying the characteristics of each group may help future researchers make the necessary connections and propose a more definite source for these textiles. For now, we can only suppose that the textiles from all three styles appear to be from the

FIG. 5.7 Embroidered mirror cover (detail), Ottoman, Turkey, early 18th century. The Textile Museum 1.31, acquired by George Hewitt Myers before 1956

Ioánnina area. The expensive materials used and the strong Ottoman influence in design and technique on all three styles indicate that these textiles were produced by embroiderers who lived in a wealthy region and had easy access to Ottoman artistic products. Embroiderers from around Ioánnina fit this description very well. They knew the Ottoman tradition firsthand and knew it long and well enough to assimilate it into their work.

History and Influence

For centuries, ideas and goods moved between Europe and western Asia through the Epirus region, which was the gatekeeper of communication and overland trade routes. Besides possessing strategic importance, the region also encompasses fertile agricultural lands.[14]

After the Fourth Crusade in 1204 and the sack of Constantinople by crusaders, during the fragmentation of the Byzantine Empire, Michael Angelos Komnenos Doukas created the Despotate of Epirus, one of three areas where the Byzantine Empire still held sway.[15] The establishment of this despotate also helped maintain the traditions of the Byzantine Empire for another two centuries in western Greece, which was surrounded by Frankish kingdoms and Latin lords.[16]

During the fourteenth century, political fragmentation and struggle in addition to social conditions eventually provided the Ottoman Empire with the opportunity to move into the Balkans.[17] In 1431, Ioánnina fell, and the Ottomans annexed central and southern Albania including the Epirus region, and assimilated it into their administrative system as a *sancak* (county).[18]

Ioánnina was the capital of the Epirus region and a wealthy commercial town in a strategically important region. In the eighteenth century, with the rise of Ali Paşa to the governorship of Epirus and southern Albania, Ioánnina became the biggest city in Greece and one of great opulence and sophistication.[19] The Greek populations of Ioánnina and the surrounding territories had been a major force in the trade of the region, especially overland trade. With Ali Paşa's policies as well as the consequences of international relations, this community continued to flourish in the eighteenth century.[20] Eventually, after 482 years of Ottoman control, Ioánnina and the Epirus region fell to the Greeks during the Balkan Wars in 1913.[21]

Epirus was one of the regions with a large Greek population that stayed in Ottoman hands the longest. During the expansion of the Ottoman Empire, Epirus was annexed into the empire much earlier than many other regions in Anatolia and northern Africa. Many aspects of Epirote culture reflected the strong Ottoman political, cultural, and social presence. During the Ottoman period, the Epirus embroidery style and its substyles were formulated and reached their zenith in the seventeenth and eighteenth centuries. When compared with the Skýros embroidery style, which also exhibits strong Ottoman influence, Epirus embroidery can be recognized as the style that had more direct contact with Ottoman artistic ideas and integrated these ideas more successfully into its local artistic tradition. This assimilation is probably due to the long exposure of Epirote society to Ottoman culture and to its people's living side by side with Ottoman Turks as a single society.

While Epirus embroidery is clearly derived from Ottoman art, the embroidery produced on the Ionian Islands just off the coast of the Epirus region is completely different.

5.1 Pillow face (fragment; warp direction horizontal), Epirus (Ípeiros), 17th–18th century. The Textile Museum 81.27, acquired by George Hewitt Myers before 1940

5.2 Pillow face (fragment; warp direction horizontal), Epirus, 17th–18th century. The Textile Museum 81.29, acquired by George Hewitt Myers before 1940

5.3 Bedspread (fragment; warp direction horizontal), Epirus, 18th century. The Textile Museum 81.8, acquired by George Hewitt Myers in 1924

5.4 Bedspread (fragment; warp direction horizontal), Epirus, 17th–18th century. The Textile Museum 81.97, acquired by George Hewitt Myers in 1939

5.5 Bedspread (fragment; warp direction horizontal), Epirus, 17th–18th century. The Textile Museum 81.28, acquired by George Hewitt Myers before 1928

102 | BRIDES AND GROOMS

5.7 (*above*; detail *right*) Bedspread (fragment; warp direction horizontal), Epirus, 18th century. The Textile Museum 81.20, acquired by George Hewitt Myers in 1925

5.6 (*left*) Bedspread, Epirus, late 17th–early 18th century. The Textile Museum 81.70, acquired by George Hewitt Myers in 1926

5.8 Bed valances, Epirus, 18th century. The Textile Museum 81.60A, B, acquired by George Hewitt Myers in 1940

5.9 Cope, Epirus, 17th–18th century. The Textile Museum 81.36, acquired by George Hewitt Myers in 1925

106

BRIDES AND GROOMS

5.10 (*left*; detail *below*) Bedspread, Epirus, 17th–18th century. The Textile Museum 81.86, acquired by George Hewitt Myers in 1926

5.11 Cover, Epirus, 17th–18th century. The Textile Museum 1962.23.3, Museum purchase

5.12 Cover, Epirus, 17th–18th century. The Textile Museum 81.96, acquired by George Hewitt Myers in 1937

CHAPTER 6

The textile arts are an integral part of the social, cultural, and political history of a region, and thus they reflect differences in sociopolitical histories and cultural traditions among regions. Although geographically closer to the Epirus region (Ípeiros) on mainland Greece, the Ionian Islands differed greatly in their embroidery style from the Aegean Islands and the Epirus region. Ionian Island embroidery exhibits unmistakably European or Venetian elements.

Stags and Eagles

Many artistic traditions have developed designs based directly on the representation of nature, especially animals. The textile arts have often relied on animal imagery as an important source of design inspiration. In particular, stags and eagles have been adapted by many cultures and applied to different art media.

Because a stag seeks freedom and lives in the unspoiled high mountains, its image often stands for solitude, freedom, and the purity of natural life. With its beautifully proportioned body and immense antlers representing strength and fortitude, the stag also creates a magnificent image for artistic expression. The eagle, on the other hand, has always embodied power, especially imperial power. The image of an eagle represented with its wings open and tail feathers spread, goes back far into the second millennium BCE. When drawn with two heads, the eagle often indicates both the dual character of a major deity and the claim for sovereignty over east and west.[1]

As long as it satisfies artistic requirements, any animal image is destined over the course of time to become a primarily or purely decorative motif. Our bestowing a religious or imperial significance upon a textile image depends on why that particular textile was produced and how it was used. Some cultures continue to use certain images, although their symbolic meanings have been altered and they appear in new or different media. While representations of stags and double-headed eagles had such symbolic significance in the past, not much of that meaning remains in their representation on the seventeenth- and eighteenth-century embroidered textiles from the Ionian Islands. These motifs had neither the religious meaning of piety or resurrection nor the secular meaning of imperial power. Instead, they appear to have been used as identifiers of the Greek origin of the embroiderers.

Method and Motif

Pillows and bedspreads embroidered with stags and eagles were made in the Ionian Islands, just off the coast of the Epirus region (cat. nos. 6.1–6.7).[2] They exhibit a character very different from those originating in the neighboring Epirus region and the Aegean Islands. Two stylistic and technical substyles can be identified among these textiles. This layered complexity and how it might have come about make the Ionian Island embroidery style fascinating to study.

The Cross-Stitch Style

One of the Ionian Island embroidery substyles may be termed the cross-stitch style, after the predominant stitch used. Bedspreads embroidered in this style are often given a provenance of Corfu (Kérkyra) and Kefallinía (Cephalonia).[3] In most cases, only the embroidered borders survived (cat. no. 6.1). There are, however, two examples, which help us identify the close relationship of design layout between Ionian Island bedspreads and those of the Epirus region (see cat. no. 5.6).[4] The motifs are embroidered as major and minor bands along all four edges of the bedspread, and the center is unpatterned. This suggests that the decorative bands hung down the side of the bed and that there may have been another cover on top.

Repeats of stags and cactus-tailed peacocks in a confronted position are the main design on these bedspreads.[5] The rest of the border is covered with other secondary motifs, such as double-headed eagles, birds with large wings, tulips, and carnations (cat. no. 6.1). Some of these motifs suggest Ottoman influence, but this influence is actually secondhand. Many of the Ionian Island embroidery motifs come from Italy, especially Venice. The tulips, carnations, and oak leaves reflect Venetian assimilation and interpretation of Ottoman motifs, which they then passed on to Ionian Island embroiderers.

Technically, Ionian Island bedspreads exhibit both possible influence from Epirus and native inventiveness. The foundation fabric is balanced plain weave with warp and weft yarns of off-white (undyed), Z-spun linen. There are approximately twenty-three warp by twenty-two weft yarns per square centimeter (fig. 6.1). The silk embroidery thread is usually two Z-twisted silk fiber bundles S-plied. In a few cases, untwisted silk thread was used. The colors are strong reds and blues, supplemented by medium greens and yellows, making a limited color range. Two variations of cross stitch, both worked by counting warp and weft yarns, are found, and both are very different from those of the southern Cyclades and southern Dodecanese including Rhodes (Ródos). Of the two variations, double-sided (or two-sided) cross stitch occurs less frequently (see glossary). This stitch appears the same on both sides of the foundation fabric. The second more common variation is a cross stitch that creates crenellations on the back of the foundation fabric. We may call it Ionian Island cross stitch (see glossary) (fig. 6.1). The direction of the second slant of each stitch is the opposite of that of the adjacent stitch, so that four adjacent stitches create a radiating pattern. Although it is a subtle effect, it brings movement to the motifs, which are otherwise considered rather rigid. The stiffness of the motifs is due to the geometry of the cross stitch and its counted thread application to the foundation fabric.

FIG. 6.1 Front and back detail showing the foundation fabric, silk thread, and embroidery stitches, bedspread (fragment), Ionian Islands, 18th century. The Textile Museum 81.23, acquired by George Hewitt Myers in 1925 (cat. no. 6.1)

The Withdrawn-Element Work Style

The second embroidery style is often attributed to Lefkás and may be referred to as the withdrawn-element work style, a name taken from its most recognizable technical characteristic.[6] Some scholars date it to the end of the eighteenth and early nineteenth centuries, later than the eighteenth-century date given to the cross-stitch style.[7] Square and long rectangular pillow faces are the typical products (cat. nos. 6.2–6.7).[8] On square pillows the design usually centers on a large motif in the middle (cat. nos. 6.2, 6.7). On long rectangular pillows, these same motifs are simply repeated. This is clearly evident when we compare catalogue nos. 6.2, 6.3, and 6.4. The designs include animals and several

FIG. 6.2 Pillow face with star design, Ionian Islands, 18th century. Victoria and Albert Museum T199-1950

different kinds of geometric compositions, such as a star, a diamond, or a combination of the two, as well as a hexagonal medallion of interlaced strapwork, often called a Holbein *gül* (figs. 6.2, 6.3; cat. nos. 6.5, 6.7).[9] All these geometric motifs appear to have come to the Ionian Islands from Venetian sources, even the Holbein *gül*, which is unquestionably Ottoman in origin. These motifs reached Venice through the luxury trade in carpets and other woven textiles between western European and eastern Mediterranean countries, and were assimilated into the Venetian motif repertoire. They probably reached the Ionian Islands through pattern books and embroidered textiles brought from Venice and Italy.[10]

Besides the pillow faces, withdrawn element work is also present on a small group of textiles represented by two bedspreads in the the Victoria and Albert Museum and the Benaki Museum collections.[11] The layout of their design, on the other hand, is similar to the cross-stitch style bedspreads.

The withdrawn-element work and cross-stitch styles share several motifs including stags and double-headed eagle. The representation of stags with large serrated horns and half-open months in the withdrawn-element work style is similar to those in the cross-stitch embroidery style (cat. nos. 6.1–6.4). Small birds with large wings are also similar in both styles (cat. nos. 6.1, 6.7).

In terms of technique, however, the two embroidery styles are different except that the foundation fabric is identical (figs. 6.1, 6.4). Silk embroidery threads are usually fine untwisted silk fiber bundles to accommodate the embroidery technique used for the withdrawn-element work style. But embroidery threads of two Z-twisted silk fiber bundles S-plied are also found. The colors are the same as in the cross-stitch style, but because different amounts of each color are used, these textiles appear darker.

FIG. 6.3 Pillow face with Holbein *gül*, Ionian Islands, 18th century. Victoria and Albert Museum Circ. 840-1924

FIG. 6.4 Front and back detail of pillow face, Ionian Islands, 17th–18th century. The Textile Museum 81.24, acquired by George Hewitt Myers in 1925 (cat. no. 6.6)

The completely distinct embroidery technique of the withdrawn-element work style sets these textiles apart from those originating in the Aegean Islands and the Epirus region. The foundation fabric is prepared by removing selected warp and weft yarns in the areas to be patterned and securing the edges with buttonhole or hem stitches creating a relatively transparent netlike fabric.[12] The design was probably first drawn with ink or an ink-like substance so that the embroiderer would know from where to remove the yarns (fig. 6.4). In some cases, alternate groups of warp and weft yarns are removed from the whole center. To make small motifs in the ground, the embroiderer replaces the removed interlacing by darning with a silk thread close in color to the warp and weft yarns (fig. 6.4).[13] The netlike area where some of the yarns were removed is worked with the overcast filling stitch, pulling the foundation yarns closer together and accentuating the netlike effect. Meanwhile, the other areas of the foundation fabric, which have been left intact, are worked with split stitch (see glossary) (fig. 6.4). The use of split stitch may indicate a connection with Epirus region embroidery, which also uses split stitch, although with different design preferences.[14]

History and Influence

It is fascinating to consider the relationship of the various foreign influences appearing in the embroidery with the local history. The Ionian Islands had a long association with Venice because they were located in an important part of the trade route from Venice to the Mediterranean Sea. By 1386, Corfu came under the control of Venice and remained a Venetian possession for more than four hundred years, while the other islands fell into Ottoman hands from time to time.[15] The longest period of Ottoman control in the Ionian Islands was on the island of Lefkás (Lefkádia, Saint Maura, or Levkás), which is the closest to the mainland.[16]

The history of the Ionian Islands differs in significant ways from that of the Aegean Islands and the Epirus region. Although the Ionian Islands came under Turkish control for short periods, they did not become part of the Ottoman Empire. Instead, the islands belonged to Venice from 1386 to 1797. They changed hands frequently in the eighteenth and nineteenth centuries. In 1797, following Napoléon's Italian campaign, they came under the control of France and from 1799 to 1807 they were under Russian protection. Then in 1807, the islands again returned to French control.[17]

During the long Venetian occupation, the Ionian Islands enjoyed a considerable degree of autonomy. Venice exercised general control through its appointed agents, but the actual rulers of the island were native aristocracy.[18] Venice recognized their lands and privileges in exchange for their support of the Venetian rule. Thus, the Ionian aristocracy, unlike those on the Greek mainland and the Aegean Islands, was for the most part satisfied with their administrative association with Venice. Although the French controlled the islands for only nine years, they had a major impact on Ionian society because they abolished feudalism.[19] This major alteration of the social structure at the beginning of nineteenth century apparently had a negative impact on many traditions, including embroidery. Toward the end of the wars between France, Britain, Russia, and the Ottoman Empire (1798–1815), the Ionian Islands became part of a British protectorate. They remained under British domination from 1815 to 1864, when they were ceded to the modern Kingdom of Greece, which had been established in 1832 after winning its independence from the Ottoman Empire.[20]

Both Ionian Island embroidery styles had certainly been formulated before the middle of the eighteenth century. Venetian influence in design is not surprising; but what is perhaps more perplexing is that embroidered textiles with

strong Venetian influence in technique, such as those in the withdrawn-element work style, are attributed to Lefkás, which was under Ottoman control from the late fifteenth to the late seventeenth century.[21] Textiles in the cross-stitch style are attributed to Corfu, which had a continuous Venetian presence. It may never be possible to determine in what period the withdrawn-element work style and the cross-stitch style were formulated and under whose control the islands were at that time. The use of different variations of cross stitch is well documented in several island embroidery styles, which suggests that it is likely to be part of the older established Greek embroidery tradition. It is possible that the cross-stitch style might have been dominant in the islands until it was replaced by the withdrawn-element work style following a European fashion that had reached the islands. Corfu, which had for centuries been under Venetian control and which had wealthy nobility in close contact with Venice, is a likely candidate for the place where this style was introduced. Otherwise the cross stitch continued to be practiced on Ionian Islands such as Lefkás, which kept their tradition because of less contact with Venice.

The Ionian Island embroidery style shows unmistakable European or Venetian elements, when compared with the Epirus embroidery style, which derives from Ottoman sources. The two regions, geographically close to each other, but so far apart because of historical and political circumstances, developed their own distinct embroidery styles. Here is clear evidence that the textile arts are an integral part of a region's social, cultural, and political history and that divergent sociopolitical histories affect the arts produced in those regions differently.

6.1 Bedspread (fragment; warp direction horizontal), Ionian Islands (Iónioi Nísoi), 18th century. The Textile Museum 81.23, acquired by George Hewitt Myers in 1925

6.2 Pillow face, Ionian Islands, 17th–18th century. The Textile Museum 81.47, acquired by George Hewitt Myers in 1925

6.3 Pillow face (warp direction horizontal), Ionian Islands, 17th–18th century. The Textile Museum 81.46, acquired by George Hewitt Myers in 1925

6.4 Pillow face (warp direction horizontal), Ionian Islands, 17th–18th century. The Textile Museum 81.25, acquired by George Hewitt Myers in 1922

6.5 Pillow face (warp direction horizontal), Ionian Islands, 17th–18th centuries. The Textile Museum 81.26, acquired by George Hewitt Myers in 1924

6.6 Pillow face (warp direction horizontal), Ionian Islands, 17th–18th century. The Textile Museum 81.24, acquired by George Hewitt Myers in 1925

6.7 Pillow face, Ionian Islands, 17th–18th century. The Textile Museum 81.84, acquired by George Hewitt Myers in 1925

CHAPTER 7

Among the embroidered textiles attributed to the Greek Islands and the Epirus region (Ípeiros), two groups are particularly enigmatic. Scholars tend to attribute one group to Argyrokastron (Gjirokastër) in what is today southern Albania, and the other to the island of Chíos in the Aegean Sea. These two groups, however, share enough structural and technical similarities for us to consider the possibility that they might be from the same region.

Ships and Flowers

Two embroidered textiles in The Textile Museum collection are representative of Argyrokastron (Gjirokastër) in southern Albania.[1] They are rectangular and usually identified as napkins or head scarves. They are distinguished by the triangular areas embroidered on both ends of the fabric (cat. nos. 7.1, 7.2). The second group is identifiable by its square shape, embroidery style, and motif layout and is attributed to Chíos (cat. no. 7.3). These textiles are thought to have been worn pinned to the shoulders of Chían women's dresses to cover the rather low décolleté (fig. 7.1).[2] The group is probably represented by one textile in the Museum's collection (cat. no. 7.1).

By the late nineteenth century, the women at Pyrgi were the only ones on Chíos who still wore recognizably traditional garments. Their costume included two of these square cloths (breast cloths), which hung in front, falling to a little below the waist and were the only major embroidered garment (fig. 7.2).[3] The breast cloths were embroidered in the four corners and in the center, often with additional motifs along the edges (fig. 7.2). The space between the motifs was always left unembroidered, leaving large white areas of the foundation fabric exposed. The cotton fabric used for the breast cloths is in balanced plain weave. It is densely woven and thus is

FIG. 7.1 Engraving of women from Chíos with their traditional garments. From Tournefort (1656–1708) 1718, p. 201

FIG. 7.2 Breast cloth (detail), Chíos, late 18th–early 19th century. World Museum Liverpool 56.210.360

not transparent, which perfectly suited its purpose and function. Satin, cross, double running, and buttonhole stitches are the predominant stitches. The colors are commonly dark yellow, light orange, and red with highlights in black and white. The materials, technique, and designs of these breast cloths are completely different from another group of square textiles also attributed to Chíos. These examples, in the collections of The Textile Museum and the Victoria and Albert Museum, have silk foundation fabric with Z-twisted warp and weft yarns. The embroidery thread is two Z-twisted silk yarns S-plied worked in double running stitch and the designs include delicately drawn lobed-flower clusters embroidered at a 45-degree angle and birds with stubby wings (cat. no. 7.3).[4]

There is no real documentation of the origin of these silk square textiles; in fact they are surprisingly similar to textiles from Argyrokastron (cat. nos. 7.1–7.3).[5] They use similar finely woven foundation fabric often with untwisted silk warp yarns. Their silk embroidery threads have similar colors. Both groups use double running and satin stitches that allow the motifs to be read equally on either side of the foundation fabric. The stitches are also executed with same fineness and delicacy. The arrangement of the motifs in triangular areas occur in both the narrow ends of the rectangular napkins and all four sides of the square covers. Besides lobed flowers and birds with stubby wings, the motif repertoire of the rectangular napkins includes three- or four-masted sailing boats and cypress trees. Given these similarities, especially in structure and technique, it seems likely that these two groups of textiles were actually from the same place. If so, the question then is whether they are originally from Argyrokastron or from Chíos.

The city of Argyrokastron lay within the northern Epirus region during the Ottoman period from 1420 to 1913 and was a major governing center. Its inhabitants were Muslim as well as Greek. Therefore it is not surprising to see influence from Ottoman embroidery, including the use of the double running stitch to create reversible embroidery as well as the motifs selected such as cypress and lobed flowers.

Chíos, on the other hand, was initially a Genoese possession and remained so until 1566, when the Ottomans took control. Its major livelihood was silk production and the manufacture of woven silk textiles. A large portion of the population, including the women, was involved in this industry.[6] As other scholars have pointed out, embroidery does not appear to have been a major occupation for Chían women.[7]

We may, therefore, posit that these textiles were more likely to have been produced in the Epirus region than in Chíos, considering the historical facts, the structural and design similarities, and the possible association with Ottoman embroidery.

7.2 Napkin, Argyrokastron, southern Albania, 18th century. The Textile Museum 81.68, acquired by George Hewitt Myers before 1940

7.1 Napkin, Argyrokastron (Gjirokastër in present-day southern Albania), 18th century. The Textile Museum 1983.59.10, Gift of John Davis Hatch in memory of Anna Van Scheick Mitchell (their collector 1923–36)

7.3 Small cover, Argyrokastron, southern Albania, or Chíos, Greece, 18th century. The Textile Museum 81.79, acquired by George Hewitt Myers in 1925

Notes

Introduction

1. Taylor 1998, pp. 175–79.
2. Myers 1931, p. 343.
3. *Merriam-Webster's Geographical Dictionary* (1998), *Hammond Atlas of the World* (1996), and the GeoNet Names Server of the National Geospatial Intelligence Agency and United States Board on Geographic Names (http://gnswww.nga.mil/geonames/GNS/index.jsp) are used for preferred spellings of place-names in the text.

CHAPTER 1
Two-Tailed Mermaid

1. Cazenave 1996a, pp. 403–4; Cazenave 1996b, pp. 634–36; Oxford English Dictionary 1989, vol. 6, p. 637.
2. It is not clear whether the two-tailed mermaid motif had connotations in Cretan culture similar to those it had in medieval Europe as the symbol of the perils the temptations of the flesh posed to the human soul—probably not, because of the way she appears in different artistic media as well as the frequency of her appearance.
3. Brown 2004, p. 78, fig. 85, and p. 93, fig, 97; Davenport 1948, p. 274, fig. 746.
4. Pauline Johnstone (1972a, pp. 28–30, 99–109) calls this garment *foustani* or *poukamiso*. On the other hand, Eleni Tseneoglou (2000, p. 180) refers to a similar garment as *kouda* and indicates that the word comes from Italian word *coda*, meaning "tail."
5. Johnstone 1972b, p. 68.
6. The skirts had a circumference of 300 to 350 centimeters (118 to 138 in.).
7. In balanced plain weave, the warp and weft yarns are visible in equal amounts, either equally spaced or identical or approximately equal in size and flexibility (Emery 1994, p. 76).
8. The yarns used for embroidery by Cretan women are also similar to those used in Ottoman embroidery. It seems likely that they came from commercial silk-producing centers rather than from the local production areas.
9. In the embroidered textiles with this type of thread, the designs tend to be a little less articulated. There is not enough information available to posit if this was a regional preference in Crete or if these textiles date later in eighteenth century.
10. The design is drawn on the front of the fabric, because the fabric is too thick for the drawing to be visible on the front if done on the back.
11. See Abegg (1978, p. 13, fig. 80, and p. 102, fig. 146) for European pattern books, lace, and other textile motifs adopted by Cretan embroiderers.
12. The Victoria and Albert Museum collection contains three dated Cretan skirts and a skirt fragment. Accession no. 2054-1876 is a polychrome skirt signed by Georgia Grammatikopoulos, and dated to 1733. Accession no. T.97-1967 is a monochrome skirt signed by Mara Papadopoula and dated to 1757. Accession no. 2051-1876 is a fragment of a monochrome skirt and contains a date of 1762. The Metropolitan Museum of Art collection contains two dated skirt fragments. Both skirt fragments dated to 1697 and 1726 are in the polychrome style. (Haywood 1983, pp. 286–89; Johnstone 1972a, pp. 100–101; Johnstone 1972b, pp. 61–68; Petrakis 1977, p. 41).
13. Crete was under Islamic control for 140 years beginning in 820. Byzantine emperors attempted to recover the island several times and succeeded in 961, holding the island until 1024. For more on the Fourth Crusade, see Norwich 2003, p. 141; Spratt 1865, pp. 27–28; Stavrianos 2001, pp. 29–30.
14. Norwich 2003, pp. 542–46.
15. Norwich 2003, pp. 162, 170–71, 215, 272. Immense convoys sailed regularly from various parts of the Mediterranean and Black Sea ports, trading bales of silk from Central Asia, spices from India and farther east, and cotton from Anatolia and the eastern Mediterranean. From the ports of Kaffa and Soldaia (now Sudak) came furs, and from the Russian north came slaves. Venetian ships also carried increasing quantities of sugar and a sweet, heavy wine; the demand for both was now insatiable throughout Europe. The first supplies of sugar had come from Syria as early as the eleventh century, but now Venetian entrepreneurs introduced it in Crete as well as in Cyprus. Venetians established vast agricultural estates that were maintained by slaves—Georgians, Armenians, and Circassians—from the Black Sea slave trade run by Venetians. Crete, Cyprus, and parts of the Morea were also the main producers of Malmsey, the above-mentioned sweet aromatic wine named after the port of Monemvasía from which most of it was shipped to northern Europeans, who imbibed it with such relish.
16. Trilling 1983, pp. 27–29.
17. The Portuguese navigator Vasco Da Gama in 1497 sailed south from Portugal, around the southern tip of Africa, north along that continent's east coast, then across the Indian Ocean to India. He returned to Portugal in 1499. See İnalcık and Quataert 1994a, p. 342; İnalcık and Quataert 1994b, pp. 520–21; Norwich 2003, p. 386.
18. McKee 1993, pp. 229–49.
19. İnalcık and Quataert 1994b, pp. 423–24; Norwich 2003, p. 473, 545–46; Stavrianos 2000, pp. 165–66.
20. Ottoman control of the island lasted for 228 years. In 1897, Crete became an autonomous island. It stayed that way until 1913, when it was incorporated into Greece. See İnalcık and Quataert 1994a; Miller 1908, pp. 636–43; Stavrianos 2001, pp. 165–69.
21. Greene 2000, pp. 9–10, 36–44, 128–31.
22. Greene 2000, p. 39; Pashley 1837, pp. 8, 181. See also note 5 above.
23. McKee 1993, pp. 229–49.

CHAPTER 2
Lions, Kings, and Queens

1. This sentence is part of a two-sentence angelic utterance said to be delivered to Saint Mark when his ship stopped at the islands of Rialto (Venice) during his travels from Aquileia to Rome. "Pax tibi, Marce, evangelista meus. Hic requiescet corpus tuum" (Peace be unto you, Mark, my evangelist. On this spot shall your body rest).
2. Norwich 2003, pp. 28–30.
3. Cyclades is the name given to a group of approximately 220 large and small islands located in the southern Aegean Sea between Crete to the south and the island group called the Dodecanese to the east, and the Peloponnese, the peninsula to the west. The largest islands in the group are Ándros, Tínos, Náxos, Amorgós, Milos, Páros, Sýros, Kéa, Kýthnos, Sérifos, Íos, and Thíra. Some of the other important islands in the group are Míkonos, Sífnos, Folégandros, Kímolos, and Anáfi. (Merriam Webster's Geographical Dictionary, Third Edition, 1998, for listing; National Geospatial Intelligence Agency and United States Board on Geographic Names for preferred spellings).
4. Taylor 1998, pp. 34–35; Wace and Dawkins 1914b, pp. 99–107.
5. Pritchard 2003, pp. 355–78.
6. Wace and Dawkins 1914a; Wace and Dawkins 1914b; Wace 1914.
7. Johnstone 1972a; Polychroniadis 1980; Taylor 1989; Trilling 1983; Wace 1914.
8. Helen Polychroniadis (1980, p. 17) notes that embroidery made by counting the threads of the cloth, so-called counted threadwork, is called *metritá* or *xombliastá*.
9. The naming of these two motifs, king and queen, was introduced by Wace (1914, pp. xxix–xxxii).
10. Polychroniadis 1980, p. 22.
11. Johnstone 1961, pp. 26–27; Petrakis 1977, pp. 37–44.
12. Wace 1935, pp. 7–11.
13. James Trilling (1983, pp. 30–34) argues that the motif was possibly adapted from French lace patterns.
14. A Greek woman who was very good at producing embroidered chemises was recommended by Costanza d'Avalos and went to work for Isabella d'Este in 1491 (Herald 1981, p. 193).
15. Trilling 1983, pp. 22–25.
16. Johnstone 1961, pp. 26–27; Polychroniadis 1980, p. 22.
17. Johnstone 1961, pp. 26–27; Petrakis 1977, pp. 37–40.
18. Trilling 1983, pp. 23–25.
19. Many scholars date these textiles from the sixteenth to the eighteenth century. They were definitely no longer in use by the early nineteenth century (Johnstone 1972a; Polychroniadis 1980; Taylor 1989; Trilling 1983; Wace 1914).
20. A. J. B. Wace argues that the cross stitch was a later introduction to the island

of Anáfi. A textile fragment with satin stitch on linen foundation fabric acquired by R. M. Dawkins in Anáfi (now in the Victoria and Albert Museum collection [T.130-1950]) is thought to be earlier than the cross-stitch examples and thus representative of an earlier tradition. The textile in question represents a motif of a deer with serrated horns, which is a typical motif of later Anáfi embroidery (Johnstone 1972a, p. 19).

21. Marco Sanudo appears to have received his authority to establish a company for the conquest of the Aegean Islands by both Venice and the Byzantine emperor (Fotheringham 1915, pp. 50–51). The Duchy of Náxos consisted of several fiefdoms and was formed as a result of Venice's wish to clear out the "pirates' nests" in the Aegean Sea. "Pirates," especially the Genoese with whom the Venetians had a long-standing rivalry over trade routes, were a serious hindrance on the Venetian trade routes that spread from the Black Sea and the eastern Mediterranean to Venice.

22. Fotheringham 1915, pp. 58–59; Miller 1908, p. 571. When the Duchy of Náxos was established, Pátmos was allowed to be independent and its monks received many privileges from the Venetians. Because Saint John the Divine was traditionally known to have received and recorded the book of Revelation in Pátmos in the first century A.D., this island was granted high status and remained a center of Christian learning.

23. See John Knight Fotheringham (1915, pp. 58–59) for an extended list of who conquered which island and set himself as overlord.

24. Marco Sanudo was a nephew of the doge Enrico Dandolo (Miller 1908, pp. 582–83; Taylor 1998 pp. 13–14). The Sanudo family ruled as dukes from 1207 to 1383, when Francesco Crispi, a son-in-law of a later duke, had Nicolo II (the last Sanudo duke) assassinated and took over the duchy himself. The Crispi family held the duchy until 1566 when the Ottomans conquered the majority of the islands in the central Aegean Sea.

William Miller (1908, p. 571) suggests that Marco Sanudo paid homage to Latin Emperor Henry (r. 1205–16), the overlord of Frankish states in the Levant, and that Henry is the one who invested Sanudo with his islands. The name "Archipelago" is thought to be a later corruption of "*Egeo pelago*" by Emperor Henry. In feudal law the Duke of Náxos (Archipelago) held his islands as a fief of the princes of Achaia (part of the Latin emperor's domain), so that Venice had no jurisdiction in any of them (Miller 1908, p. 586). Fotheringham (1915, p. 41), on the other hand writes that Marco Sanudo received his investiture as Duke of Náxos (Archipelago) not from the Venetian doge, but from the Byzantine emperor. He also mentions in his book that Marco Sanudo married a woman generally known as the sister of the emperor, although it is not clear if she was the sister of the one in Nicaea or Constantinople (Fotheringham 1915, pp. 67–68). In later centuries this turn of events had profound effects on the alliances of each island lord and the right of suzerainty over these islands.

25. Fotheringham 1915, pp. 67–68; Taylor 1998 pp. 13–14.

26. The Ottoman Empire had acquired most of mainland Greece and Anatolia, while the Aegean Islands in the middle continued to be governed by either Venice or feudal lords. As one traveled from the Ottoman capital of Istanbul, the Aegean Islands were on the route to the Ottoman provinces in northern Africa and the eastern Mediterranean.

27. Miller 1908, pp. 599, 630.

28. Between 1566 and 1579 the Duchy of Náxos survived as an independent state, consisting of Náxos, Páros, and Mílos, and ruled by Joseph Nasi. His baptized Jewish Marrano ancestors had in the late fifteenth century fled from persecutions in Spain to Portugal. Nasi eventually left Portugal for Antwerp, France, Italy, and then Constantinople, where he was finally able to practice Judaism openly and became a favorite of the sultan. After a new sultan, Selim II, came to power, Nasi was made the Duke of Náxos. When Selim II died in 1574 Nasi lost political influence. He died in 1579, and the duchy finally disintegrated. Only Tinos remained in Venetian hands, until it too was taken by the Ottomans in 1712 (İnalcık and Quataert 1994a, pp. 212–13; Miller 1908, pp. 636–41; Taylor 1998, pp. 13–14).

29. Miller 1908, pp. 636–44. The Greek Orthodox churches were to be free and could be repaired at their own pleasure; all their ancient laws and customs were to remain in full force; they were also entitled to retain their local dress; and silk, wine, and provisions were exempt from duty on their islands. These privileges were reconfirmed by Ottoman Sultan Ibrahim sixty years later and formed the charter of the Cyclades under Turkish rule.

30. Luttrell 1989, pp. 146–55.

31. Some lords and their families lived on these islands, while others were absentee landlords. In areas separate from the Greeks, Latins lived inside the castles built by them, in stately palaces many of which were decorated with coats of arms over their doors. The earliest ones date to the thirteenth century, the later ones to the Renaissance (Kininmonth 1949, pp. 158–59). Some of the islands also changed hands or were divided, either after a political struggle or after a marriage as part of a dowry.

32. Luttrell 1989, pp. 144–55.

33. The communication between islands frequently broke down. Thus, the smaller islands were more backward and seldom attracted the attention of the great powers intent on dynastic conquests, strategic bases, or commercial advantages. Sometimes the population seemed not to even know who their lords were. If a small island was prosperous, it was because of a certain product it produced, such as the silk cultivated on Tínos in the northern Cyclades. On these small islands the population tended to retreat inland to the hills, where there was often a castle and sometimes a small Latin garrison, with a suburb for Greeks and others. The villages were fortified to protect the Greeks from attacks. Sometimes houses were built so that their backs formed a continuous protective outer wall (Luttrell 1989, pp. 144–55; Wace and Dawkins 1914b, pp. 99–107).

34. Luttrell 1989, p. 150.

35. Several scholars have recently suggested that although long-distance international trade was slowing in the Mediterranean after the fifteenth century, there was a very lively and profitable trade going on between provinces within the Ottoman Empire. Thus, although the Aegean Islands lost their trade relations with continental Europe, nevertheless, they seemed to gain new trade relations with other parts of the Ottoman Empire (Quataert 2000). There is also a very interesting travel memoir about the conditions on the islands in the second half of the nineteenth century written by James Bent, who traveled in the Cyclades in the late 1800s (Bent [1885] 2002).

CHAPTER 3
Vases and Branches

1. Attaching a specific meaning to the flower-vase motif is extremely difficult. Although many things, such as social, political, spiritual, and artistic environments, can influence the meaning of a given motif, a vase filled with flowers most often represents the abundance of nature, nature's cyclical renewal, and ultimately its permanency. From the earliest times it appears that the distinction between flower vases, flowers, and trees has often been blurred and that flower vases or flower clusters are often interpreted as the tree of life.

2. Montesanto 1930, pp. 33–38; Wace and Dawkins 1914b, pp. 99–107.

3. Polychroniadis 1980, p. 21.

4. Roderick Taylor (1998, p. 64) argues that these valances were not part of the bed tent assembly but were used separately on couches or chests in keeping with Italian fashion. If they were used as a part of the bed tent, it is suggested that their decoration would not be visible.

5. Montesanto 1930, pp. 39–40.

6. Taylor (1998, p. 59) discusses in detail where the term may have originated and establishes a European origin for it. Italian *sparviere*, High German *sparwari*, and Middle English *sparver* are all related in one way or another to textiles used as bed furnishings. He also dates the first appearance of the term to the fifteenth century.

7. Taylor (1998, pp. 60–64) suggests that the first group may date earlier than the second group. The bed tents in the first group exhibit simpler design layouts, the embroidery thread used is not as thick, and they are not embroidered as densely as those in the second group.

8. The best example of this second type is in the collection of the Benaki Museum (acc. no. 7650) (Delivorrias 2000, p. 87).

9. Dodecanese Islands or the Dodecanese is the name given to a group of islands in the southeastern Aegean Sea. The island group (in Greek the Dodekánisos) derives its name from the twelve (*dodeca*) islands that accepted Ottoman control without resistance in 1478. Neither Rhodes (Ródos) nor Kos (Coo) were among these twelve islands. The twelve islands (for the following list, Greek names with the Italian names in parentheses) are Astypálaia (Stampalia), Kálymnos (Calino), Kárpathos (Scarpanto), Kásos (Caso), Chálki (Calchi), Léros (Lero), Leipsoí (Lisso or Lipsós), Nísyros (Nisiro), Pátmos (Patmo), Sými (Simi), Tílos (Piscopi), and Megísti (Megisti). Among these islands, Kárpathos, Kásos, Pátmos and Astypálaia were never part of the political entity, known as the Order of the Knights of Saint John, or the Hospitallers, which controlled the rest of the islands in the southeastern Aegean Sea until Ottoman control in 1522 (preferred Greek spellings: GeoNet Name Server of the National Geospatial Intelligence Agency

and the United States Board of Geographic Names: http://gnswww.nga.mil/geonames/GNS/index.jsp; Italian spellings: *Merriam Webster's Geographic Dictionary*, 3rd ed., 1998).

10. Johnstone 1961, pp. 26–27. Taylor (1998, p. 66) also mentions a variety of regional names used for this motif.

11. Density in the Rhodian fabric is achieved by using thicker yarns, rather than packing the yarns. There are approximately nineteen warp yarns to an average of fifteen weft yarns per square centimeter.

12. Taylor (1998, pp. 63, 68) mentions that this area was called *koumpaso* and that the term was derived from the medieval Italian word for that shape defined by the arms of a pair of compasses. He also adds that this term was changed to *mouseion* in the early twentieth century.

13. A good example of such a coat of arms—that belonging to Emery d'Amboise, Grand Master of the Order of St. John of Jerusalem, of Rhodes, and of Malta (r. 1503–12)—could be seen on the Amboise Gate of the Rhodian fortifications (Velde 1995–2003).

14. What are considered to be the earliest examples of embroidered textiles from the Greek Islands are generally dated to the sixteenth and seventeenth centuries by scholars (Johnstone 1972a; Polychroniadis 1980; Taylor 1998).

15. The Dodecanese were controlled by the Genoese (1250–1309), the Knights of Saint John (Hospitallers) (1309–1522 and 1685–1712), the Ottomans (1523–1912), and the Italians (1912–47), and they were finally transferred to Greece in 1947.

16. Between 1204 and 1250, the islands were ruled by the Cretan Gabalas family, who were replaced by the Genoese de' Vignoli family (Taylor 1998, pp. 15–16). The Knights of Saint John (Hospitallers) ruled Rhodes from 1309 until the Ottomans established themselves there in 1523. By the end of thirteenth century just before the Knights took control of the island, however, Rhodes was a known haven for many pirate groups operating in and around the Mediterranean and Aegean seas, harassing trade and pilgrim ships. The arrival of the Knights drastically altered this situation in Rhodes.

17. Luttrell 1978a, pp. 278–313; Luttrell 1989, pp. 146–55; Luttrell 1999, pp. 193–223; The Oxford English Dictionary 1989, vol. 6, pp. 415–16. After losing their land and fortifications in the Holy Land, the Knights had first moved to Cyprus but soon found their activities severely restricted by the official vassals of the island's Frankish king. They then moved to Rhodes (Cook 2001). Rhodes's position at the center of the pilgrim route to the eastern Mediterranean was a perfect base of operation for the Knights. In addition to Rhodes, the Knights became rulers of the surrounding islands, including Nísyros, Sými, Chálki, Tílos, Kálymnos, Kos, and Léros, thus creating an island kingdom.

18. Luttrell 1978e, p. 51. At the time they invaded Rhodes, the Knights regarded the island as a base from which to launch military operations aimed at Christian recovery of the Holy Land. The growing Turkish power in Anatolia, however, led to the formulation of a new policy of resistance and defense of the Latin possessions in the Mediterranean. This policy was put into action by aggressively attacking Turkish and Muslim shipping in the eastern Mediterranean. These actions were successful at the beginning when the Knights were at their peak in terms of financial and human resources. By the fifteenth century, however, the tide began to turn and the Order started losing its wealth.

19. İnalcık and Quataert 1994b, p. 320; Stavrianos 2001, pp. 72–73; Taylor 1998, pp. 16–17. After World War I, Italy took control of Rhodes and the rest of the Dodecanese, which were to be held in trust until they could be transferred to Greece. But the Italians hung on to the islands until World War II. The islands were eventually transferred to Greece in 1947 (Stavrianos 2001, pp. 589–90, 665-66, 836).

20. Taylor 1998, pp. 15–16.

21. Montesanto 1930, pp. 33–40.

22. Cook 2001.

23. Johnstone 1972a; Polychroniadis 1980; Taylor 1998.

24. See Luttrell 1978e, pp. 167–75, for some of the historical and political differences between Crete and Rhodes.

25. See İnalcık and Quataert (1994a and 1994b) for a detailed analysis of the changes taking place in the Ottoman government, politics, and finances during the sixteenth and seventeenth centuries.

26. Stavrianos 2001, p. 101; Zakythinos 1976, p. 54.

27. Further study would be required to suggest whether this unification had any direct effect on the embroidery tradition.

CHAPTER 4
Harpies and Roosters

1. Although their names and their parents' names all vary according to sources and traditions, the four Harpies were often known as Aello (meaning Rain Squall), Celaeno (Storm Dark), Okypete (Swift Flying), and Podarge (Swift Foot), who were born from Typhon and Echinda. (The Oxford English Dictionary 1989, vol. 6, p. 1129).

2. Hadjimichaeli 1935–36, pp. 98–118; Johnstone 1972a, pp. 21–22; Wace 1914, p. viii.

3. Ibid.

4. There are eleven islands in the Northern Sporades, four of which are inhabited: Skíathos, Skópelos, Alónnisos, and Skýros. This island group lies to the north and east of the island of Euboea (Évvoia) and to the east and southeast of the Pílion Peninsula, to which they were joined in prehistoric times. With their dense vegetation and mountainous terrain, the islands seem like a continuation of the peninsula. Skýros, being more southern, has a different character. The northern half has rolling, cultivated hills and pine forest, while the south is barren and rocky (Webster's New Geographical Dictionary 1988, pp. 1122–23 and 1149).

5. Liddell 1954, n.p.; Wace and Dawkins 1914b, pp. 99–107.

6. Taylor 1988, pp. 87–89.

7. Taylor 1998, pp. 99–100. A very nice example of a pair of sleeves can also be seen in the collection of the Museum of Greek Folk Art in Athens (acc. no. 36). See Lada-Minotos and Gangadis (1993), Papantoniou (1996), and Papantoniou (2000) for further discussion of costumes from the Northern Sporades.

8. Helen Polychroniadis (1988, p. 23) also mentions foundation fabrics produced by mixing cotton and silk. These may be a later development, since most of the embroidered textiles from the seventeenth and eighteenth centuries have linen foundation fabrics.

9. The most up-to-date information about dyes and dyeing can be found in Roderick R. Taylor's book (1998, pp. 171–73) in which he updates the information from A. J. B. Wace's Burlington Fine Arts Club exhibition catalogue (1914, pp. xxv–xxvii).

10. The double running stitch is thought to have been popular in the early eighteenth century, to which period many of the embroidered textiles with running stitch are often dated (Ellis and Rowney 1991, pp. 101–3).

11. Polychroniadis 1988, p. 24.

12. Such as the Harpies found on textiles in the collection of the Victoria and Albert Museum in London (T.695-1919) and The Textile Museum cushions (81.81, here cat. no. 4.1), as well as the roosters on bedspreads in the collections of the World Museum Liverpool (56.210.126), the Benaki Museum in Athens (6381) and The Textile Museum (81.80, here cat. no. 4.3).

13. Taylor 1998, p. 98. Taylor also suggests that these traveling embroiderers were likely to have come from Epirus (Ípeiros), owing to the close resemblance between the embroidered textiles of Epirus and those of Skýros.

14. As also seen in the embroidered textiles from other islands, ships are often represented on Skýros embroidery. The main wealth of Skýros came from its fishing tradition; therefore, seeing a variety of ships on these embroidered textiles is not surprising. Most of the ships represented, however, are large sailing vessels, rather than little fishing boats. The trade and long wars between Venice and the Ottoman Empire that often took place in the Aegean Sea, probably exposed the islanders to a variety of ship models, especially large galleys. Jean-Ann Weale-Badieritaki (1989) identifies at least two types of galleys on Skýros embroidered textiles, both of which appear to represent types of ships that were used beginning in the seventeenth century.

15. The Victoria and Albert Museum in London and the Benaki Museum in Athens have the largest collections of Skýros textiles. See also Taylor (1998, pp. 87–99) for a discussion of motifs on Skýros embroidery.

16. Personal communication with Yianoula Kaplani, curator, Museum of Greek Folk Art, Athens, May 24–31, 2003; Taylor 1998, p. 96.

17. Taylor 1998, p. 96.

18. Taylor 1998, p. 87.

19. The tulip was called *lale*, and the arching floral branch was known as a *kampouraki*, from the Turkish *kambur* (hunchback) (Taylor 1998, p. 98).

20. Taylor 1998, p. 98. A possible bestiary connection is suggested by an embroidered sampler attributed to Epirus (Benaki Museum 6412; Polychroniadis

1988, p. 49, fig. 25). But when the technical and design characteristics of the embroidery are considered, it seems more likely that this textile is from Skýros. A major portion of the foundation cloth is filled with fantastic animals, and each figure carries an inscription in the form of a label with phrases like "concerning sparrows" and "concerning sea monsters."

21. Jean-Ann Weale-Badieritaki (1989, pp. 45–53) identifies one galley with oars from the fifteenth century and at least two types of galleys representing ships that were used beginning in the seventeenth century.

22. The First Ottoman-Venetian War (1499–1503), the Second Ottoman-Venetian War (1537–40), and the War for Cyprus (1570–73) (Shaw 1977, pp. 47–49, 65–69, 75–76, 231–33; Stavrianos 2001, pp. 65–66, 165–66, and pp. 181–82).

CHAPTER 5
Brides and Grooms

1. The Epirus region (Ípeiros) considered in this book includes northwestern Greece and a portion of what is now southern Albania, including the town of Argyrokastron (Gjirokastër), on the coast of the Ionian Sea (Merriam Webster's Geographical Dictionary 1998, p. 429).

2. Thomas S. Hughes (1830, pp. 27–37) mentions that he participated in such a wedding in Ioánnina.

3. Hughes 1830, p. 438.

4. Taylor 1998, pp. 137–39.

5. The best examples of this textile type are in the Benaki Museum collection, Athens (11202 and 6307), and are identified as bed valances. There are also two in the Royal Scottish Museum, Edinburgh, and one in the World Museum Liverpool (before May 2005 known as the Liverpool Museum) published in Taylor (1998, pp. 138–40).

6. There is a cope in The Textile Museum collection (here cat. no. 5.9) and another in the World Museum Liverpool (56.210.65) that are attributed to Epirus. There is also an embroidered cope from Crete in the Peloponnesian Folk Art Foundation Museum, Náfplion.

7. The cope in the collection of the World Museum Liverpool (56.210.65) exemplifies this practice the best.

8. Louisa F. Pesel (1907, pp. 32–39) refers to this technique as "voiding."

9. See Hughes (1830, vol. 2, pp. 27–37) for a description of weddings in Ioánnina.

10. See James Trilling (1983, pp. 19–22) for his discussion on the impact of Ottoman textile arts on Greek Island and Epirus embroidery.

11. The most striking example of duplication can be seen in two bedspreads, one in The Textile Museum collection (81.70, see cat. no. 5.6 in this book) and the other published in Roderick R. Taylor (1998, p. 141) and in his collection.

12. There is a small group of textiles that share the same materials, design, and color as the herringbone-stitch group and the technique of the running-stitch group, including leaving unembroidered sections in the solid areas (voiding). Only three examples are known to the author; they are in the collections of the Benaki Museum, Athens (36314 and 6301), and in the Witworth Art Gallery, Manchester (9339). Finding more examples will allow us to consider them to be either a separate group or just transitional examples.

13. Hadjimichaeli 1935–36, pp. 98–118; Johnstone 1961, pp. 31–33; Johnstone 1972a, pp. 23–25; Pesel 1907, pp. 32–39; Taylor 1998, pp. 127–28; Wace 1935, pp. 16–19.

14. The four great limestone mountain ranges that run from north-northwest to south-southeast create fertile valleys and woodlands in between. Several important rivers irrigate these valleys (Foss 1978, pp. 20–21).

15. The other two places are Nicaea (İznik), in northwestern Anatolia, where the remainder of the Byzantine Empire was established, and Trebizond (Trabzon) in Anatolia on the southeastern coast of the Black Sea.

16. Stavrianos 2001, pp. 29–30, 39–41.

17. İnalcık 1975, pp. 11–12; İnalcık and Quataert 1994, vol. 1, pp. 15–16; Shaw 1977, vol. 1, pp. 18–19; Stavrianos 2001, pp. 29–66.

18. Foss 1978, pp. 44–47; İnalcık and Quataert 1994, vol. 1, pp. 15–17; Shaw 1977, vol. 1, p. 48; Stavrianos 2001, pp. 81–95. Párga and Préveza on the coast of Epirus; Valona (Vlorë) and Butrinto (Butrint) on the coast of Albania; and the Ionian Islands remained under Venetian control, while the Ottoman Empire occupied large portions of Epirus and Albania.

19. In her book, K. E. Fleming (1999) discusses, in great detail, the reign of Ali Paşa in Epirus. See also Hughes (1830, pp. 455–56) for his eyewitness account of Ioánnina in the 1810s.

20. Foss 1978, p. 29. In this period some of the most important seaports on the Adriatic coast came under the control of Ali Paşa and became part of Epirus.

21. Shaw and Shaw 1977, pp. 292–98; Stavrianos 2001, pp. 535–37.

CHAPTER 6
Stags and Eagles

1. Wehrhahn-Stauch 1967, pp. 2–44.

2. The Ionian Islands (Iónioi Nísoi) are a group of islands also known as Heptanesus (the Seven Islands), six of them in the Ionian Sea off the west coast of Greece and the seventh, Kíthira, in the Mediterranean Sea off the south coast of Pelopónnissos. The major islands in this group are Corfu (Kérkyra), Paxoí (Paxós), Lefkás (also known as Santa Maura, Levkás, or Lefkáda), Itháki (Ithaca), Kefallinía (Cephalonia), Zákynthos (Zante), and Kíthira (Cythera) (Merriam Webster's Geographical Dictionary 1998, pp. 524, 598); Greek spellings based on the preferred spellings per GeoNet Names Server).

3. Johnstone 1972a, p. 23; Polychroniadis 1980, p. 2. Roderick R. Taylor argues that just because a textile was bought or found on one of the Ionian Islands is insufficient evidence to assume it was made there (Taylor 1998, p. 119). Indeed, the textiles were collected a century or so after the tradition had died there. There are also some historical facts that bear on this subject which will be discussed later in the chapter.

4. World Museum Liverpool collection bedspread (56.210.44) is unpublished, while the Victoria and Albert Museum bedspread fragment (T.133-1927) is published in Johnstone (1972, p. 89, fig. 105).

5. "Cactus-tailed peacock" is a term coined by Pauline Johnstone (1961, pp. 33–34) and is fitting for this motif.

6. Johnstone 1972a, p. 23; Polychroniadis 1980, p. 2; Taylor 1998, p. 119.

7. Helen Polychroniadis (1980, p. 2) suggests that the withdrawn element work is later than the cross-stitch style, but she never explains why she came to this conclusion.

8. Owing to the lack of any surviving example, it is not clear if this style of embroidery was practiced on bedspreads.

9. The term "Holbein gül" gets its name from carpet studies. "Gül" is the name of the motif in the shape of a small medallion, sometimes interpreted as the representation of a flower head from above. Because *gül* features are easy to memorize and weave, they are widely used by weavers, especially for rugs. A *gül* pattern is suitable for decoration on small and large textiles alike. The name "Holbein" was coined from the painter Hans Holbein the Younger's early sixteenth-century portrait of Hanseatic merchant Georg Gisze, now in the Gemäldegalerie, Staatliche Museen, Berlin. In this painting, Holbein depicts a carpet with a repeated interlaced strapwork *gül* motif (Holbein gül) lying on a table (Denny 2002, pp. 18–19; Mackie and Thompson 1980, pp. 62–63).

10. Abegg 1978, pp. 28–124; Johnstone 1961, pp. 33–34.

11. The Victoria and Albert Museum bedspread (T244-1950) is unpublished, while the Benaki Museum bedspread border fragments (6255) are published in Polychroniadis (1980, p. 80, fig. 70).

12. Often two warp and weft yarns are removed while the next two are kept. In some instances three yarns are removed.

13. Joan Petrakis (1977, pp. 47–51) refers to this technique as *maglia quadrata*.

14. See Angeliki Hatzimichali (1935–36, pp. 96–117) for her discussion of A. J. B. Wace's hypothesis concerning the relationship among Epirus, Ionian, and Skýros embroidery.

15. Norwich 2003, pp. 71–72, 96–98, 148–49, 357, 452–53, and 579–82.

16. Ottomans took control of Zákynthos, Lefkás, Itháki, and Kefallinía in 1479–80. But they did not hold any of these islands very long, except Lefkás, which they controlled for two hundred years (Norwich 2003, p. 357).

17. Stavrianos 2001, pp. 198–200. France acquired the islands from Venice after the 1797 Treaty of Campo Formio. The remaining Venetian possessions along the Adriatic coast went to Austria under the same treaty.

18. These appointed agents consisted of a governor-general with a three-year term, a governor for each of the islands, a grand judge, and the three

"inquisitors" sent out periodically to investigate conditions and report on the conduct of all public officials (Stavrianos 2001, p. 200).

19. Stavrianos 2001, p. 200.

20. Stavrianos 2001, pp. 199–206, 289–92. The Ionian Islands were to form, under British protection, an independent state to be known as "The United States of the Ionian Islands" (Stavrianos 2001, pp. 198–211).

21. Johnstone 1972a, p. 23; Polychroniadis 1980, p. 2.

CHAPTER 7
Ships and Flowers

1. Argenti 1949, pp. 1037–46; Lada-Minotos and Gangadis 1993, pp. 44–45; Papantoniou 1996, pp. 151–52; Polychroniadis 1980, p. 26. Two other museum collections contain such material. These are the Victoria and Albert Museum (T61-1916 and T678-1919) and the Benaki Museum (6341, 6337, and 11358). The Victoria and Albert Museum textiles are published by Pauline Johnstone (1972a, p. 83).

2. Roderick R. Taylor (1998, pp. 102–3) calls this textile *stithopano* (breast cloth); Helen Polychroniadis (1980, p. 20) refers to them as *stithopana* or *brostomantila*, using a description from Philip Pandely Argenti (1949, p. 1038).

3. See Argenti (1949), Chandler ([1738–1810] 1971, p. 48), and Charlemont ([1728–1799] 1984, pp. 35–36) for a description of women's costume in Chios.

4. The Victoria and Albert Museum collection contains five examples (T380-1950, T675A-1893, T597-1894, T597A-1894, T213-1912). They have Z-twisted silk warp and weft yarns and two Z-twisted and S-plied silk embroidery thread. The design is executed in double running stitch. With one exception (T213-1912), they have the same deep red color foundation fabric. One of the red ground ones (T597-1894) was published by Pauline Johnstone (1972a, p. 81, fig. 90). Using the attribution by Argenti, she suggested that the Victoria and Albert Museum textiles might be from Chios.

5. Polychroniadis 1980, p. 26.

6. Charlemont [1728–1799] 1984, p. 48; Laurent 1821, pp. 25–28.

7. Taylor 1998, pp. 101–2.

Stitch Glossary

Chain stitch
One of the looped stitches, which can be worked with either a needle or a hook. If worked with a needle, the thread is brought up at the beginning of the row. The needle is then inserted into the same spot where the thread first emerged, forming a loop, and the needle is brought up through the fabric again a short distance beyond, passing through and over the loop of the working thread. If the stitch is done with a hook, the thread is hooked from above and pulled through to create a loop. This loop is then secured with another loop pulled through the same way (Emery 1994, p. 243; Thomas 1954, pp. 32–33). In Greek, this stitch is known as *seirítsa* (Polychroniadis 1980, pp. 17–20).

Couching
In this technique, the embroidery threads are laid on the surface of the fabric and secured with small stitches using a second thread (Thomas 1954, p. 55).

Counted work
General term for embroidery in which the stitches are disposed by counting horizontal and/or vertical warp and weft yarns.

Cretan feather stitch
A type of looped stitch related to the feather stitch. The needle is brought out on the surface of foundation fabric and inserted lower down on the right. The embroiderer, while holding the portion of the thread on the surface, brings the needle out again a few millimeters to the left of the entry point and above the thread that is held. The same movement is then repeated on the left and continues alternately from right to left down toward the embroiderer. The embroiderer has relative freedom to alter the effect considerably by changing the amount of material she picks up each time, extending the length of her steps, making the steps more slanted, or placing her steps far apart (Thomas 1954, pp. 57–59). In Cretan embroidery, the steps are tightly packed and less slanted, creating a prominent braid in the center. The Cretan feather stitch is referred to as *phrerotí* in Greek (Polychroniadis 1980, pp. 17–20).

Crossed stitches
A unit stitch composed of two flat stitches crossing the same small area at opposite or oblique angles. Each flat stitch may be crossed before the next is worked, or a whole row of parallel slanting stitches may be worked first, and the crossing stitches worked in a second "journey." Crossed stitches may be counted or not. Fishbone, herringbone, and long-armed cross stitches are a few examples of this category (Emery 1994, pp. 239–41; Thomas 1954, pp. 60–70). Crossed stitches are called *kangellotí* or Phrygian (*phrygikí*) in Greek (Polychroniadis 1980, pp. 17–20).

Cross stitch—double-sided or two-sided
A type of cross stitch in which the needle goes over the same area four times to complete a single row of crosses (Thomas 1954, pp. 68–69).

Cross stitch—Ionian Island
A type of cross stitch in which a cross is created after each four movements. At the start of the line the first three movements of the needle and thread are the same as for the regular cross stitch, but after that the stitch is continued by bringing the needle up where the first movement ended and doing the reverse of the first four movements. Worked this way, the reverse side of the stitch consists of crenellations created by the stitches. The best effect is achieved if it is worked with evenly spaced stitches.

Cretan feather stitch

Cross stitch—Ionian Island

Cross stitch—long-armed

Cross stitch—Rhodian

Cross stitch—long-armed
A type of cross stitch in which variation is achieved by changing the length and placement of the stitches. At the start of the line the first two movements of the needle and thread are the same as for the regular cross stitch, but after that the stitch is continued by bringing the needle up directly below where it entered at the end of second movement and carrying it across twice the length of the original diagonal stitch somewhere to the upper right-hand corner and then to the back of the foundation fabric. The needle is then brought to the front of the foundation fabric directly below a few yarns where it entered and is carried diagonally over the long stitch to a point halfway between the upper points of the previous stitches. The reverse side of the stitch consists of single upright stitches at regular intervals (Bucher 1971, p. 162; Thomas 1954, pp. 64–65). The best effect is achieved if it is worked with evenly spaced stitches.

Cross stitch—Rhodian
A combination stitch that utilizes long-armed cross stitch and a zigzag stitch; the long-armed cross stitch is worked on the first journey and then zigzag stitch is worked over it on the journey back. The Rhodian cross stitch is found on embroidered textiles from Rhodes.

Deflected element work
An embroidery technique characterized by warp and weft yarns of a foundation fabric pulled out of alignment and held in place with embroidery stitches under tension. The technique does not require any warp or weft yarns to be removed from the foundation fabric. Used for openwork style embroidery it is sometimes referred to as *drawn fabric work* or *pulled work*.

Double running stitch
A type of flat stitch, this stitch consists of a simple running stitch worked in two journeys over the same line. The double running stitch appears the same on both sides (Thomas 1954, pp. 121–22). Double running stitch is called *gazotí* in Greek (Polychroniadis 1980, pp. 17–20).

Embroidery style
This term describes a type of embroidery often identified with characteristic techniques, embroidery stitches, designs, or colors and yarns used. Embroidery style defines any type of embroidery specific to a culture or time period.

Embroidery technique
This term is a guide term for embroidery processes. It defines different types of work, with different actions being performed upon the foundation fabric.

Eyelet stitch
A type of flat stitch, this stitch consists of a series of back stitches worked in pairs, disposed from the same center (Thomas 1954, p. 86).

Feather stitch
A type of looped stitch; the embroiderer starts by bringing out her threaded needle on the surface of the foundation fabric and then inserting it lower down to the right at an angle. The embroiderer next pulls the needle through over the thread she is holding on the surface (Thomas 1954, pp. 92–93).

Flat stitches
Stitches formed by working the needle alternately in and out of a fabric and thus laying the sewing element flat and straight on first one face and then, depending on the stitch, making a return journey along the same line. Running, double running, satin, stem, back, and outline stitches are a few of the stitches in this category. Stitches may be parallel to the axis of the fabric weave, oblique, or diagonal. They may be equal or unequal in length on either face. Distinctions may be made between stitches derived from the running stitch, which progress from entry point to entry point, and stitches derived from the back stitch, which have a regressive (or wrapping) motion between entry points. This distinction does not always reflect reversibility. Flat stitches may be worked singly, along a line, and in vertical or horizontal rows, and they may be disposed in a straight or slanted manner on the surface (Emery 1994, pp. 234–41).

Fishbone stitch
A type of cross stitch, generally worked as a filling stitch. A series of slanted cross stitches, with satin stitches taken alternately from one side to the other and crossing at the center of the work, near the base of each individual stitch (Thomas 1954, pp. 97–98).

Grafta
A Greek term used to describe embroidery made after tracing the design on to the foundation fabric (Mitchell and Thurston 2004, pp. 42–45; Polychroniadis 1980, p. 17; Taylor 2001b, pp. 26–27; Taylor 1998, p. 167).

Hem stitch—interlaced
A type of withdrawn element work, this stitch is worked on areas where some of either the weft or the warp yarns are removed. The needle emerges from the back of the foundation fabric and weaves over the first group of yarns and under the second group. It then turns back and weaves over the second group and under the first. Each segment of the stitch needs to be pulled tight so that the yarns of the foundation fabric will be pulled out of alignment, creating open spaces for decorative purposes (Christie 1948, p. 107; Thomas 1954, p. 116).

Herringbone stitch
A type of cross stitch in which the needle is inserted in and out on a horizontal line toward the already completed stitches alternately along the top and bottom of the row of stitches (Thomas 1954, pp. 117–18). A variation used in Epirote embroidery, called *close herringbone stitch*, has the crossed points of the stitches touching each other at top and bottom. It produces parallel lines of single straight stitches in alternating alignment on the reverse. In Greek, this stitch is called *psarokókkalo* and is also known as *Byzantine stitch* (Polychroniadis 1980, pp. 17–20). The herringbone stitch and long-armed cross stitch are similar in having multiple, progressively interworking relationships between stitch segments. This is achieved by having one arm of the cross always longer than the other and by having each stitch segment on the face of the work not only crossing another but often being crossed by a third. The easy way to differentiate between these two stitches is to see the way the stitches are taken: in the long-arm cross stitch those at the reverse are vertical, and in the herringbone stitch they are horizontal (Emery 1994, pp. 240–41).

Herringbone stitch

Interlacing stitch
A type of stitch that is built up of threads that constantly interlace one with another. In withdrawn element work, an embroidery thread is wrapped around and interlaced with the crossing of the warp and weft yarns (Christie 1948, p. 125; Thomas 1954, p. 133). This stitch is found in Ionian Island embroidery, where two or more threads of the warp and weft are removed alternately to form the foundation.

Insertion stitch—plaited
This term refers to any of a variety of stitches that both work on themselves forming a decorative band and connect two edges of fabric. In the plaited insertion stitch, the joining yarn works in a figure-eight motion and is interlaced with adjoining stitches (Thomas 1954, pp. 130–31). When used to join the two edges of fabric, it requires that the two fabrics be stretched so they will not move and so they can maintain an even distance between them (Christie 1948, p. 125; Thomas 1954, p. 155).

Knot stitches
Stitches with a looped structure in which the loop(s) are secured by a flat stitch to form a knot. *Bullion*, *French knot*, and *pearl stitch* are examples of knotted stitches (Emery 1994, p. 244).

Looped stitches
Stitches in which the element is made to deviate from a direct line and is held out of line by the next stitch; the process can be described as looping the thread under the needle. Chain stitch, buttonhole stitch, and feather stitch are a few of the stitches in this category (Emery 1994, pp. 241–43).

Metritá (xombliastá)
A Greek term used to describe embroidery made with counted stitches (Mitchell and Thurston 2004, pp. 42–45; Polychroniadis 1980, p. 17; Taylor 1998, p. 167; Taylor 2001b, pp. 26–27).

Openwork
An embroidery style, identified by holes or spaces in or between elements of a fabric either as an integral part of the structure or as a result of accessory stitching; produced by a variety of textile-working techniques.

Outline stitch
This stitch is worked similarly to the stem stitch. The only difference is that the thread is carried on the left or above the needle, and the resulting line of stitches twists in the reverse direction to stem stitch (Thomas 1954, p. 154).

Overcast filling stitch
A type of stitch used for withdrawn element work. The foundation fabric must be prepared by removing and leaving two or more threads alternately. The overcasting stitch is carried out in zigzag diagonal lines, two stitches passing over the horizontal threads, one across the diagonal, and then two across perpendicular threads. At the junction two working threads pass across the same square of fabric threads (Christie 1948, p. 125; Thomas 1954, p. 155).

Pattern darning
A method of disposing running stitches as a filling by counting warp and weft yarns of the foundation fabric to create one or more patterns. It is usually worked by placing each row of running stitches close together. The stitches on the front and back of the foundation fabric might be of unequal length.

Running stitch
A series of straight flat stitches worked along a line in a continual forward motion through the foundation fabric; the stitches may or may not be of equal length on the face and/or the reverse. It can be worked in a single line as an outline, or it may be disposed in rows to create a filling. The number of yarns that are picked up from the foundation fabric between each stitch has an effect on how solid the stitched line appears in the embroidery. Alternating the pickup of the yarns from the foundation fabric for each row of running stitch also provides either a diagonal or staggered appearance. The term *darning stitch* is often used for running stitch where stitches are disposed in rows, the stitches are longer, and fewer foundation fabric yarns are picked up (Emery 1994, pp. 234–35; Eaton 2002, pp. 12, 82; Thomas 1954, p. 177). Running stitch is called *perastí* in Greek (Polychroniadis 1980, pp. 17–20).

Satin stitch
A type of flat stitch in which simple straight flat stitches are disposed by laying a series of straight stitches parallel and close together on both faces of the ground cloth. Each stitch returns on the reverse of the cloth to a point contiguous to its starting point so that the area is covered on both faces by identical stitches. Satin stitches can be of any length and can cover the shape of the motif from one edge to another (Eaton 2002, p. 102; Emery 1994, p. 237; Thomas 1954, p. 179). Satin stitch is referred to as *anachytí* or *tylichtikó* in Greek (Polychroniadis 1980, pp. 17–20).

Self-couching
A couching technique in which the same yarn that is used to create the float across the surface of the fabric is used on the

return pass, to tie down the long straight float with a short straight or a long slanting stitch.

Split stitch
A type of flat stitch in which the needle always emerges from the material a short distance back from the spot where it last entered. But in emerging, the point of the needle splits the already laid working thread close to its base and the needle and thread are pulled through this split portion. Split stitch is more closely related to the stem stitch in which the back stitch, instead of emerging from the fabric either above or below the surface segment and causing it to slant, pierces it and splits the thread (Emery 1994, p. 243; Thomas 1954, pp. 186–87). The Greek name given for the stitch is *dichalotí* (Polychroniadis 1980, p. 19). In Epirus embroidery, this stitch is used as a filling stitch and often worked over six and under three yarns. In each row the stitches are placed in alternation to the row above.

Stem stitch
A type of flat stitch, in which the forward-moving overlapping segments of the stitch are on the face of the foundation fabric. The stitch is worked from left to right. The needle emerges at the end of the line to be covered and then enters the foundation fabric a little farther along the right and emerges again a short distance towards the left. The thread is always carried to the right of or below the needle and above the line already worked so that the stitches form Z slant (Christie 1948, pp. 8–9; Thomas 1954, pp. 189–91). In Greek it is called *ríza* or *rízoveloniá* (Polychroniadis 1980, pp. 17–20).

Stitch
One complete movement of an element through a fabric or portion of a fabric structure by means of a needle or with some equivalent implement; also, the portion of the element disposed in or on the fabric by such a movement (Emery 1994, p. 232). Simple stitch structures fall into five general categories: flat stitches, looped stitches, knotted stitches, crossed stitches, and composite stitches.

Whipping
This term refers to the action of going over the already-stitched threads and catching them with a same or a different thread in circular motion.

Withdrawn element work
An embroidery technique characterized by cutting and removing a certain number of warp and weft yarns of the foundation fabric to prepare the fabric for embroidery, creating a foundation fabric similar to a net. This net effect is heightened by using certain embroidery stitches that pull the remaining warp and weft yarns out of alignment and hold them in place. This technique is also known as *drawn thread work*.

Z- or S-spun
These terms refer to the direction(s) of a single yarn's twist. A yarn is Z-spun if, when held in a vertical position, the spiral conforms to the slant of the central portion of the letter Z; a yarn is S-spun if the spiral conforms to the slant of the central portion of the letter S (Emery 1994, p. 11). The terms S2Z or Z2S refer to the direction(s) of two or more yarns twisted (plied) together. The first letter indicates the direction of the individual yarn's spin, the number in the middle indicates how many yarns were twisted (plied) together, and the final letter indicates the direction of the ply.

Technical and Structural Information

CHAPTER 1: Two-Tailed Mermaids

CAT 1.1
Skirt border (fragments)
Crete
Late 17th century
The Textile Museum 81.69A, B
Acquired by George Hewitt Myers in 1922

Foundation
Warp: linen, Z-spun, 23 yarns per cm, off-white (undyed)
Weft: cotton, Z-spun, 24 yarns per cm, off-white (undyed)
Structure: balanced plain weave
Dimensions for 81.69A: overall length (warp direction) 42 cm, overall width 34.7 cm
Dimensions for 81.69B: overall length (warp direction) 46 cm, overall width 35.6 cm
Edge finish: one selvedge

Embroidery
Embroidery thread: silk, S2Z, Z-twisted, S-twisted, I (untwisted), 10 colors: light blue, dark green, white, off-white, red, yellow, brown, dark brown, 2 shades of dark yellow
Embroidery stitches: satin stitch, chain stitch, outline stitch, stem stitch, herringbone stitch
Notes: pattern drawn on front face of foundation fabric

CAT 1.2
Skirt border (fragment)
Crete
Early 18th century
The Textile Museum 81.50
Acquired by George Hewitt Myers in 1925

Foundation
Warp: linen, Z-spun, 27 yarns per cm, off-white (undyed)
Weft: cotton, Z-spun, 25 yarns per cm, off-white (undyed)
Structure: balanced plain weave
Dimensions: overall length (warp direction) 35 cm, overall width 79.5 cm
Construction: two panels sewn together
Edge finish: one folded and hemmed side

Embroidery
Embroidery thread: silk, I (untwisted), 8 colors: red, dark blue, light blue, green, yellow, dark brown, light brown, white
Embroidery stitches: herringbone stitch, chain stitch, satin stitch, stem stitch (whipped), outline stitch
Dimensions: embroidered design is 29 cm tall including 5.5 cm tall border
Notes: pattern drawn on front face of foundation fabric; embroidered before assembly

CAT 1.3
Skirt borders
Crete
Early 18th century
The Textile Museum 81.54A, B
Acquired by George Hewitt Myers before 1928

Foundation
Warp: linen, Z-spun, 17 yarns per cm, off-white (undyed)
Weft: cotton, Z-spun, 16 yarns per cm, off-white (undyed)
Structure: balanced plain weave
Dimensions for 81.54A: overall length (warp direction) 40 cm, overall width 160.4 cm
Dimensions for 81.54B: overall length (warp direction) 38.1 cm, overall width 161.3 cm
Construction: two loom-width and one half-loom-width panels sewn together
Edge finish: four folded and hemmed sides

Embroidery
Embroidery thread: silk, I (untwisted), 4 colors: red, yellow, green, blue
Embroidery stitches: Cretan feather stitch, herringbone stitch, chain stitch (doubled), satin stitch, outline stitch, feather stitch
Dimensions: embroidered design is 35 cm tall including 6 cm tall border
Notes: pattern drawn on front face of foundation fabric; embroidered before assembly; mixing of embroidery threads (red and yellow and blue, yellow and red) perhaps a regional variation or simply a later practice

CAT 1.4
Skirt border
Crete
Early 18th century
The Textile Museum 81.51
Acquired by George Hewitt Myers in 1924

Foundation
Warp: linen, Z-spun, 20 yarns per cm, off-white (undyed)
Weft: cotton, Z-spun, 20 yarns per cm, off-white (undyed)
Structure: balanced plain weave
Dimensions: overall length (warp direction) 22.2 cm, overall width 325.12 cm; panel width (left to right) 65 cm, 65.5 cm, 65.5 cm, 64.5 cm, 65 cm
Construction: five loom-width panels sewn together
Edge finish: two selvedges

Embroidery
Embroidery thread: silk, I (untwisted), 3 colors: red, green, light green
Embroidery stitches: Cretan feather stitch, stem stitch, satin stitch, double running stitch
Dimensions: embroidered design is 17 cm tall including 5.5 cm tall border
Notes: pattern drawn on front face of foundation fabric; embroidered before assembly

CAT 1.5

Skirt border
Crete
Early 18th century
The Textile Museum 81.52
Acquired by George Hewitt Myers in 1924

Foundation

Warp: linen, Z-spun, 22 yarns per cm, off-white (undyed)
Weft: cotton, Z-spun, 22 yarns per cm, off-white (undyed)
Structure: balanced plain weave
Dimensions: overall length (warp direction) 17.8 cm, overall width 275.6 cm; panel width (left to right) 56 cm, 54 cm, 54.5 cm, 54.5 cm, 55 cm
Construction: five loom-width panels sewn together
Edge finish: two selvedges, one folded and hemmed end

Embroidery

Embroidery thread: silk, I (untwisted), 7 colors: red, blue, light green, dark blue, dark green, yellow, light brown
Embroidery stitches: Cretan feather stitch, satin stitch, stem stitch (whipped)
Dimensions: embroidered design is 15 cm tall including 4.5 cm tall border
Notes: pattern drawn on front face of foundation fabric; embroidered before assembly

CAT 1.6

Skirt border (fragment)
Crete
Late 17th century
The Textile Museum 81.53A
Acquired by George Hewitt Myers before 1928

Foundation

Warp: linen, Z-spun, 19 yarns per cm, off-white (undyed)
Weft: cotton, Z-spun, 18 yarns per cm, off-white (undyed)
Structure: balanced plain weave
Dimensions: overall length (warp direction) 40 cm, overall width 70.5 cm
Construction: two loom-width skirt panels sewn together horizontally
Edge finish: two selvedges

Embroidery

Embroidery thread: silk, I (untwisted), 6 colors: red, medium blue, dark blue, green, yellow, off-white
Embroidery stitches: chain stitch, herringbone stitch
Notes: pattern drawn on front face of foundation fabric

CAT 1.7

Bedspread
Crete
17th century
Collection of Mr. and Mrs. Joseph W. Fell

Foundation

Warp: linen, Z-spun, 23 yarns per cm, light brown (undyed)
Weft: linen, Z-spun, 30 yarns per cm, light brown (undyed)
Structure: balanced plain weave
Dimensions: overall length (warp direction) 231 cm, overall width 193 cm; panel widths (from left to right) 42.5 cm, 44.5 cm, 44 cm, 43 cm
Construction: four loom-width panels sewn together and a border made out of four strips added
Edge finish: four rolled and hemmed sides

Embroidery

Embroidery thread: silk, I (untwisted), 12 colors: red, yellow, white, green, light green, pink, light green, gray, purple, brown, red-brown, dark green
Embroidery stitches: Cretan feather stitch, satin stitch, outline stitch, stem stitch, buttonhole (single and double) stitch, split stitch, fishbone stitch, stepped running stitch, couching
Notes: pattern drawn on front face of foundation fabric; embroidered after assembly

CHAPTER 2: Lions, Kings, and Queens

CAT 2.1

Bed curtain panels
Mílos, south-central Cyclades
17th century
The Saint Louis Art Museum 195.1952.1, .2
Gift of Mrs. Frank H. Cook

Foundation

Warp: linen, Z-spun, 18 yarns per cm, off-white (undyed)
Weft: linen, Z-spun, 18 yarns per cm, off-white (undyed)
Structure: balanced plain weave
Dimensions: overall length (warp direction) 330 cm, overall width 99 cm
Edge finish: two selvedges, two rolled and hemmed ends

Embroidery

Embroidery thread: silk, S2Z, 1 color: red
Embroidery stitches: running stitch, satin stitch

CAT 2.2

Bed curtain panels
Folégandros, south-central Cyclades
17th century
The Textile Museum 81.77
Acquired by George Hewitt Myers before 1940

Foundation

Warp: linen, Z-spun, 18 yarns per cm, off-white (undyed)
Weft: linen, Z-spun, 19 yarns per cm, off-white (undyed)
Structure: balanced plain weave
Dimensions: overall length (warp direction) 221 cm, overall width 190 cm; panel width (left to right) 47 cm, 47 cm, 47 cm, 47 cm
Construction: four loom-width panels sewn together with plaited insertion stitch
Edge finish: two selvedges, two rolled and hemmed ends

Embroidery

Embroidery thread: silk, S2Z, 7 colors: red, orange-red, light blue, light yellow, green, brown-black, yellow-green
Embroidery stitch: running stitch

CAT 2.3

Bed curtain panels
Folégandros, south-central Cyclades
17th–early 18th century
The Textile Museum 2001.4.3A, B
The Ann Fraser Brewer Collection

Foundation

Warp: linen, Z-spun, 19 yarns per cm, off-white (undyed)
Weft: linen, Z-spun, 20 yarns per cm, off-white (undyed)
Structure: balanced plain weave
Dimensions for 2001.4.3A: overall length (warp direction) 328 cm, overall width 99 cm; panel width (left to right) 50 cm, 48 cm
Dimensions for 2001.4.3B: overall length (warp direction) 315 cm, overall width 97 cm; panel width (left to right) 47 cm, 50 cm
Construction: two loom-width panels attached together with plaited insertion stitch
Edge finish: two selvedges, two rolled and hemmed ends

Embroidery

Embroidery thread: silk, S2Z, 5 colors: red, green, black, white, red-brown
Embroidery stitches: running stitch, satin stitch, chain stitch, plaited insertion stitch

CAT 2.4

Bed curtain panels
Folégandros, south-central Cyclades
17th century–early 18th century
The Textile Museum 81.32
Acquired by George Hewitt Myers in 1924

Foundation

Warp: linen, Z-spun, 18 yarns per cm, off-white (undyed)
Weft: cotton, Z-spun, 15 yarns per cm, off-white (undyed)
Structure: balanced plain weave
Dimensions: overall length (warp direction) 330 cm, overall width 107 cm; panel width (left to right) 52.5 cm, 53.5 cm
Construction: two loom-width panels attached together with plaited insertion stitch
Edge finish: two selvedges, two folded and hemmed ends

Embroidery

Embroidery thread: silk, S2Z, 3 colors: red, green, light yellow
Embroidery stitches: running stitch, satin stitch, plaited insertion stitch

CAT 2.5

Pillow face
Náxos, central Cyclades
17th–18th century
The Textile Museum 81.2
Acquired by George Hewitt Myers before 1940

Foundation

Warp: linen, Z-spun, 17 yarns per cm, off-white (undyed)
Weft: linen, Z-spun, 17 yarns per cm, off-white (undyed)
Structure: balanced plain weave
Dimensions: overall length (warp direction) 111 cm, overall width 44 cm
Edge finish: four folded and hemmed.sides

Embroidery

Embroidery thread: silk, S2Z, 1 color: red
Embroidery stitch: running stitch in alternate alignment

CAT 2.6

Pillow face
Náxos, central Cyclades
17th–18th century
The Textile Museum 81.3
Acquired by George Hewitt Myers before 1940

Foundation

Warp: linen, Z-spun, 19 yarns per cm, off-white (undyed)
Weft: linen, Z-spun, 19 yarns per cm, off-white (undyed)
Structure: balanced plain weave
Dimensions: overall length (warp direction) 116 cm, overall width 46.5 cm
Edge finish: two selvedges, two folded and hemmed ends

Embroidery

Embroidery threads: silk, S2Z and Z2S, 1 color: red
Embroidery stitch: running stitch in alternate alignment

CAT 2.7

Bedspread (fragment)
Náxos, central Cyclades
17th–18th century
The Textile Museum 81.5
Acquired by George Hewitt Myers before 1940

Foundation

Warp: linen, Z-spun, 19 yarns per cm, off-white (undyed)
Weft: linen, Z-spun, 19 yarns per cm, off-white (undyed)
Structure: balanced plain weave
Dimensions: overall length (warp direction) 116 cm, overall width 46.5 cm
Edge finish: two selvedges, two rolled and hemmed ends

Embroidery

Embroidery threads: silk, S2Z, Z2S, 1 color: red
Embroidery stitch: running stitch

CAT 2.8

Bedspread (fragment)
Náxos, central Cyclades
17th–18th century
The Textile Museum 1972.20
Gift of Mrs. J. Warren Joyce

Foundation

Warp: linen, Z-spun, 19 yarns per cm, off-white (undyed)
Weft: linen, Z-spun, 20 yarns per cm, off-white (undyed)
Structure: balanced plain weave
Dimensions: overall length (warp direction) 108.5 cm, overall width 47.5 cm

Embroidery

Embroidery thread: silk, S2Z, 1 color: red
Embroidery stitch: running stitch in alternate alignment

CAT 2.9

Bedspread or bed curtain
Náxos, central Cyclades
17th–18th century
The Textile Museum 81.22
Acquired by George Hewitt Myers in 1925

Foundation

Warp: linen, Z-spun, 16 yarns per cm, off-white (undyed)
Weft: linen, Z-spun, 15 yarns per cm, off-white (undyed)
Structure: balanced plain weave
Dimensions: overall length (warp direction) 172.7 cm, overall width 144.7 cm; panel width (left to right) 49 cm, 22 cm, 26 cm, 48.5 cm
Construction: four panels (two at either end loom-width) sewn together
Edge finish: two selvedges

Embroidery

Embroidery thread: silk, Z2S, 2 colors: red and light yellow
Embroidery stitch: running stitch in alternate alignment

CAT 2.10

Pillow case
Náxos, central Cyclades
18th century
The Textile Museum 81.63
Acquired by George Hewitt Myers in 1925

Foundation

Warp: cotton, Z-spun, 18 yarns per cm, off-white (undyed)
Weft: cotton, Z-spun, 16 yarns per cm, off-white (undyed)
Structure: balanced plain weave
Dimensions: overall length (warp direction) 71 cm, overall width 52 cm
Edge finish: two selvedges, two rolled and hemmed ends

Embroidery

Embroidery threads: silk, Z2S, S, 3 colors: red, dark green, medium green
Embroidery stitch: running stitch in alternate alignment

CAT 2.11

Bed curtain (fragment)
Náxos, central Cyclades
18th century
The Textile Museum 81.61
Acquired by George Hewitt Myers in 1916

Foundation

Warp: linen, Z-spun, 16 yarns per cm, off-white (undyed)
Weft: cotton, Z-spun, 18 yarns per cm, off-white (undyed)
Structure: balanced plain weave
Dimensions: 30 x 157.5 cm
Construction: eight panels sewn together

Embroidery

Embroidery thread: silk, Z2S, 3 colors: red, green, blue
Embroidery stitch: running stitch in alternate alignment

CAT 2.12

Pillow face
Náxos, central Cyclades
18th century
The Textile Museum 81.62
Acquired by George Hewitt Myers in 1916

Foundation

Warp: linen, Z-spun, 19 yarns per cm, off-white (undyed)
Weft: linen, Z-spun, 15 yarns per cm, off-white (undyed)
Structure: balanced plain weave
Dimensions: overall length (warp direction) 105.4 cm, overall width 51.5 cm
Edge finish: two selvedges, two rolled and hemmed ends

Embroidery

Embroidery thread: silk, S2Z, 5 colors: red, blue, green, yellow, brown-black
Embroidery stitches: running stitch in alternate alignment, running stitch in steps, double running stitch

CAT 2.13

Pillow case
Pátmos, northern Dodecanese
18th century
The Textile Museum 81.41
Acquired by George Hewitt Myers in 1925
(warp direction horizontal)

Foundation

Warp: linen, Z-spun, 16 yarns per cm, off-white (undyed)
Weft: linen, Z-spun, 15 yarns per cm, off-white (undyed)
Structure: balanced plain weave
Dimensions: overall length (warp direction) 103 cm, overall width 45 cm
Edge finish: two selvedges, two hemmed ends

Embroidery

Embroidery thread: silk, S2Z, 3 colors: red, light green, yellow
Embroidery stitches: running stitch in alternate alignment

CAT 2.14

Bed curtain panels
Pátmos, northern Dodecanese
17th century
The Textile Museum 81.6A, B, C, and D
Acquired by George Hewitt Myers in 1924

Foundation

Warp: linen, Z-spun, 17 yarns per cm, off-white (undyed)
Weft: linen, Z-spun, 17 yarns per cm, off-white (undyed)
Structure: balanced plain weave
Dimensions 81.6A: overall length (warp direction) 243 cm, overall width 48 cm
Dimensions 81.6B: overall length (warp direction) 231 cm, overall width 47 cm
Dimensions 81.6C: overall length (warp direction) 239 cm, overall width 48 cm
Dimensions 81.6D: overall length (warp direction) 241 cm, overall width 48 cm
Edge finish: two selvedges, two hemmed ends

Embroidery

Embroidery thread: silk, S2Z, 1 color: red
Embroidery stitches: running stitch in alternate alignment, satin stitch

CAT 2.15

Bed tent
Kos, northern Dodecanese
17th century
The Textile Museum 81.34
Acquired by George Hewitt Myers before 1940

Foundation

Warp: linen, Z-spun, 16 yarns per cm, off-white (undyed)
Weft: linen, Z-spun, 14 yarns per cm, off-white (undyed)
Structure: balanced plain weave
Dimensions: overall length (warp direction) 250 cm, overall width 145 cm
Construction: four triangular bed tent panels and one bed tent door attached together with silk warp-faced ribbons (red and off-white stripes)
Edge finish: two selvedges, two rolled and hemmed ends; crochet band on three sides

Embroidery

Embroidery thread: silk, S2Z, 4 colors: 2 shades of red, green, blue-green gold metallic-wrapped thread, S, dark yellow silk core thread
Embroidery stitches: running stitch, satin stitch, chain stitch, cross stitch (long-armed)

TECHNICAL AND STRUCTURAL INFORMATION

CAT 2.16

Bed tent (fragments)
Kos, northern Dodecanese
17th century
The Textile Museum 81.16A, B
Acquired by George Hewitt Myers in 1915

Foundation

Warp: linen, Z-spun, 17 yarns per cm, off-white (undyed)
Weft: linen, Z-spun, 14 yarns per cm, off-white (undyed)
Structure: balanced plain weave
Dimensions 81.16A: overall length (warp direction) 256 cm, overall width 95.5 cm
Dimensions 81.16B: overall length (warp direction) 256.5 cm, overall width 85 cm
Construction: each fragment made out of three triangular bed tent panels sewn together
Edge finish: four rolled and hemmed ends

Embroidery

Embroidery threads: silk, I (untwisted) and Z2S, 2 colors: red, green
Embroidery stitches: running stitch, double running stitch

CAT 2.17

Bed tent (fragment)
Kos, northern Dodecanese
17th century
The Textile Museum 81.67
Acquired by George Hewitt Myers in 1925

Foundation

Warp: linen, Z-spun, 10 yarns per cm, off-white (undyed)
Weft: linen, Z-spun, 8 yarns per cm, off-white (undyed)
Structure: balanced plain weave
Dimensions: overall length (warp direction) 79 cm, overall width 51.5 cm
Edge finish: two selvedges, two hemmed ends

Embroidery

Embroidery thread: silk, S2Z, 5 colors: red, green, blue, pale yellow, white
Embroidery stitches: running stitch, satin stitch, eyelet stitch

CAT 2.18

Bed valance
Sífnos, central Cyclades
18th century
The Textile Museum 81.9
Acquired by George Hewitt Myers in 1925

Foundation

Warp: linen, Z-spun, 17 yarns per cm, off-white (undyed)
Weft: linen, Z-spun, 13 yarns per cm, off-white (undyed)
Structure: balanced plain weave
Dimensions: overall length (warp direction) 233.7 cm, overall width 108.5 cm; panel width (top to bottom) 48 cm, 60.5 cm
Construction: two panels (one linen, other cotton) sewn together; cotton panel possible later addition; embroidered end panel shortened.
Edge finish: two selvedges, two rolled and hemmed ends; crochet band on three sides

Embroidery

Embroidery threads: silk, I (untwisted) and S, 6 colors: dark blue, light blue, green, off-white, red, yellow
Embroidery stitches: double running stitch, satin stitch

CAT 2.19

Bed valance
Sífnos, central Cyclades
17th–18th century
The Textile Museum 81.11
Acquired by George Hewitt Myers in 1925

Foundation

Warp: linen, Z-spun, 17 yarns per cm, off-white (undyed)
Weft: linen, Z-spun, 13 yarns per cm, off-white (undyed)
Structure: balanced plain weave
Dimensions: overall length (warp direction) 200 cm, overall width 48 cm
Edge finish: two selvedges, two rolled and hemmed ends; applied braid and tassels along the three edges

Embroidery

Embroidery thread: silk, S2Z, 7 colors: red, red-brown, 2 shades of green (one in the fringe), blue, dark yellow, white
Embroidery stitch: satin stitch

CAT 2.20

Band valance (fragment)
Sífnos, central Cyclades
18th century
The Textile Museum 81.75
Acquired by George Hewitt Myers in 1925

Foundation

Warp: linen, Z-spun, 15 yarns per cm, off-white (undyed)
Weft: linen, Z-spun, 15 yarns per cm, off-white (undyed)
Structure: balanced plain weave
Dimensions: overall length (warp direction) 60 cm, overall width 12 cm
Construction: two loom-width panels sewn together
Edge finish: one selvedge with needle lace fringe

Embroidery

Embroidery thread: silk, Z2S, 5 colors: red, green, blue, yellow-green, dark yellow
Embroidery stitch: satin stitch

CAT 2.21

Bed valance
Central Cyclades
18th century
The Textile Museum 81.57
Acquired by George Hewitt Myers in 1925

Foundation

Warp: linen, Z-spun, 18 yarns per cm, off-white (undyed)
Weft: cotton, Z-spun, 16 yarns per cm, off-white (undyed)
Structure: balanced plain weave
Dimensions: overall length (warp direction) 199 cm, overall width 48 cm
Construction: two loom-width panels sewn together
Edge finish: two selvedges, two folded and hemmed ends; added fringe on three sides

Embroidery

Embroidery thread: silk, Z2S, 3 colors: 2 shades of green, red
gold metallic-wrapped thread, S, light yellow silk core thread
Embroidery stitches: satin stitch, running stitch, double running stitch

CAT 2.22

Bed valance
Íos, central Cyclades
18th century
The Textile Museum 81.48
Acquired by George Hewitt Myers
before 1928

Foundation

Warp: cotton, Z-spun, 19 yarns per cm, off-white (undyed)
Weft: cotton, Z-spun, 15 yarns per cm, off-white (undyed)
Structure: balanced plain weave
Dimensions: overall length (warp direction) 227 cm, overall width 53 cm
Edge finish: two selvedges, two rolled and hemmed ends; applied braid and tassels along the three edges

Embroidery

Embroidery thread: silk, I (untwisted), 7 colors: red, blue, green, blue-green, yellow, pink, light brown
Embroidery stitch: satin stitch

CAT 2.23

Bed valance
Anáfi, southern Cyclades
18th century
The Textile Museum 81.49
Acquired by George Hewitt Myers
in 1925

Foundation

Warp: cotton, Z-spun, 18 yarns per cm, off-white (undyed)
Weft: cotton, Z-spun, 14 yarns per cm, off-white (undyed)
Structure: balanced plain weave
Dimensions: overall length (warp direction) 200 cm, overall width 48 cm
Edge finish: two selvedges, two rolled and hemmed ends; applied braid and tassels along the three edges

Embroidery

Embroidery thread: silk, I (untwisted), 8 colors: red, pink, black, 2 shades of blue, dark yellow, yellow, green
Embroidery stitch: cross stitch (long-armed)

CAT 2.24

Pillow case
Anáfi, southern Cyclades
18th–19th century
The Textile Museum 81.42
Acquired by George Hewitt Myers
in 1925

Foundation

Warp: cotton, Z-spun, 16 yarns per cm, off-white (undyed)
Weft: cotton, Z-spun, 13 yarns per cm, off-white (undyed)
Structure: balanced plain weave
Dimensions: overall length (warp direction) 39.5 cm, overall width 61 cm

Embroidery

Embroidery thread: silk, I (untwisted), 8 colors: pink, red, yellow, green, blue, dark yellow, light blue, gray
Embroidery stitch: cross stitch

CHAPTER 3: Vases and Branches

CAT 2.25

Pillow case
Anáfi, southern Cyclades
18th–19th century
The Textile Museum 81.39
Acquired by George Hewitt Myers
in 1925

Foundation

Warp: cotton, Z-spun, 19 yarns per cm, off-white (undyed)
Weft: cotton, Z-spun, 13 yarns per cm, off-white (undyed)
Structure: balanced plain weave
Dimensions: overall length (warp direction) 37.5 cm, overall width 55.7 cm

Embroidery

Embroidery thread: silk, I (untwisted), 6 colors: red, blue, yellow, light green, gray, pink
Embroidery stitch: cross stitch

CAT 3.1

Bed curtain panel
Rhodes (Ródos), southern Dodecanese
17th–early 18th century
The Textile Museum 81.33A
Acquired by George Hewitt Myers
in 1926

Foundation

Warp: linen, Z-spun, 19 yarns per cm, off-white (undyed)
Weft: linen, Z-spun, 14 yarns per cm, off-white (undyed)
Structure: balanced plain weave
Dimensions: overall length (warp direction) 269 cm, overall width 39 cm
Edge finish: one selvedge, three rolled and hemmed sides

Embroidery

Embroidery thread: silk, Z2S, 2 colors: red, green
Embroidery stitch: Rhodian cross stitch

CAT 3.2

Bed curtain panel
Rhodes, southern Dodecanese
17th–early 18th century
The Textile Museum 81.33F
Acquired by George Hewitt Myers in 1926

Foundation

Warp: linen, Z-spun, 19 yarns per cm, off-white (undyed)
Weft: linen, Z-spun, 16 yarns per cm, off-white (undyed)
Structure: balanced plain weave
Dimensions: overall length (warp direction) 269 cm, overall width 39 cm
Edge finish: one selvedge, three rolled and hemmed sides

Embroidery

Embroidery thread: silk, Z2S, 5 colors: 2 shades of red, light green, medium green, blue
Embroidery stitch: Rhodian cross stitch

CAT 3.3

Bed curtain panel
Rhodes, southern Dodecanese
17th–early 18th century
The Textile Museum 81.33C
Acquired by George Hewitt Myers in 1926

Foundation

Warp: linen, Z-spun, 18 yarns per cm, off-white (undyed)
Weft: linen, Z-spun, 16 yarns per cm, off-white (undyed)
Structure: balanced plain weave
Dimensions: overall length (warp direction) 269 cm, overall width 39 cm
Edge finish: one selvedge, three rolled and hemmed sides

Embroidery

Embroidery thread: silk, Z2S, 3 colors: red, light green, green
Embroidery stitch: Rhodian cross stitch

CAT 3.4

Bed curtain panel
Rhodes, southern Dodecanese
17th–early 18th century
The Textile Museum 81.33E
Acquired by George Hewitt Myers in 1926

Foundation

Warp: linen, Z-spun, 19 yarns per cm, off-white (undyed)
Weft: linen, Z-spun, 16 yarns per cm, off-white (undyed)
Structure: balanced plain weave
Dimensions: overall length (warp direction) 269 cm, overall width 39 cm
Edge finish: one selvedge, three rolled and hemmed sides

Embroidery

Embroidery thread: silk, Z2S, 2 colors: red, green
Embroidery stitch: Rhodian cross stitch

CAT 3.5

Bed curtain panel
Rhodes, southern Dodecanese
17th–early 18th century
The Textile Museum 81.33B
Acquired by George Hewitt Myers in 1926

Foundation

Warp: linen, Z-spun, 19 yarns per cm, off-white (undyed)
Weft: linen, Z-spun, 16 yarns per cm, off-white (undyed)
Structure: balanced plain weave
Dimensions: overall length (warp direction) 269 cm, overall width 39 cm
Edge finish: one selvedge, three rolled and hemmed sides

Embroidery

Embroidery threads: silk, I (untwisted) and Z2S, 2 colors: red, green
Embroidery stitch: Rhodian cross stitch

CAT 3.6

Bed curtain panel
Rhodes, southern Dodecanese
17th–early 18th century
The Textile Museum 81.33D
Acquired by George Hewitt Myers in 1926

Foundation

Warp: linen, Z-spun, 20 yarns per cm, off-white (undyed)
Weft: linen, Z-spun, 16 yarns per cm, off-white (undyed)
Structure: balanced plain weave
Dimensions: overall length (warp direction) 269 cm, overall width 39 cm
Edge finish: one selvedge, three rolled and hemmed sides

Embroidery

Embroidery thread: silk, Z2S, 3 colors: red, 2 shades of green
Embroidery stitch: Rhodian cross stitch

CAT 3.7

Bed valance
Rhodes, southern Dodecanese,
17th–early 18th century
The Textile Museum 81.30
Acquired by George Hewitt Myers before 1928

Foundation

Warp: linen, Z-spun, 17 yarns per cm, off-white (undyed)
Weft: linen, Z-spun, 14 yarns per cm, off-white (undyed)
Structure: balanced plain weave
Dimensions: overall length (warp direction) 238.7 cm, overall width 105.4 cm
Construction: two loom-width panels sewn together
Edge finish: two selvedges, two rolled and hemmed ends

Embroidery

Embroidery thread: silk, I (untwisted), 4 colors: blue-green, red, green, and yellow
Embroidery stitches: Rhodian cross stitch, running stitch, satin stitch

CAT 3.8

Bed tent door and side panel
Rhodes, southern Dodecanese
17th–early 18th century
The Textile Museum 81.31, 81.76
Acquired by George Hewitt Myers in 1924

Foundation

Warp: linen, Z-spun, 29 yarns per cm, off-white (undyed)
Weft: linen, Z-spun, 17 yarns per cm, off-white (undyed)
Structure: balanced plain weave
Dimensions for door panels: overall length (warp direction) 350 cm, overall width 105.5 cm
Dimensions for side panels: overall length (warp direction) 312.4 cm, overall width 331.4 cm
Construction for door panels: two loom-width panels were sewn together on the top and left open for door opening
Construction for side panels: seven tapering panels were sewn together
Edge finish for door panels: four selvedges, folded and hemmed sides

Embroidery

Embroidery thread for door panels: silk, I (untwisted) and S2Z, 10 colors: brown (not original), black, 2 shades of red, 2 shades of green, yellow, light yellow, 2 shades of blue
Embroidery threads for side panels: silk, I (untwisted) and S2Z, 3 colors: green, red, blue-green
Embroidery stitch: Rhodian cross stitch

CAT 3.9

Bed tent (fragment)
Rhodes, southern Dodecanese
18th century
The Textile Museum 81.35
Acquired by George Hewitt Myers in 1922

Foundation

Warp: linen, Z-spun, 17 yarns per cm, off-white (undyed)
Weft: linen, Z-spun, 12 yarns per cm, off-white (undyed)
Structure: balanced plain weave
Dimensions: overall length (warp direction) 260 cm, overall width 29 cm

Embroidery

Embroidery thread: silk, I (untwisted), 11 colors: off-white (cream), light brown (tan), dark yellow, 3 shades of blue, red, brown, black, 2 shades of green
Embroidery stitch: Rhodian cross stitch

CAT 3.10

Pillow
Rhodes, southern Dodecanese
17th–early 18th century
The Textile Museum 81.74
Acquired by George Hewitt Myers in 1925

Foundation

Warp and weft: linen, Z-spun, 19 x 17 yarns per cm, off-white (undyed)
Structure: balanced plain weave
Dimensions: overall length 55 cm, overall width 45 cm
Edge finish: four rolled and hemmed sides

Embroidery

Embroidery thread: silk, I (untwisted), 2 colors: red, green
Embroidery stitches: Rhodian cross stitch, running stitch, satin stitch

CAT 3.11

Bed valance (fragment)
Rhodes (?), southern Dodecanese
18th century
The Textile Museum 81.66
Acquired by George Hewitt Myers in 1925
(warp direction horizontal)

Foundation

Warp: linen, Z-spun, 16 yarns per cm, off-white (undyed)
Weft: linen, Z-spun, 16 yarns per cm, off-white (undyed)
Structure: balanced plain weave
Dimensions: overall length (warp direction) 181 cm, overall width 51.4 cm
Edge finish: two selvedges, two rolled and hemmed ends

Embroidery

Embroidery thread: silk, I (untwisted), 2 colors: red, green
Embroidery stitch: Rhodian cross stitch

CHAPTER 4: Harpies and Roosters

CAT 4.1

Pillow face
Skýros, Northern Sporades
18th century
The Textile Museum 81.81
Acquired by George Hewitt Myers in 1927

Foundation

Warp: linen, Z-spun, 21 yarns per cm, off-white (undyed)
Weft: linen, Z-spun, 19 yarns per cm, off-white (undyed)
Structure: balanced plain weave
Dimensions: overall length (warp direction) 101.6 cm, overall width 42 cm
Construction: three loom-width panels sewn together
Edge finish: two selvedges, two rolled and hemmed ends

Embroidery

Embroidery threads: silk, Z and Z4S, 8 colors: red, blue, yellow, green, light green, light brown, brown, white
Embroidery stitches: running stitch in diagonal alignment, chain stitch
Notes: pattern drawn on back face of foundation fabric; stamped on back of pillow face

CAT 4.2

Bedspread
Skýros, Northern Sporades
18th century
The Textile Museum 81.21
Acquired by George Hewitt Myers in 1924

Foundation

Warp and weft: linen, Z-spun, 21 x 23 yarns per cm, off-white (undyed)
Structure: balanced plain weave
Dimensions: 167.7 cm x 122 cm
Construction: multiple pieces sewn together, lined
Edge finish: lace (bobbin lace?)

Embroidery

Embroidery threads: silk, Z3S and Z4S, 7 colors: red, blue, yellow, dark yellow, brown, white, green
Embroidery stitches: running stitch in alternate alignment, outline stitch, chain stitch, satin stitch
Notes: pattern drawn on front face of foundation fabric

CAT 4.3

Bed valance
Skýros, Northern Sporades
18th century
The Textile Museum 81.80
Acquired by George Hewitt Myers in 1927

Foundation

Warp: linen, Z-spun, 22 yarns per cm, off-white (undyed)
Weft: linen, Z-spun, 22 yarns per cm, off-white (undyed)
Structure: balanced plain weave
Dimensions: overall length (warp direction) 219 cm, overall width 83 cm; panel width (top to bottom) 41.5 cm, 41.5 cm
Construction: two loom-width panels attached together with plaited insertion stitch
Edge finish: two selvedges, two rolled and hemmed ends, added tassel

Embroidery

Embroidery thread: silk, Z4S, 7 colors: red, pink, 2 shades of blue, yellow, brown, white
Embroidery stitches: running stitch in alternate alignment, cross stitch, double running stitch, plaited insertion stitch

CAT 4.4

Pillow face
Skýros, Northern Sporades
18th century
The Textile Museum 81.99
Acquired by George Hewitt Myers in 1950

Foundation

Warp: linen, Z-spun, 21 yarns per cm, off-white (undyed)
Weft: linen, Z-spun, 23 yarns per cm, off-white (undyed)
Structure: balanced plain weave
Dimensions: overall length (warp direction) 96 cm, overall width 45.7 cm
Edge finish: two selvedges, two rolled and hemmed ends

Embroidery

Embroidery threads: silk, Z3S and Z4S, 8 colors: red, light blue, white, brown, light green, light yellow/ brown, dark yellow, brown
Embroidery stitches: running stitch in diagonal alignment, double running stitch

CAT 4.5

Bedspread
Skýros, Northern Sporades
18th century
The Textile Museum 81.59
Acquired by George Hewitt Myers in 1928
(warp direction horizontal)

Foundation

Warp: linen, Z-spun, 20 yarns per cm, off-white (undyed)
Weft: linen, Z-spun, 25 yarns per cm, off-white (undyed)
Structure: balanced plain weave
Dimensions: overall length (warp direction) 189 cm, overall width 130 cm, panel width (left to right) 43 cm, 42.5 cm, 44.5 cm
Construction: three loom-width panels attached together with plaited insertion stitch
Edge finish: embroidered with buttonhole stitch

Embroidery

Embroidery thread: silk, S2Z, 10 colors: dark brown, dark reddish brown, pink, 2 shades of light green, dark green, red, white, yellow, blue
Embroidery stitches: split stitch, satin stitch, double running stitch, chain stitch, buttonhole stitch (edge), plaited insertion stitch
Notes: pattern drawn on front face of foundation fabric

CAT 4.6

Bedspread
Skýros, Northern Sporades
18th century
The Textile Museum 81.15
Acquired by George Hewitt Myers in 1924

Foundation

Warp: linen, Z-spun, 22 yarns per cm, off-white (undyed)
Weft: linen, Z-spun, 21 yarns per cm, off-white (undyed)
Structure: balanced plain weave
Dimensions: overall length (warp direction) 224 cm, overall width 138.5 cm; panel width (left to right) 45.5 cm, 47.5 cm, 45.5 cm
Construction: three loom-width panels attached together with plaited insertion stitch
Edge finish: embroidered with buttonhole stitch

Embroidery

Embroidery thread: silk, S2Z, 10 colors: red, yellow, green, blue, white, pink, light brown, purple, dark pink, dark brown
Embroidery stitches: running stitch in alternate alignment, satin stitch, split stitch, double running stitch, buttonhole stitch (edge), plaited insertion stitch
Notes: pattern drawn on back face of foundation fabric; embroidered before assembly

CAT 4.7

Bedspread
Skýros, Northern Sporades
18th century
The Textile Museum 81.58
Acquired by George Hewitt Myers in 1925

Foundation

Warp: linen, Z-spun, 22 yarns per cm, off-white (undyed)
Weft: linen, Z-spun, 23 yarns per cm, off-white (undyed)
Structure: balanced plain weave
Dimensions: overall length (warp direction) 171 cm, overall width 124 cm; panel width (left to right) 41 cm, 42 cm, 41 cm
Construction: three loom-width panels attached together with plaited insertion stitch, buttonhole stitch (edge)
Edge finish: embroidered with buttonhole stitch

Embroidery

Embroidery thread: silk, Z2S, 7 colors: blue, brown, light brown, white, green, yellow-green, red
Embroidery stitches: running stitch, chain stitch, satin stitch, stem stitch, plaited insertion stitch
Notes: pattern drawn with blue ink(?) on front face of foundation fabric

CAT 4.8

Pillow face
Skýros, Northern Sporades
18th century
The Textile Museum 81.37
Acquired by George Hewitt Myers in 1925

Foundation

Warp: cotton, Z-spun, 18 yarns per cm, off-white (undyed)
Weft: cotton, Z-spun, 17 yarns per cm, off-white (undyed)
Structure: balanced plain weave
Dimensions: overall length (warp direction) 48.3 cm, overall width 45.7 cm
Edge finish: two selvedges

Embroidery

Embroidery thread: silk, Z2S, 6 colors: blue, red, light yellow, yellow, green, off-white
Embroidery stitches: chain stitch, double running stitch, satin stitch

CAT 4.9

Napkin or towel
Skýros, Northern Sporades
18th century
The Textile Museum 81.10
Acquired by George Hewitt Myers in 1925

Foundation

Warp: linen, Z-spun, 21 yarns per cm, off-white (undyed)
Weft: linen, Z-spun, 24 yarns per cm, off-white (undyed)
Structure: balanced plain weave
Dimensions: overall length (warp direction) 72 cm, overall width 40.5 cm
Edge finish: two selvedges, two rolled and hemmed ends; added tassels

Embroidery

Embroidery thread: silk, Z2S, 5 colors: red, light blue, off-white, white, light green
Embroidery stitches: double running stitch, satin stitch, hem stitch

CHAPTER 5: Brides and Grooms

CAT 5.1
Pillow face (fragment)
Epirus (Ipeiros)
17th–18th century
The Textile Museum 81.27
Acquired by George Hewitt Myers before 1940

Foundation

Warp: linen, Z-spun, 25 yarns per cm, off-white (undyed)
Weft: linen, Z-spun, 30 yarns per cm, off-white (undyed)
Structure: balanced plain weave
Dimensions: overall length (warp direction) 114 cm, overall width 38 cm
Edge finish: two selvedges, one rolled and hemmed end

Embroidery

Embroidery thread: silk, Z2S, 9 colors: blue, red, off-white, light brown, green, pink, dark pink, light orange, yellow-green
silver and gold metallic-wrapped thread, S, white and yellow silk core thread
Embroidery stitches: running stitch in alternate alignment, satin stitch, chain stitch
Notes: pattern drawn on back face of foundation fabric possibly with ink

CAT 5.2
Pillow face (fragment)
Epirus
17th–18th century
The Textile Museum 81.29
Acquired by George Hewitt Myers before 1940

Foundation

Warp: linen, Z-spun, 23 yarns per cm, off-white (undyed)
Weft: linen, Z-spun, 27 yarns per cm, off-white (undyed)
Structure: balanced plain weave
Dimensions: overall length (warp direction) 108 cm, overall width 38.5 cm
Construction: three loom-width panels sewn together
Edge finish: two selvedges, one rolled and hemmed end, one folded and hemmed end

Embroidery

Embroidery thread: silk, Z2S, 10 colors: blue, red, yellow green, light yellow-green, off-white, red-brown, white, blue-green, dark blue, brown
silver metallic wrapped thread, S, silver, white silk core thread
Embroidery stitches: running stitch in alternate alignment, stem stitch, chain stitch, herringbone stitch
Notes: pattern drawn on back face of foundation fabric possibly with ink

CAT 5.3
Bedspread (fragment)
Epirus
18th century
The Textile Museum 81.8
Acquired by George Hewitt Myers in 1924

Foundation

Warp: linen, Z-spun, 25 yarns per cm, off-white (undyed)
Weft: linen, Z-spun, 23 yarns per cm, off-white (undyed)
Structure: balanced plain weave
Dimensions: overall length (warp direction) 223 cm, overall width 40 cm
Edge finish: two selvedges, two rolled and hemmed ends, needlelace along one side

Embroidery

Embroidery thread: silk, Z2S, 6 colors: red, blue, light green, yellow, off-white, brown
Embroidery stitches: running stitch in alternate alignment, chain stitch, split stitch
Notes: pattern drawn on back face of foundation fabric

CAT 5.4
Bedspread (fragment)
Epirus
17th–18th century
The Textile Museum 81.97
Acquired by George Hewitt Myers in 1939

Foundation

Warp: linen, Z-spun, 21 yarns per cm, off-white (undyed)
Weft: linen, Z-spun, 21 yarns per cm, off-white (undyed)
Structure: balanced plain weave
Dimensions: overall length (warp direction) 100 cm, overall width 42 cm
Edge finish: one selvedge, three rolled and hemmed sides

Embroidery

Embroidery thread: silk, S2Z, 5 colors: red, blue, green, brown, white
Embroidery stitches: running stitch in diagonal alignment, chain stitch, satin stitch
Notes: pattern drawn on back face of foundation fabric

CAT 5.5
Bedspread (fragment)
Epirus
17th–18th century
The Textile Museum 81.28
Acquired by George Hewitt Myers before 1928

Foundation

Warp: linen, Z-spun, 27 yarns per cm, off-white (undyed)
Weft: linen, Z-spun, 27 yarns per cm, off-white (undyed)
Structure: balanced plain weave
Dimensions: overall length (warp direction) 75.7 cm, overall width 35.5 cm
Edge finish: one selvedge

Embroidery

Embroidery thread: silk, I (untwisted), 7 colors: red, blue, yellow-green, off-white, white, dark brown, orange
gold metallic-wrapped thread, S, tarnished, light yellow silk core thread
Embroidery stitches: split stitch, chain stitch, buttonhole stitch, stem stitch
Notes: pattern drawn on back face of foundation fabric

CAT 5.6
Bedspread
Epirus
Late 17th–early 18th century
The Textile Museum 81.70
Acquired by George Hewitt Myers in 1926

Foundation

Warp: linen, Z-spun, 23 yarns per cm, off-white (undyed)
Weft: linen, Z-spun, 23 yarns per cm, off-white (undyed)
Structure: balanced plain weave
Dimensions: overall length (warp direction) 275.6 cm, overall width 224 cm; panel width (left to right) 43 cm, 46 cm, 45 cm, 45 cm, 45 cm
Construction: four loom-width panels sewn together
Edge finish: two selvedges; two warp fringe ends

Embroidery

Embroidery thread: silk, I (untwisted), 4 colors: brown, purple, dark pink, dark brown
Embroidery stitches: split stitch, outline stitch
Notes: pattern drawn on back face of foundation fabric with reddish-brown ink; embroidered before assembly

CAT 5.7

Bedspread (fragment)
Epirus
18th century
The Textile Museum 81.20
Acquired by George Hewitt Myers in 1925

Foundation

Warp: linen, Z-spun, 24 yarns per cm, off-white (undyed)
Weft: linen, Z-spun, 25 yarns per cm, off-white (undyed)
Structure: balanced plain weave
Dimensions: overall length (warp direction) 263 cm, overall width 124 cm; panel widths (from left to right) 40cm, 43 cm, 41 cm
Construction: three loom-width panels sewn together
Edge finish: one selvedge

Embroidery

Embroidery thread: silk, I (untwisted), 4 colors: red, green, blue, white
Embroidery stitches: split stitch, satin stitch
Notes: pattern drawn on back face of foundation fabric possibly with dark blue/black ink

CAT 5.8

Bed valances
Epirus
18th century
The Textile Museum 81.60A, B
Acquired by George Hewitt Myers in 1940

Foundation

Warp: linen, Z-spun, 18 yarns per cm, off-white (undyed)
Weft: linen, Z-spun, 21 yarns per cm, off-white (undyed)
Structure: balanced plain weave
Dimensions for 81.60A: overall length (warp direction) 103 cm, overall width 202.5 cm; panel widths (from left to right) 67 cm, 68 cm, 67.5 cm
Dimensions for 81.60B: overall length (warp direction) 103 cm, overall width 207 cm; panel widths (from left to right) 70 cm, 68 cm, 69 cm
Construction: three loom-width panels sewn together
Edge finish: added woven fringe

Embroidery

Embroidery thread: silk, S2Z, 4 colors: red, green, blue, white
Embroidery stitches: running stitch in alternate alignment, split stitch
Notes: embroidered before assembly

CAT 5.9

Cope
Epirus
17th–18th century
The Textile Museum 81.36
Acquired by George Hewitt Myers in 1925

Foundation

Warp: linen, Z-spun, 23 yarns per cm, off-white (undyed)
Weft: linen, Z-spun, 23 yarns per cm, off-white (undyed)
Structure: balanced plain weave
Dimensions: overall length (warp direction) 137 cm, overall width 215 cm
Construction: three loom-width panels and several smaller fragments sewn together, a few from other textiles; lined

Embroidery

Embroidery thread: silk, I (untwisted), 9 colors (main textile): dark blue, dark green, light green, yellow, white, red, pinkish red, light blue, off-white
Embroidery stitch: split stitch
Notes: pattern drawn on front face of foundation fabric

CAT 5.10

Bedspread
Epirus
17th–18th century
The Textile Museum 81.86
Acquired by George Hewitt Myers in 1926

Foundation

Warp: linen, Z-spun, 22 yarns per cm, light brown (undyed)
Weft: linen, Z-spun, 23 yarns per cm, light brown (undyed)
Structure: balanced plain weave
Dimensions: overall length (warp direction) 164 cm, overall width 196 cm; panel widths 32 cm (left and right borders), 32 cm (top and bottom borders), 48 cm (left central panel) 46 cm (right central panel)
Construction: six loom-width panels (four embroidered border panels, two plain central panels)
Edge finish: two selvedges, two rolled and hemmed ends

Embroidery

Embroidery thread: silk, Z2S, 7 colors: red, blue, 2 shades of green, yellow, brown, white
Embroidery stitches: herringbone stitch, chain stitch, outline stitch
Notes: pattern drawn on front face of foundation fabric

CAT 5.11

Cover
Epirus
17th–18th century
The Textile Museum 1962.23.3
Museum purchase

Foundation

Warp: linen, Z-spun, 24 yarns per cm, light brown (undyed)
Weft: linen, Z-spun, 22 yarns per cm, light brown (undyed)
Structure: balanced plain weave
Dimensions: overall length (warp direction) 186 cm, overall width 135 cm; panel widths (left to right) 33 cm, 34 cm, 34 cm, 34 cm
Construction: four loom width panels sewn together
Edge finish: two selvedges

Embroidery

Embroidery threads: silk, Z2S and Z3S, 7 colors: white, dark yellow, brown, red, blue, 2 shades of green
Embroidery stitches: herringbone stitch, chain stitch
Notes: pattern drawn on front face of foundation fabric

CAT 5.12

Cover
Epirus
17th–18th century
The Textile Museum 81.96
Acquired by George Hewitt Myers in 1937

Foundation

Warp: linen, Z-spun, 23 yarns per cm, light brown (undyed)
Weft: linen, Z-spun, 22 yarns per cm, light brown (undyed)
Structure: balanced plain weave
Dimensions: overall length (warp direction) 184 cm, overall width 107.5 cm; panel width (from left to right) 36.5 cm, 36 cm, 35 cm
Construction: seven panels sewn together, one from another embroidered textile
Edge finish: two selvedges; two rolled and hemmed ends

Embroidery

Embroidery thread: silk, Z2S, 9 colors: blue, red, yellow, white, black (dark brown), green brown, purple, dark pink, dark brown
Embroidery stitches: herringbone stitch, chain stitch, outline stitch
Notes: pattern drawn on front face of foundation fabric; embroidered before assembly

CHAPTER 6: Stags and Eagles

CAT 6.1
Bedspread (fragment)
Ionian Islands (Iónioi Nísoi)
18th century
The Textile Museum 81.23
Acquired by George Hewitt Myers in 1925
(warp direction horizontal)

Foundation

Warp: cotton, Z-spun, 21 yarns per cm, white (undyed)
Weft: cotton, Z-spun, 26 yarns per cm, white (undyed)
Structure: balanced plain weave
Dimensions: overall length (warp direction) 87 cm, overall width 28 cm
Construction: two panels sewn together
Edge finish: one selvedge

Embroidery

Embroidery thread: silk, Z2S, 4 colors: red, green, blue, yellow
Embroidery stitch: Ionian Island cross stitch

CAT 6.2
Pillow face
Ionian Islands
17th–18th century
The Textile Museum 81.47
Acquired by George Hewitt Myers in 1925

Foundation

Warp: linen, Z-spun, 28 yarns per cm, off-white (undyed)
Weft: linen, Z-spun, 26 yarns per cm, off-white (undyed)
Structure: balanced plain weave
Dimensions: overall length (warp direction) 54 cm, overall width 47 cm
Edge finish: two selvedges

Embroidery

Embroidery thread: silk, Z2S, 7 colors: 2 shades of red, blue, green, dark brown/black, off-white, yellow
silver metallic-wrapped thread, S, white silk core thread
Embroidery stitches: overcast filling stitch, split stitch, cross-stitch, interlacing stitch, outline stitch
Notes: interlacing stitch used to fill some of the background areas to create an effect of solid ground.

CAT 6.3
Pillow face
Ionian Islands
17th–18th century
The Textile Museum 81.46
Acquired by George Hewitt Myers in 1925
(warp direction horizontal)

Foundation

Warp: linen, Z-spun, 28 yarns per cm, off-white (undyed)
Weft: linen, Z-spun, 31 yarns per cm, off-white (undyed)
Structure: balanced plain weave
Dimensions: overall length (warp direction) 121.5 cm, overall width 43 cm
Edge finish: two selvedges

Embroidery

Embroidery thread: silk, Z2S, 4 colors: blue, red, green, off-white
Embroidery stitches: split stitch, cross stitch, stepped running stitch
Notes: pattern drawn on front face of foundation fabric

CAT 6.4
Pillow face
Ionian Islands
17th–18th century
The Textile Museum 81.25
Acquired by George Hewitt Myers in 1922

Foundation

Warp: linen, Z-spun, 26 yarns per cm, off-white (undyed)
Weft: linen, Z-spun, 24 yarns per cm, off-white (undyed)
Structure: balanced plain weave
Dimensions: overall length (warp direction) 127 cm, overall width 45.5 cm
Edge finish: two selvedges, two rolled and hemmed ends

Embroidery

Embroidery thread: silk, I (untwisted), 5 colors: red, blue, green, off-white, dark brown
Embroidery stitches: overcast filling stitch, split stitch, interlacing stitch
Notes: interlacing stitch used to fill background areas to create an effect of solid ground

CAT 6.5
Pillow face
Ionian Islands
17th–18th century
The Textile Museum 81.26
Acquired by George Hewitt Myers in 1924

Foundation

Warp: linen, Z-spun, 27 yarns per cm, light brown (undyed)
Weft: linen, Z-spun, 25 yarns per cm, light brown (undyed)
Structure: balanced plain weave
Dimensions: overall length (warp direction) 134 cm, overall width 47 cm
Edge finish: two selvedges, two rolled and hemmed ends

Embroidery

Embroidery thread: silk, Z2S, 6 colors: red, blue, green, yellow, off-white, dark brown
Embroidery stitches: overcast filling stitch, split stitch, double running stitch, interlacing stitch
Notes: interlacing stitch used to fill some of the background areas to create an effect of solid ground

CAT 6.6
Pillow face
Ionian Islands
17th–18th century
The Textile Museum 81.24
Acquired by George Hewitt Myers in 1925

Foundation

Warp: linen, Z-spun, 24 yarns per cm, off-white (undyed)
Weft: linen, Z-spun, 24 yarns per cm, off-white (undyed)
Structure: balanced plain weave
Dimensions: overall length (warp direction) 50 cm, overall width 44 cm
Edge finish: two selvedges

Embroidery

Embroidery thread: silk, Z2S, 6 colors: red, green, blue, yellow, off-white, dark brown
Embroidery stitches: overcast filling stitch, split stitch, interlacing stitch, double running stitch
Notes: interlacing stitch used to fill some of the background areas to create an effect of solid ground

TECHNICAL AND STRUCTURAL INFORMATION

CAT 6.7

Pillow face
Ionian Islands
17th–18th century
The Textile Museum 81.84
Acquired by George Hewitt Myers in 1925

Foundation

Warp: linen, Z-spun, 25 yarns per cm, off-white (undyed)
Weft: linen, Z-spun, 24 yarns per cm, off-white (undyed)
Structure: balanced plain weave
Dimensions: overall length (warp direction) 53 cm, overall width 45 cm
Edge finish: two selvedges, two rolled and hemmed ends

Embroidery

Embroidery thread: silk, I (untwisted) and 2S, 5 colors: red, green, blue, yellow, off-white (ivory)
Embroidery stitches: overcast filling stitch, interlacing stitch
Notes: interlacing stitch used to fill background areas to create an effect of solid ground

CHAPTER 7: Ships and Flowers

CAT 7.1

Napkin
Argyrokastron (Gjirokastër in present-day southern Albania)
18th century
The Textile Museum 1983.59.10
Gift of John Davis Hatch in memory of Anna Van Scheick Mitchell (their collector 1923–36)

Foundation

Warp: linen, Z, off-white (undyed)
Supplementary warp: silk, I (untwisted), white
Weft: linen, Z, off-white (undyed)
Structure: balanced plain weave
Dimensions: overall length (warp direction) 106.5 cm, overall width 49 cm
Edge finish: two selvedges, two warp fringes

Embroidery

Embroidery thread: silk, I (untwisted), 4 colors: dark blue, red, pink, light brown
gold metallic-wrapped thread, Z, yellow silk core thread
Embroidery stitches: double running stitch, satin stitch

CAT 7.2

Napkin
Argyrokastron, southern Albania
18th century
The Textile Museum 81.68
Acquired by George Hewitt Myers before 1940

Foundation

Warp: linen, Z, 18 yarns per cm, off-white (undyed)
Weft: linen, Z, 16 yarns per cm, off-white (undyed)
Structure: balanced plain weave
Dimensions: overall length (warp direction) 118 cm, overall width 49 cm
Edge finish: two selvedges, two warp fringes

Embroidery

Embroidery thread: silk, S2Z, 10 colors: blue, white, green, red, yellow, pink, brown, light brown, dark green, yellow green
gold metallic-wrapped thread, Z, light yellow silk core thread
Embroidery stitches: double running stitch, woven hem stitch, satin stitch

CAT 7.3

Small cover
Argyrokastron, southern Albania, or Chios, Greece
18th century
The Textile Museum 81.79
Acquired by George Hewitt Myers in 1925

Foundation

Warp: silk, Z-twisted and I (untwisted), 21 yarns per cm, red
Supplementary warp: silk, I (untwisted), red
Weft: silk, Z-twisted, 24 yarns per cm, red
Structure: balanced plain weave
Dimensions: overall length (warp direction) 42.3 cm, overall width 45.5 cm
Edge finish: four rolled and hemmed sides, tassels added

Embroidery

Embroidery thread: silk, Z2S, 5 colors: pink, blue, green, white, and yellow-green
gold metallic-wrapped thread, Z, light yellow silk core thread
Embroidery stitches: double running stitch, fishbone stitch, satin stitch

Bibliography

Embroidery—General

Boser, Renée, and Irmgard Müller
1969 *Stickerei: Systematik der Stichformen*. G. Krebs, Basel.

Bucher, Jo
1971 *The Complete Guide to Embroidery Stitches and Crewel*. Creative Home Library, Des Moines.

Christie, Mrs. Archibald
1989 *Samplers & Stitches*. A Batsford Embroidery Paperback. Reprint, original 1920.

Eaton, Jan
2002 *Mary Thomas's Dictionary of Embroidery Stitches*. Trafalgar Square Publishing, North Pomfret, Vermont.

Emery, Irene
1994 *The Primary Structures of Fabrics: An Illustrated Classification*. The Textile Museum, Washington, and Watson-Guptill Publications, New York.

Enthoven, Jacqueline
1964 *The Stitches of Creative Embroidery*. Reinhold Publishing Corporation, New York.

Gostelow, Mary
1975 *A World of Embroidery*. Charles Scribner's Sons, New York.
1977 *The Complete International Book of Embroidery*. Simon & Schuster, New York.
1978 *Mary Gostelow's Embroidery Book*. E. P. Dutton, New York.

Haskins, Nancy Arthur
1982 *Universal Stitches for Weaving Embroidery and Other Fiber Arts*. Skein Publications, Eugene.

Pesel, Louisa F.
1921 *Stitches from Eastern Embroideries from Countries Bordering on the Mediterranean, from Greece, the Near East & Persia*. Percy Lund, Humphries & Co., ltd., London.

Schuette, Marie, and Sigrid Müller-Christensen
1964 *A Pictorial History of Embroidery*. Frederick A. Praeger, New York.

Swift, Gay
1984 *The Larousse Encyclopedia of Embroidery Techniques*. Larousse & Co., Inc., New York.

Thomas, Mary
1953 *Mary Thomas's Embroidery Book*. Hodder & Stoughton, London.
1954 *Mary Thomas's Dictionary of Embroidery Stitches*. Hodder & Stoughton, London.

Embroidery—Greek Islands

Argenti, Philip Pandely
1953 *The Costumes of Chios. Their Development from the XVth to the XXth Century*. B. T. Batsford, Ltd., London.

Benaki Museum
1965a *Epirus and Ionian Islands Embroideries*. Benaki Museum, Athens.
1965b *Skyros Embroideries*. Benaki Museum, Athens.
1966 *Crete-Dodecanese-Cyclades Embroideries*. Benaki Museum, Athens.

Ellis, Marianne, and Barbara Rowney
1991 Eastern Mediterranean Treasures, *Treasures from the Embroiderers' Guild Collection*, chapter 3, pp. 70–115. Edited by Elizabeth Benn. David & Charles Craft Books, Devon.

Gentles, Margaret
1964 *Turkish and Greek Island Embroideries from the Burton Yost Berry Collection in the Art Institute of Chicago*. The Art Institute of Chicago, Chicago.

Hatzimichali, Angeliki
1935– Μεσογειακα και Εγγυς Ανατοληϛ Κεντηματα∇τα
1936 Ελληνικα Κεντηματα∇Ηρειροϛ, Σκυροϛ, (Mediterranean and Near Eastern Embroideries, The Greek Embroideries, Epirus and Skyros), *Byzantinisch-Neugriechische Jahrbucher*, vol. 12, pp. 96–117. Byzantinisch-Neugriechische Jahrbucher, Athens.

Hauser, Walter
1943 Greek Island Embroideries, *The Bulletin of the Metropolitan Museum of Art*, vol. 1, no. 3, April 1943, pp. 254–60. The Metropolitan Museum of Art, New York.
1977 *The Greek Folk Costume*. 2 Volumes. Benaki Museum and "Melissa" Publishing House, Athens.

Haywood, Catherine van Steen
1983 Early Cretan Embroideries from Greek Museums, *Hali*, vol. 5, no. 3, pp. 286—89. Hali Publications Ltd., London.

Holme, Geoffre, (editor)
1921 *A Book of Old Embroidery*. With articles by A. F. Kendrick, Louisa F. Pesel, and E. W. Newberry. 'The Studio,' Ltd., London, Paris, and New York.

Hubbell, Sue
2001 *Shrinking the Cat: Genetic Engineering Before We Knew about Genes*. Houghton Mifflin Company, Boston and New York.

Johnstone, Pauline
1961 *Greek Island Embroidery*. Alec Tiranti, London.
1972a *A Guide to Greek Island Embroidery*. Victoria & Albert Museum, London.
1972b Cretan Costume Embroidery of the Eighteenth Century, *Apollo, The Magazine of the Arts*, vol. 46, no. 125, July, pp. 61–68. Edited by Denys Sutton. London.

Jones, Mary Eirwen
1969 *A History of Western Embroidery*. Studio Vista, London, and Watson-Guptill Publications, New York.

Koyria, Aphrodite
1989 Η Παραστοη της Ελληνιχης Φορεσιας στα χαραχτικα των Ευρωπαιχων Περιηγτικων Εχδοσεων (15οϛ–19 οϛ αι) (The Representation of Greek Costumes in Engravings in the Accounts of European Travelers (15th–19th Century), Εθνογραφικα (Etnografica), vol. 7, pp. 55–66, Peloponnese Folklore Foundation, Náfplion.

Lada-Minotos, Maria, and Diana Gangadis
1993 *Greek Costumes: Collection of the National Historical Museum*. Historical and Ethnological Society of Greece, Athens.

MacMillan, Susan L.
n.d. *Greek Islands Embroideries*. Museum of Fine Arts, Boston.

Mitchell, Elizabeth A., and Sally J. Thurston
2004 Metrites and Graftes: Greek Embroideries, *Piecework*, vol. XII, no. 6, November/December, pp. 42–45. Interweave Press, Loveland, Colorado.

Papantoniou, Ioanna
1996 *Greek Regional Costumes*. Peloponnesian Folklore Foundation, Náfplion.
2000 *Greek Dress from Ancient Times to the Early 20th Century*. Commercial Bank of Greece, Athens.

Pesel, Louisa F.
1906 Cretan Embroidery, *The Burlington Magazine*, no. XLV, vol. X, December, pp. 155–61, London.
1907a The Embroideries of the Aegean, *The Burlington Magazine*, no. XLVI, vol. X, January, pp. 230–39, London.
1907b The So-called 'Janina' Embroideries, *The Burlington Magazine*, no. XLIX, vol. XI, April, pp. 32–39. The Burlington Magazine, Ltd., London.

Petrakis, Joan
1977 *The Needle Arts of Greece: Design and Techniques*. Charles Scribner's Sons, New York.

Polychroniadis, Helen
1980 *Greek Embroideries*. Benaki Museum, Athens.

Taylor, Roderick R.
1987 The Early Collectors, *Hali*, issue 36, vol. 9, no. 4, October/November/December, pp. 36–47. Hali Publications, London.
1993 Greece, The Greek Islands and Albania, *5000 Years of Textiles*, pp. 242–49. Edited by Jennifer Harris. British Museum Press in association with The Whitworth Art Gallery and The Victoria and Albert Museum, London.
1998 *Embroidery of the Greek Islands and Epirus*. Interlink Books, Brooklyn.
2001a Greek Textiles: The Art of Embroidery, *Ghereh*, issue 28, pp. 17–25, Turin.
2001b Uses and Techniques of Embroidery in Greece, *Ghereh*, issue 28, pp. 26–27, Turin.

Towsend, Gertrude
1930 Mediterranean Embroideries, *Bulletin of the Museum of Fine Arts*, vol. XXVIII, no. 170, December, pp. 100–113. The Museum of Fine Arts, Boston.
1933 Four Embroideries form the Greek Islands, *Bulletin of the Museum of Fine Arts*, vol. XXXI, no. 188, December, pp. 84–88. The Museum of Fine Arts, Boston.

Trilling, James
1983 *Aegean Crossroads: Greek Island Embroideries in The Textile Museum*. With contributions by Ralph S. Hattox and Lilo Markrich. The Textile Museum, Washington.

Tsenoglou, Eleni
2000 Οι Φορεσιες της Κρητης (The Costumes of Crete), Ενδυματολογικα (Endymatologjka), vol. 1, pp. 170—84, Peloponnese Folklore Foundation, Náfplion.

Underhill, Gertrude
1927 Greek Island Embroideries, *The Bulletin of the Cleveland Museum of Art*, April, no. 4, pp. 64–66. Cleveland Museum of Art, Cleveland.

Wace, A. J. B.
1914 *Catalogue of A Collection of Old Embroideries of the Greek Islands and Turkey*. Burlington Fine Arts Club, London.
1928 *Old Embroideries of the Greek Islands from the Collection of George Hewitt Myers*. Catalog of an exhibition held in the Gallery of the Century Association, 3–21 March 1928, The Century Association.
1933 Rhodian Embroideries—True and so-called: Distinctive pieces of needlework which have not yet been clearly classified, *The Antique Collector*, no. 9, vol. 4, September, pp. 598–602. London.
1935 *Mediterranean and Near Eastern Embroideries from the Collection of Mrs. F. H. Cook*. Halton & Company Ltd., London.
n.d. *Catalogue of a Collection of Modern Greek Embroideries Exhibited at the Fitzwilliam Museum Cambridge*. University of Cambridge, Cambridge.

Wace, A. J. B., and R. M. Dawkins
1914a Greek Embroidery-I, *The Burlington Magazine*, no. CXL, vol. XXVI, November, pp. 49–50. London.
1914b Greek Embroidery-II, *The Burlington Magazine*, no. CXLI, vol. XXVI December, pp. 99–107. London.

Weale-Badieritaki, Jean-Ann
1989 A New Approach to Greek Island Embroideries, *Ethnographika*, vol. 7, pp. 45–53, Peloponnese Folk Art Foundation, Náfplion.

Welters, Linda
1982 Greek Women's Chemises, *Dress*, vol. 8, pp. 10–21. The Costume Society of America, Earleville, Maryland.
1994 Embroidery on Greek Women's Chemises in The Metropolitan Museum of Art, *The Bulletin of The Needle and Bobbin Club*, vol. 67, no. 1, pp. 4–47. Needle and Bobbin Club, New York.
2000a The Peloponnesian "Zonari" A Twentieth-century String Skirt, *The Folk Dress in Europe and Anatolia: Beliefs about Protection and Fertility*, pp. 53–70. Edited by Linda Welters. Berg, Oxford and New York.
2000b Gilding the Lily: Dress and Women's Reproductive Role in the Greek Village, 1850–1950, *The Folk Dress in Europe and Anatolia: Beliefs about Protection and Fertility*, pp. 71–95. Edited by Linda Welters. Berg, Oxford and New York.

Travel Books and Memoirs—19th century and earlier

Argenti, Philip Pandely (1891–?), and
Herbert Jennings Rose (1883–1961)
1949 *The Folk-lore of Chios*. 2 Volumes. University Press, Cambridge.

Bent, James Theodore (1852–1897)
2002 *The Cyclades (Life Among the Insular Greeks)*. A new edition with additional material edited by Gerald Brisch. First published by Longmans, Green and Co. in 1885. Archaeopress and Gerald Brisch, Oxford.

Chandler, Richard (1738–1810)
1971 *Travels in Asia Minor, 1764–1765.* Edited and abridged by Edith Clay; with an appreciation of William Pars by Andrew Wilton. British Museum, London.

Charlemont, James Caulfeild, Lord (1728–1799)
1984 *The Travels of Lord Charlemont in Greece & Turkey*, 1749. Edited by William Bedell Stanford and E. J. Finopoulos, drawings by Richard Dalton. Trigraph for the A. G. Leventis Foundation, London.

Chateaubriand, François-René, Vicomte de (1768–1848)
1814 *Travels in Greece, Palestine, Egypt, and Barbary, during the years 1806 and 1807.* Translated from the French by F. Shoberl. Van Winkle and Wiley, New York.

Flandin, Eugène (1809–1876)
1867 *Histoire des chevaliers de Rhodes, depuis la création de l'ordre à Jérusalem jusqu'à sa capitulation à Rhodes.* A. Mame et fils, Tours.

Garnett, Lucy Mary Jane
1981 *Balkan Home-life.* Dodd, Mead & Company, New York. Reprinted from the edition of 1917, New York, from an original in the collections of the University of Michigan Library.

Hughes, Thomas Smart (or Samuel) (1786–1847) (Reverend)
1830 *Travels in Greece and Albania.* 2 Volumes, second edition. H. Colburn and R. Bentley, London.

Laurent, Peter Edmund (1796–1837)
1821 *Recollections of a Classical Tour through Various Parts of Greece, Turkey, and Italy: Made in the Years 1818 & 1819.* Illustrated with coloured plates. G. and W. B. Whittaker, London.

Pashley, Robert (1805-1859)
1885 *Travels in Crete*, 2 Volumes. Pitt Press, London. Reprinted by Dion N. Karavias Reprints, Athens in 1989.

Pococke, Richard (1704-1765)
1745a Observation on Palaestine or the Holy Land, Syria, Mesopotamia, Cyprus, and Candia, *A Description of the East, and Some Other Countries*, vol. II, part 1. Printed for the author by W. Bowyer, London.

1745b Observations on the islands of the Archipelago, Asia Minor, Thrace, Greece, and some other parts of Europe, *A Description of the East, and Some Other Countries*, vol. II, part 2. Printed for the author by W. Bowyer, London.

Spratt, T. A. B. (Thomas Abel Brimage), (1811–1888)
1865 *Travels and Researches in Crete.* J. van Voorst, London.

Taylor, Bayard (1825–1878)
1859 *Travels in Greece and Russia, with an Excursion to Crete.* G. P. Putnam's Sons, New York.

Thévenot, Jean de (1633–1667)
1971 *The Travels of Monsieur de Thévenot into the Levant.* Original English translation from French by A. Lovell and printed by H. Clark for H. Faithorne [and others], 1687, London. Reprint by Gregg International Publishers Ltd., Westmead, Farnborough, Hants, England.

Tournefort, Joseph Pitton de (1656–1708)
1718 *A Voyage into the Levant. Perform'd by Command of the Late French King. Containing the Ancient and Modern State of the Islands of the Archipelago; as also of Constantinople, the Coasts of the Black Sea, Armenia, Georgia, the Frontiers of Persia, and Asia Minor.* Translated by Honoré Maria Lauthier. Printed by D. Browne, A. Bell, J. Darby, A Bettesworth, J. Pemberton, C. Rivington, J. Hooke, R. Cruttenden, and T. Cox, J. Battley, E. Symon, London.

Travel Books and Memoirs—20th century

Antoniades, Xenophon A.
1977 *He Skýros stous periegetes kai geographous (1400–1900) [Η ΣΥΡΟΣ ΣΤΟΥΣ ΠΕΡΙΗΓΗΤΕΣ ΚΑΙ ΓΕΩΓΡΑΦΟΥΣ (1400–1900)].* Hetaireia Euvoïkon Spoudon, Athens.

Kininmonth, Christopher
1949 *The Children of Thetis: A Study of Islands and Islanders in the Ægean.* John Lehmann, London.

Liddell, Robert
1954 *Aegean Greece.* Jonathan Cape, London.

Linton, William
1857 *The Scenery of Greece and Its Islands.* Published by the artist, London.

Mayne, Peter
1958 *The Private Sea.* John Murray, London.

Shipley, A. E. (Arthur Everett), Sir (1861–1927)
1924 *Islands, West Indian-Aegean*, M. Hopkinson & Co., Ltd., London.

Znamierowski, Nell
1998 A Textile Lover's Travels in Greece, *Piecework*, vol. 6, no. 1, January/February, pp. 27–32, Interweave Press, Loveland, Colorado.

History, Art, and Architecture

Abegg, Margaret
1978 *Apropos Patterns for Embroidery, Lace, and Woven Textiles.* Abegg-Stiftung, Bern.

Ascherson, Neal
1996 *Black Sea: The Birthplace of Civilisation and Barbarism.* Vintage, London.

Brown, Patricia Fortini
2004 *Private Lives in Renaissance Venice: Art, Architecture, and the Family.* Yale University Press, New Haven and London.

Byrne, Janet S.
1981 *Renaissance Ornament Prints and Drawings.* The Metropolitan Museum of Art, New York.

Cazenave, Michel (editor)
1996a Melusine, *Encyclopédie des Symboles*, pp. 403–4. La Pochothèque, Le Livre de Poche, Paris.

1996b Sirène, *Encyclopédie des Symboles*, pp. 634–36. La Pochothèque, Le Livre de Poche, Paris.

Clogg, Richard
1992 *A Concise History of Greece*, Cambridge University Press, New York.

Cook, Michael W.
2001 Medieval Rhodes, The Knights of St. John, Greece. http://www.castles-abbeys.co.uk/Medieval-Rhodes.html.

Coulentianou, Joy
1977 *The Goat-dance of Skýros*. Hermes, Athens.

Davenport, Millia
1948 *The Book of Costume*. Volume 1. Crown Publishers, New York.

Delivorrias, Angelos
2000 *A Guide to the Benaki Museum*. Benaki Museum, Athens.

Denny, Walter
2002 *The Classical Tradition in Anatolian Carpets*. With contributions by Sumru Belger Krody. The Textile Museum, Washington, and Scala Publishers, London.

Encyclopedia Iranica
2001 *Genoa, Encyclopedia Iranica*, vol. X, pp. 422–26. Bibliotheca Persica Press, New York.

Fleming, K. E.
1999 *The Muslim Bonaparte: Diplomacy and Orientalism in Ali Pasha's Greece*. Princeton University Press, Princeton.

Foss, Arthur
1978 *Epirus*. Faber, London and Boston.

Fotheringham, John Knight.
1915 *Marco Sanudo, conqueror of the Archipelago*. Assisted by Laurence Frederic Rushbrook Williams. Clarendon Press, Oxford.

Greene, Molly
2000 *A Shared World: Christians and Muslims in the Early Modern Mediterranean*. Princeton University Press, Princeton.

Herald, Jacqueline
1981 *Renaissance Dress in Italy 1400-1500*. The History of Dress Series. General Editor Dr. Aileen Ribeiro. Bell & Hyman, London and Humatinities Press, New Jersey.

İnalcık, Halil
1975 *The Ottoman Empire: The Classical Age 1300-1600*. Translated by Norman Itzkowitz and Colin Imber. Weidenfeld and Nicolson, London.

İnalcık, Halil, and Donald Quataert (editors)
1994a *An Economic and Social History of the Ottoman Empire, 1300–1600*, volume 1, Cambridge University Press, Cambridge.
1994b *An Economic and Social History of the Ottoman Empire, 1600–1914*, volume 2, Cambridge University Press, Cambridge.

Jacoby, David
1997 Silk Crosses the Mediterranean, *Le vie del Mediterraneo: Idee uomini oggetti (secoli XI-XVI)*, pp. 55–79. Edited by G. Airaldi. Collana dell' Istituto di Storia del medioevo e della espansione europea, no. 1, Universita degli studi di Genova, Genova.
2000 The Production of Silk Textiles in Latin Greece, *ΤΕΧΝΟΓΝΩΣΙΑ ΣΤΗ ΛΑΤΙΝΟΚΡΑΤΟΥΜΕΝΗ ΕΛΛΑΔΑ* (Technognosia eto latinokratoymene Ellada), pp. 22–35. ΠΟΛΙΤΙΣΤΙΚΟ ΤΕΧΝΟΛΟΓΙΚΟ ΙΔΡΥΜΑ ΕΤΒΑ (Politistiko Technologiko Idroma Etna), Athens.

Kühnel, Ernst
1927 *Islamische Stoffe aus Ägyptischen Gräbern in der Islamischen Kunstabteilung und in der Stoffsammlung des Schlossmuseums*. Verlag Ernst Wasmuth, Berlin.

Luttrell, Anthony T.
1958 Venice and the Knights Hospitallers of Rhodes in the Fourteenth Century, *Papers of the British School at Rome*, vol. XXVI (new series, vol. XIII), pp. 195–212. British School at Rome, London.
1978a The Hospitaller at Rhodes: 1306–1421, *The Hospitallers in Cyprus, Rhodes, Greece and the West 1291–1440*, chapter 1. Variorum Reprints, London. Originally published in *A History of the Crusades*, pp. 278–313. Edited by K. Setton, III. University of Wisconsin Press, Madison, Wisconsin, 1975.
1978b The Hospitallers in Cyprus after 1291, *The Hospitallers in Cyprus, Rhodes, Greece and the West 1291–1440*, chapter II. Variorum Reprints, London. Originally published in *Acts of the I International Congress of Cypriot Studies*, vol. II, pp. 161–71. Nicosia, 1972.
1978c The Feudal Tenuire and Latin Colonization at Rhodes: 1306–1415, *The Hospitallers in Cyprus, Rhodes, Greece and the West 1291–1440*, chapter III. Variorum Reprints, London. Originally Published in *English Historical Review*, vol. LXXXV, pp. 755–75. London, 1970.
1978d Venice and the Knights Hospitallers of Rhodes in the Fourteenth Century, *The Hospitallers in Cyprus, Rhodes, Greece and the West 1291–1440*, chapter V. Variorum Reprints, London. Originally Published in *Papers of the British School at Rome*, vol. XXVI, pp. 195–212. London, 1958.
1978e Crete and Rhodes: 1340–1360, *The Hospitallers in Cyprus, Rhodes, Greece and the West 1291–1440*, chapter VI. Variorum Reprints, London. Originally published in *Acts of the III International Congress of Cretological Studies*, vol. II, pp. 167–75. Athens, 1974.
1982 Slavery at Rhodes: 1306–1440, Latin Greece, *The Hospitallers and the Crusdes 1291-1440*, chapter II, Variorum Reprints, London. Originally published in *Bulletin de L'Institut historique belge de Rome*, vols. XLVI–XLVII, pp. 81–100. Brussells and Rome, 1976–77.
1989 The Latins and Life on the Smaller Aegean Islands, 1204–1453, *Latins and Greeks in the Eastern Mediterranean After 1204*, pp. 146–55. Edited by Benjamin Arbel, Bernard Hamilton, and David Jacoby. Frank Cass in association with The Society for the Promotion of Byzantine Studies, The Society for the Study of the Crusades and the Latin East, London.
1999 The Greeks of Rhodes under Hospitaller Rule: 1306–1462, *The Hospitaller State on Rhodes and its Western Provinces, 1306–1462*, chapter III, pp. 193–223. Variorum, Ashgate Publishing Company, Aldershot, Hampshire, and Brookfield, Vermont.

McKee, Sally
1993 Greek Women in Latin Households of Fourteenth Century Venetian Crete, *Journal of Medieval History*, vol. 19, September, pp. 229–49. Elsevier Science Publishers B.V., Amsterdam, London, New York, and Tokyo.

Mackie, Louise W., and Jon Thompson
1980 *Turkmen: Tribal Carpets and Traditions*. The Textile Museum, Washington.

Merriam-Webster Inc.
1998 *Webster's New Geographical Dictionary*. Third edition. Merriam-Webster Inc., Publishers, Springfield, Massachusetts.

Miller, William (1864–1945)
1908 *The Latins in the Levant; a History of Frankish Greece (1204–1566)*, John Murray, London.

Montesanto, Marica
1930 *La Citta Sacra (Lindo)*. Sindacato Italiano Arti Grafiche, Rome.

Myers, George Hewitt
1931 The Washington Textile Museum, *American Magazine of Art*, pp. 334–45, vol. 22, no. 5, May. The American Federation of Arts, Washington.

Norwich, John Julius
2003 *A History of Venice*. Penguin Books, London.

The Oxford English Dictionary
1989a The Knights of St. John, *The Oxford English Dictionary*, volume VI, pp. 415–16. Second edition. Clarendon Press, Oxford.
1989b Mermaid, *The Oxford English Dictionary*, volume VI, p. 637. Second edition. Clarendon Press, Oxford.
1989c Harpies, *The Oxford English Dictionary*, volume VI, p. 1129. Second edition. Clarendon Press, Oxford.

Pritchard, Frances
2003 The Use of Textiles, c. 1000–1500, *The Cambridge History of Western Textiles*, vol. 1, pp. 355–78. Edited by David Jenkins. 2 Volumes. Cambridge University Press, Cambridge.

Quataert, Donald
1995 The Workers of Salonica, 1850–1912. *Workers and the working class in the Ottoman Empire and the Turkish Republic, 1839–1950*, pp. 59–74. Edited by Donald Quataert and Erik Jan Zürcher. Tauris Academic Studies, London, New York in association with the International Institute of Social History, Amsterdam.
2000 Consumption Studies and the History of the Ottoman Empire, 1550–1922: An Introduction. State University of New York Press, Albany.

Riley-Smith, Jonathan
1999 *Hospitallers: the History of the Order of St. John*. Hambledon Press, London, and Rio Grande, Ohio.

Shaw, Stanford J.
1977 *History of the Ottoman Empire and Modern Turkey, Empire of the Gazis: The Rise and Decline of the Ottoman Empire, 1280–1808*. Volume 1. Reprint from 1976 edition. Cambridge University Press, Cambridge, London, New York, and Melbourne.

Shaw, Stanford J., and Ezel Kural Shaw
1977 *History of the Ottoman Empire and Modern Turkey, Empire of the Gazis: The Rise and Decline of the Ottoman Empire, 1808–1975*. Volume 2. Cambridge University Press, Cambridge, London, New York, and Melbourne.

Stavrianos, Leften Stavros
2001 *The Balkans Since 1453*. With a new introduction by Traian Stoianovich. New York University Press, New York.

Tolias, Georgios (compiler)
1995 *British Travelers in Greece, 1750–1820*. Exhibition Catalogue (25 May–30 July 1995). Introduction by Catherine Koumarianou. Foundation for Hellenic Culture, London.

Tsigakou, Fani-Maria
1981 *The Rediscovery of Greece: Travellers and Painters of The Romantic Era*. Introduction by Sir Steven Runciman. Thames and Hudson Ltd., London.
1991 *Through Romantic Eyes: European Images of Nineteenth-century Greece from the Benaki Museum, Athens*. Art Services International, Alexandria, Virginia.

Velde, François R.
1995– Heraldic Tour of Rhodes, Heraldry and Coat of Arms Web
2003 Ring, http://www.heraldica.org/topics/orders/malta/rhodes.htm.

Wehrhahn-Stauch, Liselotte
1967 Animal Motifs on Fabrics, *CIBA Review*, vol. 1, pp. 2–44. CIBA Limited, Basel.

Zachariadou, Elizabeth A.
1983 *Trade and Crusade: Venetian Crete and the Emirates of Menteshe and Aydin (1300–1415)*. Library of the Hellenic Institute of Byzantine and Post-Byzantine Studies, no. 11. Instituto ellenico di studi bizantini e postbizantini di Venezia per tutti i paesi del mondo, Venice.

Zakythenos, Dionysios A.
1976 *The Making of Modern Greece from Byzantium to Independence*. Translated with an introduction by K. R. Johnstone. Basil Blackwell, Oxford.

Zervos, Skevos Georges
1919? *The Dodecanese, the History of the Dodecanese through the Ages, its Services of Mankind and its Rights*. London.

Zürcher, Erik Jan
2003 Greek and Turkish Refugees and Deportees 1912–1924, *Turkology Update Leiden Project Working Papers Archive*, Department of Turkish Studies, Universiteit Leiden, http://www.let.leidenuniv.nl/tcimo/tulp/Research/ejz18.htm.

Index

Aegean Islands, 116
Albania, 123, 125, *126*, *127*, 131*n*, 150
Ali Paşa, 99
Amboise, Emery d', 130*n*
Amorgós, 34, 43, 67
Anáfi, 41, 43, *59*, 65, 129*n*, 143
Argyrokastron (Gjirokastér), 122–25, *127*, 150
Astypálaia, 65, 68
Austria, 131*n*
Avalos, Costanza d', 128*n*

Balkan Wars, 99
bed covers, Cyclades and northern Dodecanese 31, 36
bed curtains
 Cyclades and northern Dodecanese 31, 32, 34, *35*, 36, *36*, 41, *41*, 44, *45*, 47, *50*, *51*, *53*, 79, 139–40, 141
 Rhodes *72–73*, 143–44
bed furnishings, Cyclades 32
bed tents
 northern Dodecanese 31, *31*, 32, 37, *54–56*, 65–67, *65*, *66*, 79, 141, 142, 144–45
 (*sperveri*), Rhodes (Ródos), *61*, 62–63, *62*, 68, 71, *75–76*
bed valances
 Cyclades 32, 34, 41, *56–59*, 142, 143
 Epirus 91, 94, 95, *100*, 148
 Rhodes, 62, 74, 77, 144–45
 Skýros 80, 82, *86*, 145, 146
bedspreads 21
 Cretan *29*, 139
 Cyclades *49*, *50*, 140
 Epirus (Ípeiros), 91, 92, *93–95*, *93–94*, 95, 96, *100–103*, *107*, 147–48, *150*
 Ionian Islands 111, 112, *113*, 114, *118*, 149
 Skýros 79, 80–81, *84*, *87–89*, 145, 146
bench valances, Skýros 79
Bent, James 129*n*
breast cloths (*stithopano*, *brostomantila*), Chios 123–25, *124*, 132*n*
Byzantine Empire 99

Campo Formio, Treaty of 131*n*
Candia 23
Chíos 122–25, *127*, 150
 women's clothing 123, *123*
colors 18–19, 80, 95, 96, 112, 114, 125
 monochrome and polychrome styles 19, 21, 23

compound-weave panel, Ottoman *98*
copes, Epirus, Skýros, and Crete 92, *105*, 148
Corfu (Kérkyra), 111, 116, 117
counted thread embroidery, geometric 36, 133
covers
 Argyrokastron, Albania or Chios *127*, 150
 Epirus *108–9*, 148
Crete (Kríti or Candia), 14–23, 42, 68, 71, 80, 82, 83, 92, *105*, 128*n*, 148
 women's clothing 16, *16*, *17*, 23, *23*
Crispi, Francesco 129*n*
Cyclades 31–59, 62, 67, 79, 80, 81, 112, 139–43
Cyprus 128*n*

Dandolo, Enrico 129*n*
Divans 91
Dodecanese 80, 81
 northern 31–59, 79, 139–40, 141, 143
 southern 37, 112

Egypt 38
Epirus (Ípeiros), 90–109, 116, 130*n*, 147–48
 Despotate of 99
 men's and women's clothing 94
Este, Isabella d' 128*n*

Folégandros 34, *35*, 36, 38, 41, *45*, 47, 67, 139, 140
France 131*n*

Gabalas family 130*n*
gables 68
Gama, Vasco Da 128*n*
Genoa 130*n*
Ghisi family 82
grafta technique 80, 94, 135
Grammatikopoulos, Georgia 128*n*

head scarves 123
headgear 82, 94
Holbein, Hans, the Younger 131*n*
Homer, *Odyssey* 79

Ioánnina 91, 94, 99
Ionian Islands 110–21, 149–50
Íos 41, *58*, 143
Italy 83

jelek (*yelek*) 82
John the Divine, Saint 129*n*

Kaffa 128*n*
kaftans 79, 82
Kálymnos 65
Kárpathos 65, 68
Kásos 68
Kefallinía (Cephalonia), 111
Knights of Saint John 43, 67, 68–70, 129*n*, 130*n*
Kos 32, 34, 38, 43, *54–56*, 65, *65*, 66, 67, 68, 70, 141, 142
koumpaso 66, 130*n*

Lefkás (Lefkádia), 113, 116, 117
Leipsoí (Lipsós), 65, 68

Mark, Saint 31
metritá (*xombliastá*) 94, 128*n*, 136
Michael Angelos Komnenos Doukas 99
Mílos 34, 36, 38, 43, *44*, 67, 129*n*, 139
milosperveri 62, *62*
mirror cover, Ottoman *99*
Monemvasía 128*n*
Morocco 38
motifs
 animals 21, 113
 birds 19, *37*, 41, 61, 63, 67, 91, 95, 96, 111, 125
 boats 67
 branch (queen) *36*, 37–38, 67, 83, 98
 brides and grooms 91–92, 94
 carnations 19
 castle-like structures 91–92
 curvilinear 82, 94, 95
 deer 41, 67
 diamonds 114
 dixos 63–64, *63*
 eagles, double-headed 19, 67, 91, 111, 114
 floral scrolls 91
 flowers 67, 81, 91, 94, 95, 98
 carnations 94, 111
 hyacinths 94
 lobed 125
 tulips 81, 83, 94, 96, 111
 geometric style 81, 94, 114
 Harpies 79, 81, 95
 Holbein *gül* 114, *114*
 Horses 83, 94
 human figures 67, 81, 82, 83, 91–92, 94, 96

INDEX

hybrid beings 81
interlaced strapwork 114
lace 37
leaf (king) 36–37, *36*, 98, 111
lion 31, *31*, *38*
mermaids 81
 two-tailed 15, *15*, 19, 21, 36
peacocks, cactus-tailed 111
plants 41
qadi figures 82, *82*
religious 81
roosters 81, 82
ships 82, 83
 single-masted 91
 three- or four-masted 81, 125
snakes 19
spítha and *platýphyllo* 64, *64*, 66, 67
stags 111, 114
stars 63, 114, *114*
tree of life 37–38, *37*
trees, cypress 125
vase (*glastra*) 21, 41, 61–62, *61*, 63, 95, 96
xouna 82
mouseion 130*n*

napkins 123, 125, 150
 Skýros *89*, 146
Napoléon I, Emperor 23, 116
Nasi, Joseph 42, 129*n*
Náxos 34, 36, *48*, *49*, *50*, 67, 83, 140, 141
 Duchy of 42, 67, 68, 70
Nicaea 131*n*
Nicolo I, Duke 129*n*
Nísyros 65

Ottoman Empire 14, 23, 42, 68, 70–71, 82, 90–99, 111, 116, 117, 125, 129*n*, 130*n*, 131*n*

Papadopoula, Mara 128*n*
Páros 43, 129*n*
Pashley, Robert 23
Pátmos 32, 34, *35*, 38, 42, 43, *51*, *53*, 65, *65*, 66, 67, 141
pattern-darning technique 39
pillows 21
 Cyclades and northern Dodecanese 31, 32, *35*, 36, *48*, *50*, *51*, *59*, 140, 141, 143
 Epirus 91, 94, 96, *100*, 147
 Ionian islands 111, 113–14, *114–15*, *118–21*, 149–50
 Rhodes 62, 77, 145
 Skýros 79, *80*, *84*, *86*, *89*, 145, 146
pirates 129*n*
Portugal 128*n*
Pyrgi 123

Rhodes (Ródos), 18, 61–77, 82, 83, 112, 143–45
 stone door *69*
 Street of Knights *70*

Sanudo, Marco 42
Selim II, Sultan 129*n*
shalvars 23, 82
Sieber, F. W. 23
Sifnos 41, *56–57*, 142
skirt borders, Cretan 21, *24–27*, 138–39
skirts, Cretan 16, 21, 23
Skýros 78–89, 94, 145–46
 men's and women's clothing 79
 Turkish influence 83
Soldaia 128*n*
Sporades, Northern 71, 78–89
stitches 137
 buttonhole 125
 composite (Rhodian cross stitch) 65, 134
 cross 34, 41, 64, 67, 96, 111–12, 113, 117, 125, 133
 double-sided 112, 133
 Ionian island 112, 114, 133
 double-running 80, 125, 134
 feather 19, *21*, 133, 135
 herringbone *18*, 19, 92, 96–99, 135
 running 34–39, *35*, 67, 80, 92–95, 96, 136
 diagonal and alternate alignment 92, *93*, 94
 satin 34, 41, 80, 96, 125, 136
 split 92, 94, 95–96, 98, 116, 137
 zigzag 65
Süleyman I (the Magnificent) 68, 71
Syria 128*n*

thread, silk
 untwisted 96, 114
 Z-twisted 125, 137
Tínos 129*n*
towels, Skýros 79, *89*, 146
Trebizond 131*n*
Trilling, James 36
Turkey, women's clothing 23

Venice 14, 21–23, 37, 38, 82, 111, 114, 116, 131*n*
Vignoli, de', family 130*n*
voiding 131*n*

Wace, A. J. B. 34, 36, 37
withdrawn-element work style 113–17, 137

yarns 18, 32, 64, 67, 79, 92, 94, 112, 116, 125

Picture Credits

Photographs are by: © The Textile Museum, Washington, photographed by Jeffrey Crespi, cat. nos. 1.1—1.6,—2.2—7.3; photography courtesy of Mr. and Mrs. Joseph W. Fell, photographed by Jeffrey Crespi, cat. no. 1.7; © Saint Louis Art Museum, Saint Louis, cat. no. 2.1; © Benaki Museum, Athens, fig. nos. 1.1, 1.3, 3.4, 3.5; © The Textile Museum, Washington, photographed by Sumru Belger Krody, fig. nos. 1.4, 1.5, 2.1, 2.3—2.5, 2.6, 2.8, 2.9, 3.1, 3.6—3.8, 4.2, 4.3, 5.1—5.7, 6.1, 6.4; ; photograph courtesy of Ioanna Papantonio, Athens fig. no. 1.6; © World Museum Liverpool, fig. nos. 2.2, 7.2; © Staatliche Museen zu Berlin, fig. no. 2.7; © Metropolitan Museum of Art, New York, fig. no. 3.2; © Victoria and Albert Museum, London, fig. nos. 3.9, 4.4, 6.2, 6.3

Front/back cover: Cover (detail), Epirus, 17th–18th century. The Textile Museum 1962.23.3, Museum purchase (cat. no. 5.11)

Details: frontispiece (cat. no. 5.11), p. 4, (cat. no. 5.9), p. 6 (cat. no. 5.4), p. 7 (cat. no. 5.10), p. 10 (cat. no. 4.4), p. 11 (cat. no. 4.3), p. 14 (background, cat. no. 1.1), p. 14 (number, cat. no. 1.2), p. 30 (background, cat. no. 2.17), p. 30 (number, cat. no. 2.15), p. 60 (background, cat. no. 3.6), p. 60 (number, cat. no. 3.7), p. 78 (background and number, cat. no. 4.1), p. 90 (background, cat. no. 5.4), p. 90 (number, cat. no. 5.2), p. 110 (background and number, cat. no. 6.4), p. 60 (background, cat. no. 3.8), p. 122 (background, cat. no. 7.3), p. 122 (number, cat. no. 7.2), p. 151 (cat. no. 5.5)

Copyright © 2006 Scala Publishers
Text and Photography Copyright © 2006 The Textile Museum

First published in 2006 by
Scala Publishers
Northburgh House
10 Northburgh Street
London EC1V 0AT

in association with
The Textile Museum
2320 S Street NW
Washington, DC 20008-4088

on the occasion of the exhibition "Harpies, Mermaids, and Tulips: Embroidery of the Greek Islands and Epirus Region" at The Textile Museum, Washington, DC, March 17—September 3, 2006

ISBN 1 85759 426 6
All rights reserved. No part of this book may be reproduced, stored in a retrieval system or transmitted in any form or by any means electronic, mechanical, photocopying, recording or otherwise, without the written permission of Scala Publishers and The Textile Museum.

Project Editor: Esme West
Copy Editor: Richard G. Gallin
Designer: Janet James
Map: Adrian Kitzinger
Produced by Scala Publishers

Printed and bound in Singapore